BRITISH SCREEN S

THE STORY OF
BRITISH
ANIMATION

Jez Stewart

THE BRITISH FILM INSTITUTE
Bloomsbury Publishing Plc
50 Bedford Square, London, WC1B 3DP, UK
1385 Broadway, New York, NY 10018, USA
29 Earlsfort Terrace, Dublin 2, Ireland

BLOOMSBURY is a trademark of Bloomsbury Publishing Plc

First published in Great Britain 2021 by Bloomsbury on behalf of the
British Film Institute
21 Stephen Street, London W1T 1LN
www.bfi.org.uk

The BFI is the lead organisation for film in the UK and the distributor of Lottery funds for film. Our mission is to ensure that film is central to our cultural life, in particular by supporting and nurturing the next generation of film-makers and audiences. We serve a public role which covers the cultural, creative and economic aspects of film in the UK.

Copyright © Jez Stewart, 2021

Jez Stewart has asserted his right under the Copyright, Designs and Patents Act, 1988, to be identified as author of this work.

For legal purposes the Acknowledgements on p. 5 constitute an extension of this copyright page.

Cover design: Louise Dugdale
Front cover image: *Two Off the Cuff* (1968), courtesy of The Bob Godfrey Collection.

All rights reserved. No part of this publication may be reproduced or transmitted in any form or by any means, electronic or mechanical, including photocopying, recording, or any information storage or retrieval system, without prior permission in writing from the publishers.

Bloomsbury Publishing Plc does not have any control over, or responsibility for, any third-party websites referred to or in this book. All internet addresses given in this book were correct at the time of going to press. The author and publisher regret any inconvenience caused if addresses have changed or sites have ceased to exist, but can accept no responsibility for any such changes.

A catalogue record for this book is available from the British Library.

Library of Congress Cataloging-in-Publication Data
CIP Data Applied for

ISBN: PB: 978-1-9112-3965-9
HB: 978-1-9112-3973-4
ePDF: 978-1-9112-3971-0
ePUB: 978-1-9112-3972-7

Series: British Screen Stories

Designed, typeset and packaged by Tom Cabot/ketchup
Printed and bound in India

To find out more about our authors and books visit www.bloomsbury.com and sign up for our newsletters.

CONTENTS

 Acknowledgements 5
 British Screen Stories: Editors' Introduction 6
 Introduction 8

1. Signing In and Signing Up 11
 Close-up: Arise, Sir Lancelot 20

2. Dog Eat Dog 25
 Montage: Cats and Dogs 29

3. The Shadow of the Mouse 37
 Close-up: All Together Now 42

4. Shelter from the Storm 49
 Montage: Animated Ads 53

5. Back to the Front 63

6. Rebuilding 72
 Montage: The Larkins Studio 75
 Close-up: Bob Godfrey 78

7. Never Had It So Good 89
 Close-up: Grasshopper Group 94
 Montage: Animation Art 102
 Close-up: Richard Williams 106

8. Kids' Stuff 110
　　Montage: Animated Opposition 124
　　Close-up: Alison De Vere 126

9. Top of the World 129
　　Close-up: Money for Nothing 140

10. OK Computer 146
　　Close-up: Search for the British Simpsons 150

11. British Animation in the 21st Century 157

　　Recommended Reading 170
　　A British Animation Playlist 172
　　Notes 174
　　Index 187
　　Illustration Credits 192

ACKNOWLEDGEMENTS

I am hugely grateful to my editors, Mark and Patrick, for not only giving me the opportunity to write this book, but for having the patience and skill to whip it into shape. Special credit is due to Mark for his countless hours of assiduous pruning and course correction; I hope it wasn't too painful. I would like to thank Rebecca Barden, Camilla Erskine and Anna Coatman at Bloomsbury for seeing the potential of the book to launch this new series, and for the anonymous reader who gave generous and supportive feedback on the manuscript. Huge thanks also to Storm Patterson for her able indexing and to Tom Cabot for his work on the design.

Sonia Genaitay and Kristina Tarasova read early versions of some of these chapters, offering valuable advice and reassurance that was much needed. So many people have dropped nuggets of information that crop up across these pages it is impossible to thank them all here, but I would like to particularly thank Vivien Halas, Tom Lowe, Steve Henderson, Martin Pickles, Emma Calder and Alex Dudok de Wit for their support and friendship. I am also indebted to the work of the late Ken Clark, and hope that his unpublished history of British animation and his priceless research compiled over so many years will soon earn the credit it deserves.

Finally, apologies as well as gratitude are owed to Sonia, Eliott and Chloe for putting up with me over the many months of research and writing this book. I promise to never to do it again. Maybe.

BRITISH SCREEN STORIES: EDITORS' INTRODUCTION

A century and a quarter since the first films flickered onto the screen, moving images dominate our lives. Our workplaces, schools and homes – even the journeys between them – are saturated with film. So how did we get here? What's the story? Or rather, the stories – because film contains multitudes. Moving images preceded the cinema, found a new home on television, and began to fill the online space as soon as capacities allowed. Today, most of us carry a cinema in our pocket. And film has always taken countless forms, performed many different functions and (intentionally or not) elicited numerous effects. From the start, films have entertained, informed and educated, but also provoked, disturbed, challenged, experimented, aroused, recorded, reported, promoted, sold, persuaded and deceived.

This dizzying variety is an enduring feature of film, linking its present to its past and its future. Digital technology has transformed the ways moving images are produced, distributed and consumed, and the volume of screen 'content' has skyrocketed. But while almost none has ever seen a strip of celluloid, today's 'films' – be they features or television programmes, adverts or pop videos, gallery installations or TikToks – share a common ancestor in the first moving images to dazzle 1890s' audiences.

As studios and broadcasters mine their back catalogues and public archives – who have been conscientiously preserving film heritage for many decades – open up their vaults with mass digitisation initiatives, so much

that was previously largely hidden from public view is now available on a device near you. Britain has been in the vanguard of this digitisation revolution. For example, the BFI's own video-on-demand platform, BFI Player, now boasts well over 10,000 films. The borders between past and present are collapsing, as are the boundaries between the mainstream and what were once assumed to be niche tastes. Silent newsreels and CGI blockbusters, Edwardian street scenes and 21st Century vlogs: all these and countless more now sit side-by-side on video streaming platforms.

This sudden superabundance demands a redrawing of the boundaries of what film in Britain is, while laying bare just how much remains unmapped. This series will strive to explore this territory, telling fresh stories, retelling and revitalising familiar ones in the light of new discoveries and shining a light on overlooked or undervalued sectors, traditions and genres of British filmmaking.

Perhaps surprisingly, *The Story of British Animation* is the first book-length history of the subject from its late-Victorian origins to its digital present. Jez Stewart's many years as curator of the national collection of animation have given him a deep understanding of the form's rich heritage and an unusually informed view of the contemporary scene. His book not only stands as a lively and very readable introduction to a long and complex history, but paves the way for many more stories to come.

Mark Duguid & Patrick Russell

INTRODUCTION

Wallace & Gromit, Peppa Pig, Postman Pat – British animated characters are internationally famous. Britain has advanced the art of animation, too, in landmarks such as *A Colour Box* (1935), *Yellow Submarine* (1968) and *The Snowman* (1982). But understanding of the development of animation in Britain, the personalities who have driven it and the highs and lows of the industry, is sketchy to say the least.

How do we even begin to evaluate animation in Britain, when its story is so often overlooked in studies of screen history? When even an otherwise essential reference work like *The British Cinema Book*, for example, neglects to mention a single animated film in its 464 pages?[1]

But then British animators are well used to fighting for the limelight. In 1936 Anson Dyer, one of the form's pioneers, set out his own thoughts:

> By the way, has it ever struck you that there is only one standard by which a British Colour Cartoon is judged? – the American Cartoon! – which spells practically unlimited production costs which are probably covered before their cartoons even enter this country! Secondly, an already established home on the British screen, advance bookings months ahead, and low rental charges for 'Super' productions which forces the British animator to try and make a competitive Cartoon for as many hundreds as our cousins are spending thousands!!
>
> It's a tough proposition, isn't it?[2]

The dominance of Disney, Pixar and other American animation studios has long hampered the domestic industry in the UK. But Dyer's 'tough proposition' also points to a wider problem. The overwhelming popularity of family-friendly, colourful cartoons has tended to get in the way of appreciation of the sheer diversity of both animation art and the animation industry. While recent years have seen a number of valuable books that have helped bring focus to key periods[3] and certain studios – notably the two most successful, Halas & Batchelor and Aardman[4] – no comprehensive history of British animation has been published before now.[5] But a true understanding of the subject needs breadth as well as depth. Only a holistic approach does justice to the story's fascinating richness. British animation is an extremely broad church, encompassing, at one end, multi-million pound feature films requiring huge teams, and at the other, solitary artists producing short, often commissioned work. And yet it is also a small world, with a tangled web of interconnections.

Today's animation fans may well have come across the already cult children's classic *Hey Duggee* (2014–). But how many know that its creator, Grant Orchard, made his reputation on a series of viral online shorts like *Park Football* (2007), has produced countless promotional films and adverts, and won a BAFTA for his short film *A Morning Stroll* (2011)? Or that *Peppa Pig* co-creator Mark Baker was taught by Bob Godfrey, the maker of *Roobarb* (1974), who in turn gained his first animation experience in the 1950s at the little-known but innovative Larkins Studio, under the guidance of the German-born Peter Sachs, who started animating with George Pal in Holland, making British cinema adverts for Horlicks with scripts by future Ealing director Alexander Mackendrick?

While far from complete, this book aims to be inclusive, joining the dots between the distinct but overlapping sectors of advertising, sponsored filmmaking, children's television, feature films and independent art, while trying to make sense of a complex history spanning well over a century. Each chapter would merit a book of its own, and I hope someday to read discrete studies of subjects like British animated children's television.[6]

Squeezing such an immense story into a book of this length has inevitably meant some difficult decisions. I have given particular prominence to those areas that seem to me to have been poorly covered elsewhere,

such as the decades between the First and Second World Wars, which in many ways have set the pattern for the industry. The experiences of the first generations of British animators echo down the years: their struggles to secure funding and distribution; their efforts to compete with better-resourced overseas rivals; the refuge of advertising and sponsorship; the opportunities offered by new technology. But above all, the key to surviving and thriving has always been animators' bottomless creativity, ingenuity and adaptability. It's these qualities that make the story of animation one of the most diverse and colourful in British screen history.

1. SIGNING IN AND SIGNING UP

In *Artistic Creation* (1901), a man at an easel sketches body parts which he magically assembles into a real woman, before frightening her off by adding a baby. Even without that resonant title, it feels like a perfect start for the story of British animation, bringing together drawing and impossible cartoon logic, topped off with a good gag. But clever though it is, the film stops short of 'true' animation. To make it, Walter Booth combined

Artistic Creation (Walter Booth, 1901).

two important early film phenomena. In the 'lightning sketch' or 'chalk talk' – originally a music hall act – an artist rapidly sketches caricatures or other scenes on paper or blackboard. Film could enhance the 'lightning' aspect by cranking the camera at a slower speed during filming, thereby accelerating the drawing process when the film is projected at normal speed. 'Stop action' involves pausing the filming process to allow objects or people to be added, removed or replaced before filming recommences, so that when the film is projected they magically appear, disappear or transform.[7]

True animated films are created frame by frame, rather than captured in real time. They require a change to the internal gearing of a motion picture camera so that, at the turn of a handle or press of a button, it can take single, discrete frames rather than the usual machine-gun sequences of multiple frames per second. Where live-action cinema captures real movement in successive still photographic frames so that it can be reproduced on screen, in 'stop motion' animation, those fixed frames are artificially created – as drawings or using objects – so that, when run together, they create an illusion of movement that never happened in real life.[8]

In truth, confidently identifying Britain's first animated film is difficult, if not impossible. Historians and researchers working on the jigsaw of early film soon discover that not just some but most of the pieces are missing. Films were bankrolled for entertainment, not posterity; there were few incentives for producers to retain film prints beyond their commercial life – if they survived that long. The cellulose nitrate stock in use until 1951 was notoriously unstable and highly flammable, and so a liability to keep around. Some prints were sacrificed for the precious silver they contained (especially during WWI); others were left to rot. By the time Britain's national film archive arrived in 1935,[9] well over half of the films made in the medium's first 30 years were already lost.[10] Catalogues, advertising and trade press can help us fill some gaps in our knowledge, though descriptions of the films may be sketchy at best. And how do we identify actual animation at a time when any kind of film was routinely described as 'animated pictures'?

Our most reliable guide to what happened in the medium's earliest years is what survives. For our purposes, that's chiefly the 20-odd works preserved in the BFI National Archive which are known to have been produced before the outbreak of the First World War and in which we can observe some

Sorcerer's Scissors (Walter Booth, 1907).

'true' animation. A later Walter Booth film, *Hand of the Artist* (1906) is often claimed as Britain's first animated film, although the surviving footage made available from the National Film and Sound Archive in Australia shows only stop action and visual effects rather than animation. But his 1907 film, *The Sorcerer's Scissors*, makes several uses of actual stop motion, with a pair of magical scissors moving independently across the screen, along with a paintbrush and glue. In one scene transition, a new costume is 'cut and pasted' onto a character.

One often-cited claim to what would be not be just Britain's but the world's earliest-known animated film can probably be safely dismissed.[11] Arthur Melbourne Cooper's *Matches: An Appeal*, in which an animated matchstick scrawls a plea for donations to supply matches to British troops was almost certainly not, as the filmmaker claimed in later life, made in 1899 – which would make it the world's earliest-known animated film.[12] In fact, newspaper adverts for the same appeal by the film's sponsor, match

Dreams of Toyland (Arthur Melbourne-Cooper, 1908).

manufacturer Bryant & May, point to a release date of late 1914, as part of a patriotic campaign in the early months of the First World War.

Nevertheless, Melbourne-Cooper, like Walter Booth, would be a key player in the flowering of animation between 1906 and 1908, alongside James Stuart Blackton in the USA and Emile Cohl and Segundo de Chomón in France. His *Dreams of Toyland*, released in 1908, is a true milestone. The film begins with live-action scenes of a boy visiting a toy shop and then being put to bed, after which the scene transforms to a model town square in which his toys are brought to life through stop-motion. This animated 'dream sequence' lasts almost four minutes – and would have involved manoeuvring a large cast of puppets and assorted vehicles over 3500 times around the purpose-built set.

A similar narrative framing of an animated dream sequence is found in the subsequent *Tale of the Ark* (1909). It's another stop-motion marvel in which the story of Noah and his animals is ambitiously brought to life – biblical flood and all. A description of Melbourne-Cooper's lost 1901 film, *Dolly's Toys* – 'A child dreams that toys come to life'[13] – has fuelled speculation that it too may be animated film, while even stronger claims have been made for another missing film, *The Old Toymaker's Dream* (1904), made by Melbourne-Cooper's Alpha Trading Company, in which 'An old man dreams that a toy Noah's ark and animals grow to full size'.[14]

But evidence from a slightly later film – which happily survives – suggests that another trick might have been at play. Trade press hailed Walter Booth's *Dreamland Adventures* (1907) as 'a beautiful and unique Magic and Mystery Film which will enthral and captivate every audience, [in which] a party of children are accompanied through Wonders of Ocean Ice and Cloud by a Doll and a Golliwog, filled with life and characteristic animation.'[15] But Booth's toys come to life thanks not to stop motion, but to stop action and double exposure: the two inanimate dolls first appear to grow and are then replaced by actors, with outfits and make-up matching the toys'. Once full-size they can interact with the children and head off on their fantastical adventure, achieved with assorted special effects.

Booth was a former painter and amateur magician, who came to specialise in 'trick' films initially for Robert Paul from 1899, then on his own. Britain's closest rival to France's early genius of film fantasy, Georges Méliès, Booth clearly had stop-motion in his tool kit from around 1906, but used it sporadically when it suited his needs, and seems to have spared himself the effort when he could.

In fact, the earliest verifiable use of stop motion I have found in a British film is a sequence of animated lettering in the intertitles of a 1904 film called *The Latest News* – more an attractive visual flourish than a Eureka moment. The moment of discovery of animation techniques was less important than the realisation that films which found innovative uses for them could be popular. Entirely new kinds of stories and effects could be achieved by those artists prepared to invest the time and effort to work one frame at a time.

While filmmakers became more skilled in its techniques, animation had a haphazard advance in the years leading up to the First World War.

Melbourne-Cooper would further his experiments with the likes of *Road Hogs in Toyland* (1911), a no-holds-barred, drunken, car chase thriller 'enacted entirely by mechanical toys,' as the main title billed it. But he continued to work in live-action filmmaking and was also a pioneer in exhibition before his career stalled around the mid-1910s.

New players were entering the field. Charles Armstrong animated shadow puppets frame-by-frame in films like *A Clown and his Donkey* (1910), pioneering silhouette animation techniques later perfected by Lotte Reiniger. Nature photographer F. Percy Smith used stop motion to recreate the then-unfilmable actions of arachnids in *To Demonstrate How Spiders Fly* (1909). This scientific use of animation blazed new trails for the form, but Smith also appeared in trick films like Walter Booth's *Animated Cotton* (1909), and is credited with the early Claymation film *Animated Putty* (1911)[16]. Smith seems to be alone of all those named so far in continuing to work with animation beyond 1915, and then only as a peripheral part of his career as a wildlife filmmaker. Britain's first true 'animators' were yet to come.

One further development emerged around this time: colour animation. Kinemacolor was a two-colour additive process commercially available between 1908 and 1914. Colour was often artificially applied to early films, whether by

Animated Doll and Toytown Circus (Unknown, c1913).

hand- or stencil-colouring of individual frames, or tinting and toning whole sections. Kinemacolor was different. Black-and-white film was filmed and projected through alternating red and green filters at double speed so as to create an illusion of 'natural' colour when projected. Though principally used in live-action, Kinemacolor was used for stop-motion animation in at least five films described in contemporary trade press but all believed lost (the BFI National Archive holds a two-colour print known as *Animated Doll and Toy Town Circus* after etchings on its opening frames, which

OPPOSITE: *The Latest News* (Warwick Trading Company, 1904).

may be Kinemacolor but which doesn't match any known titles). *Love and War in Toyland* (1913) is listed as 3,000 feet long (about 25 minutes at the Kinemacolor speed of 32 frames per second) and left cinema trade paper *The Bioscope*, for one, awestruck:

> When it is estimated that the production required some 200,000 changes of position in photographing, and that it occupied nearly 4,000 hours of hard work, it will be seen that the result has not been easily carried out. The pitched battle between the leaden troops of the Lovelanders and the Nogoods, and the fearsome onslaught by every wild beast ever conceived by the designers of the Gamages, take rank with the greatest of battle films, while the aeroplane duel which takes place many inches above the earth is amazing in its manipulation and daring. The colouring of the film embraces all tints of the spectrum, and is a continual delight to the eye.[17]

The film was animated by Edgar Rogers, drawing on his family history of puppetry and his own background as a set designer and creator of special effects for spectacular stage shows.[18] Even allowing for the hyperbole of the time, it sounds a monumental achievement. But an all-too real war was on the way, and with it British animation discovered a new sense of purpose. The toys were put back into their box and the trick film novelties disappeared, replaced by films tweaking the Kaiser's nose or invoking outrage at his purported crimes, and by graphic reconstructions of distant incidents from the conflict.

The lightning sketch act, with its track record of tackling political subjects, moved easily to a war footing. Max J Martin's *Pathé Cartoons* series, a 'Satirical Review of Topical Events',[19] which had started in November 1913, released its 37th and final issue on 3 August 1914, the day before Britain declared war on Germany. But patriotic 'celebrity cartoonists' like Sidney Aldridge and Harry Furniss stood ready to fill the gap. Furniss was particularly quick off the mark: his *Peace and War Pencillings* (1914) series premièred in early August, although, with no actual animation, it was quicker to produce. The artist's larger-than-life figure was as much the star as his drawings, and his interest in film proved short-lived. Alick Ritchie was another star illustrator whose film career failed to catch fire:

the 'chalk talk' showcase *A Pencil and Alick P. F. Ritchie* (1915), was fun, but didn't match the graphic invention of his celebrity caricatures for *Vanity Fair* and cigarette cards.

As in the previous decade, many wartime films are lost, leaving us speculating about their claims to a place in animation history. On the AWOL list are some very intriguing works. In 1918, Tom Webster, better known for his 1920s sports cartoons in the *Daily Mail*, made *Charlie at the Front* and *Charlie Joins the Navy*, featuring one of several animated versions of Chaplin's 'little tramp'. Photographer and 'artist-entertainer' Ernest H Mills presented animated portraits of prominent politicians in *The Romance of David Lloyd George* and *The Romance of President Wilson* (both 1917). Celebrated war cartoonists Bruce Bairnsfather and Louis Raemaekers each had his own series of films in 1917, but the extent of their involvement in what were likely lightning sketches rather than animation is a mystery.

Many of those drawn into filmmaking in this period were postcard artists, and their films demonstrate a lighter, less political humour. The basic recipe blended comical puns at the expense of prominent Germans, heroic representations of British generals and situational comedy bewailing the trials of wartime life. Douglas Tempest was another early enlistee, with Bamforth & Co. releasing his *War Cartoons* to cinemas on 28 August 1914. The Yorkshire-based firm had been a major early film player, but by now was largely specialising in postcards; the *War Cartoons* usefully traversed both media. While Tempest's films appear lost, fellow postcard man Dudley Buxton's have fared better. Buxton's experience was more diverse – he had contributed humorous cartoons to weekly tabloid magazines like *The Tatler* and *The Sketch* – and his commitment to British animation would be more long term. *John Bull's Animated Sketchbook* ran for 22 episodes from mid-1915 until late December 1916, with Buxton producing the first seven editions single-handed. Surviving issues include many lightning sketches, but they also demonstrate a zeal for the potential of the new art, with increasingly innovative use of cut-out animation.

Anson Dyer, one of the few new arrivals with no background in postcards or illustration, was similarly ambitious. He spent the early part of his career in a stained glass studio before, just shy of 40, plunging into filmmaking with the three-issue *Dicky Dee* series, a mix of lightning sketch and cut-out

Close-up: Lancelot Speed

As a child in the 1870s, Lancelot Speed borrowed his mother's scissors to craft village scenes out of paper, and was left spellbound by his first encounter with a zoetrope. It was perfect training for a job that didn't yet exist.[*]

Some 50 years later, the aptly-named Speed was instrumental in evolving British animation from lightning sketch to independent art form. Abandoning medicine, he developed his gift for drawing at the Slade School of Fine Art, then worked as an illustrator, specialising in fantasy literature. Speed claimed that he spent two years 'experimenting exhaustively in trick drawing for the screen' before, in 1914, he designed an animated logo for Percy Nash's Neptune Films, featuring King Neptune emerging from the sea. That logo soon graced his own propaganda cartoon series, *Bully Boy* (1914–15).

Speed's apprenticeship at the more romantic and dramatic end of illustration distinguishes his work from the cartoonists, caricaturists and postcard men like Dudley Buxton. There's a brooding menace to his portrait of the Kaiser in 'Sea Dreams' (1914), feet up on a world dominated by Imperial Germany, with an eagle and a dragon at his command. As well as cut-out and lightning sketch, Speed also employed a kind of replacement animation: painting and over-painting layers of detail frame-by-frame to create movement. Later in the film he shows his more playful side: no sooner have two seagulls been conjured by his paintbrush than they flutter away.

His films were evidently popular: '*Bully Boy* cartoons are so successful that one sees them in almost any picture show one visits, and very frequently they form a turn at some of the best music halls,' remarked *Pictures and the Picturegoer*.[†]

Speed served as production designer on a live-action adaptation of H Rider Haggard's *She* (1916), and by the second half of the war his films had grown longer, with more sophisticated narratives. In *The U-Tube* (1917), Kaiser Wilhelm plots to invade Britain by means of a tunnel, but the Iron Cross medals he frivolously doles out to his mutinous crew confuse their compass, diverting them to the North Pole. This clever mix of comedy and propaganda is one of the best films of the war years.

[*] Bowler Reed, 'An Interview with the Inventor of the "Bully Boy" Cartoons', *The Bioscope*, 5 November 1914, pp. 497–99

[†] *Pictures and the Picturegoer*, 6 February 1915, p. 408

'Sea Dreams', *Bully Boy* series (Lancelot Speed, 1914).

In peacetime, Speed animated a popular *Daily Mirror* comic strip. Speed's fun and surprisingly ambitious series The Wonderful Adventures of *Pip, Squeak and Wilfred* (1921) featured exotic locations and included favourite characters like Popski the Bolshevik dog. It was a fine swansong to an underrated and all-too brief animation career.

Speed's death on 31 December 1931 merited a short obituary in *The Times*, which noted his contributions to *Punch*, the *Illustrated London News* and 'The Limbersnigs', a book of nursery rhymes written with his wife, but left his film work entirely unmentioned.[‡] He deserves remembering as a 'serious artist' who seriously applied himself to animation.

‡ *The Times*, 4 January 1932: p. 17

animation. ('Dicky' was presumably a nickname; his real name was Ernest John Anson Dyer.) Dyer and Buxton soon joined forces, producing alternate episodes of *John Bull's Animated Sketchbook*.

Animation also proved useful for illustrative purposes. F. Percy Smith – he of the flying spiders – used animated graphics in the *Kineto War Map* series, presenting succinct, evolving visualisations of changing battle fronts or naval manoeuvres. One (incomplete) surviving episode illuminates the notorious fate of British submarine HMS E13, which ran aground in neutral Danish waters days after its launch and was fired upon by German ships while stricken, killing half the crew. The animated map, complete with moving ships and supported by informative intertitles, proved the perfect tool to explain a complex incident, and the film successfully blended illustration with propaganda. The surviving section presents the British Navy's retaliatory sinking of a German dreadnought in the Gulf of Riga, with plenty of cotton wool to simulate gun smoke and burning battleships. The same objectives were behind Dudley Buxton's recreation of the sinking of the Lusitania in 'John Bull's Animated Sketchbook No. 4' (1915), which, while far less accomplished than Winsor McCay's famous version of 1918, was rush-released just six weeks after the event.

Their often obscure references and – to modern eyes – clumsy techniques make these films hard to appreciate today. But for audiences of the time they clearly had real impact, and they could be extremely popular. Another newcomer to film, illustrator Lancelot Speed, won praise for the first episode

LEFT: *Peter's Picture Poems* (Anson Dyer, 1917). **RIGHT:** *Studdy's War Studies* (George Studdy, 1915).

Ever Been Had? (Dudley Buxton, 1917).

of his *Bully Boy* series, which, said *The Bioscope*, 'concludes with an amusingly realistic reproduction of the British Bulldog consuming the German Sausage.'[20] George Studdy's work became a regular feature of the *Gaumont Graphic* newsreel, and his cartoons demonstrate both his newspaper roots and a lively interest in true animation. Critics judged *Studdy's War Studies* 'as good as anything the war has produced'.[21] Few artists could match Studdy's skills and insight, but cinema trade paper *The Bioscope*, while acknowledging that quality might suffer as cartoons proliferated, found that 'The reception accorded by picture theatre audiences to the average animated cartoon of a topical nature makes it quite clear that there is still room for any number of films such as this class, provided, of course, that they be good.'[22]

One effect of the German U-boat campaign was to limit the flow of competing films from overseas, while US neutrality until 1917 gave home-grown productions a virtual monopoly on topical subjects. As the war

dragged on, the more ambitious animators moved away from short topical gags in favour of extended narrative, increasingly embellished with fantasy and escapism. In Dudley Buxton's *Ever Been Had?* (1917), the man on the moon falls to Earth to discover the last surviving Englishman in a landscape of devastation. This harried survivor explains that a premature peace deal to end the Great War allowed the German army to retreat to secret underground workshops, emerging decades later with laser-armed flying warships to lay waste to London. The punchline reveals this to be a tall tale, told by an actor on a film set – long after a British victory which left just one surviving German residing in London Zoo. It's an impressive and enjoyable film in many ways. Buxton pulls off some surprisingly dramatic science fiction special effects considering he has only paper cut-outs at his disposal, and he enhances the twisting narrative with sharp characterisation. The moon-man's cheeky wink to the audience, after a mildly risqué joke about marrow sizes, is just one sign of Buxton's confidence as a storyteller. He and his peers still had a lot to learn, but despite the surrounding turmoil, British animation had come a long way in its first decade.

2. DOG EAT DOG

October 1924, and in the Chancery Division of the High Court of Justice, judgement is about to be passed on one of the decade's more unusual legal cases – officially listed as Studdy vs. Pathé Frères Cinema, but reported as 'Bonzo vs. Pongo'.

George Studdy's much-loved Bonzo the dog had found fame in a series of one-page comic drawings in *The Sketch*, leading to books, toys and assorted merchandising – even a stage appearance in pantomime with the great Lupino Lane. After the success of Studdy's war cartoons, it was a natural step

'Booster Bonzo', or 'Bonzo in Gay Paree', *Bonzo* series (WA Ward, *c.* 1925).

to bring Bonzo to the cinema. Having invested much time and money to bring his creation to life, Studdy was incensed to learn that a series of cartoons featuring the previously unheard-of 'Pongo the Pup' was about to pip him to the post. On Studdy's behalf, Sir Duncan Kerly KC, immediately demanded an injunction against Pongo's producers, Pathé, on the grounds that:

> 'Pongo' was not a pup; he was very much more like 'Felix the Cat.' It was very probable that the public would confuse 'Pongo' and 'Bonzo,' with the result that persons who had seen 'Pongo' would not see 'Bonzo.'[23]

Inadvertently, Kerly's objection gets to the nub of the problem. Bonzo's real adversary wasn't Pongo – nor any of the several other British cartoon canines – it was imported American animation, and above all the phenomenally successful Felix.

In March 1919 the Phillips Film Company placed an advert in the trade press billing their new *Phillips Philm Phables* series of cartoons 'by the leading British black and white humourists of the day'.[24] Two of the advertised artists certainly were well known from print media: Percy Fearon, aka 'Poy', then of the *Daily Mail* and *Evening News*; and JA Shepherd, a regular contributor to *Punch* and *The Strand*. The other two artists were more obscure but had established themselves as film animators in the First World War: Anson Dyer and Dudley Buxton[25].

Examples of the series were screened on both sides of the Atlantic. To the British trade press, Buxton's *Cheerio Chums* was 'Clean, clever [and] humorous in every way… a sure antidote to the 'flu, the hump, or anxiety due to strikes and other causes'.[26] But when it was shown in New York in May 1919, at a special exhibition of British films, a US cinema trade journal advised curtly that 'Displaying the "Cheerio Chum" [sic] in this country would be a needless hazard of audience displeasure'.[27]

A dozen *Philm Phables* were advertised, but it's unclear if all were made, and only an incomplete fragment of one of Dyer's films survives. It uses cut-out animation, but given the inexperience of Poy and Shepherd, other

OPPOSITE: Anson Dyer at an animation rostrum, *c.* 1920.

episodes likely relied on the already old-fashioned lighting sketch technique. But what irked the American reviewer was less the quality of the animation than the prevalence of British slang in the intertitles. British exhibitors seemed to have fewer concerns about content crossing the Atlantic in the other direction, and in 1921, when Pathé was looking for a cartoon series to include in its cinemagazine[28] *Eve and Everybody's Film Review*, it opted for an American one, *Bud and Susie*, followed in 1922 by *Felix the Cat*.

Born in 1919, Felix emerged from Pat Sullivan's New York cel animation studio to become the first international cartoon superstar. Cel animation, pioneered in the US from 1914 onwards by Earl Hurd and John Randolph Bray, radically speeded up the animation process, using layers of clear celluloid sheets to avoid the constant redrawing of every detail in a scene on paper. This Taylorisation of the cartoon process turned animation studios from workshops into factories (and obscured the contribution of Otto Messmer, who drew Felix anonymously for the studio owner, Sullivan). The ready and affordable supply of industrially-produced US cartoons threatened to consign to history the artisanal creator working alone at a rostrum. So let's celebrate the last hurrah of the cut-out animators of the silent era.

In 1919 Anson Dyer paired up with British cinema pioneer Cecil Hepworth for a series of cartoon burlesques of Shakespeare for the then-expanding Hepworth Picture Plays company. A feature in *The Times* welcomed his version of *The Merchant of Venice* (1919): '[it] strikes a new note in British work,' the author rhapsodised, adding, 'One cannot fail to be impressed by the vast amount of detail'.[29] *Oh'Phelia* (1919), the only one of the films to survive intact, offers plenty of evidence of the series' qualities. There are irreverent jokes that wouldn't look out of place in a Terry Gilliam cartoon 50 years later: a caricatured version of silent Western star William S Hart is eccentrically cast as Ophelia's brother Laertes, complete with miniature wheeled cannons in his holster; the censor fleetingly pops on-screen to sanitise a potentially offensive intertitle. It also features Hamlet agonising over cutting Ophelia's long hair ('To bob or not to bob?'), before whipping out the shears and leaving her 'visibly dis-tressed'. Even if you're not keen on puns, it is evidence of a lively comic sensibility in touch with the flapper fashions of the day.

A scene among the surviving sections of *Othello* (1920) is similarly inventive. A cut-out puppet is shown backstage preparing his make-up to play the

Montage: Cats & Dogs

Throughout the 1920s, British animators hunted for a homegrown hit to take on American superstar Felix the Cat. Already a pop culture phenomenon in print, Bonzo the dog seemed well placed to take on the felicitous feline. But he faced strong canine competition.

CLOCKWISE FROM TOP LEFT:
C.O.D. [*Jerry the Troublesome Tyke*] (Sid Griffiths, 1925); *Bonzo No. 1* (W.A. Ward, 1924); *Pongo Catches the Crossword Craze* (Dudley Buxton, c. 1925); *Putting the Wind up Winnie* [*Sammy and Sausage*] (Joe Noble, 1928); *Bingo the Battling Bruiser* (Norman Cobb, 1930); Louise Brooks with stuffed Dismal Desmond and Bonzo … Felix, centre.

title role – aided by Dyer's own hand. The animator lights a cut-out candle and proceeds to burn a cork on the cut-out flame, handing it to his cut-out actor, who uses it to blacken his face. This interplay between the artist and his creation anticipates the self-referentiality of later classics like Chuck Jones' *Duck Amuck* (US, 1953) and Daniel Greaves' *Manipulation* (1991). It's the cut-out equivalent of the cartoon logic that allowed Felix to use his tail as an umbrella or a question mark.

Hepworth's firm ran into trouble and folded by 1924, and after almost a decade in the industry Dyer, too, was starting to flag. His *Kiddiegraph* series (1922) retold fairy tales over a series of still drawings rather than animation. Dyer and his daughter featured in live-action sequences for a film that was less effort to produce and no less financially rewarding. Dyer left little mark on the remainder of the 1920s[30], hopping between animated diagrams, live-action documentaries and helping run a patisserie in Westcliff-on-Sea.[31] His time, though, would come again.

A Geni and a Genius (Victor Hicks, 1919).

The British, at least, never forgot that the world's most popular comic star was born in London, and many British animators felt entitled to ride Chaplin's tattered coat tails with cartoon appropriations of his 'little tramp' character. Victor Hicks took the idea to new heights in the two *A Geni and A Genius* films he produced in 1919. His background in poster design gave him a very different visual sense to those artists raised in print cartoon or caricature, and he tended to work in shapes rather than lines – perfect for cut-out animation. In the opening half of the first episode, Chaplin goes fishing, discovers a Geni in a bottle and is confronted by his own genius on the cinema screen, before finding himself whisked off into space to find 'fresh worlds to conquer'. The design is stronger than the narrative, however; in the remaining episode and a half, our hero rattles around the solar system with many ingenious details but diminishing returns for the audience. At the end of 1919 Hicks also developed his own characters, Spick and Span, and was the subject of a full-page focus in *Picture Plays* magazine describing his ambitions for the form,[32] but by 1920 he appears to have abandoned animation for good.

Another animator who stuck with his scissors was Lancelot Speed, who used cut-outs for his 26-part *The Wonderful Adventures of Pip, Squeak and Wilfred* (1921). Alongside Bonzo, it was a rare example of a British comic strip making the leap to animation (a more common phenomenon in America). The *Daily Mirror* – which, as the cartoon's publisher, had a particular interest in this 'living cartoon serial' – boasted that 'for the first "run" of the film in London a world's record price has been obtained – a higher figure than that paid for Charlie Chaplin, Mary Pickford and Douglas Fairbanks productions.'[33] The involvement of the strip's creators, writer Bertram 'Uncle Dick' Lamb and artist AB Payne, is signalled by their appearance in a live-action prologue to the first film, but it's unmistakably Speed who is the star turn. The peripatetic series took its characters to Egypt, Calcutta, the summit of Mount Everest and the North Pole – a remarkably ambitious creative effort. Far from limiting the series' appeal, the cut-out animation brings texture and detail to the settings and a delightful spontaneity to the characters. It's a great shame that it appears to be Speed's last animated work (see 'Close-up', p. 20) and by the mid-20s, cut-out animation was largely a thing of the past – for now.

But a few forward-looking animators in Britain had already been trying to modernise. In their *Kincartoons* (1917–18), produced for the National War

Savings Committee, Edward Kinsella and Horace Morgan graduated from cut-out animation to layered drawings, likely involving cels. 'Simple Simon' (c. 1917) features the popular actor and comedian George Robey in both live-action and cartoon form, ignoring the pieman and buying war certificates instead, using his savings to open Robey's Stores. The overlapping of drawn characters and scenery reveal that steps beyond cut-out animation are being used. Kinsella and Morgan seem to have left cartoons behind at the end of the war, and Kinsella, the artistic one, is remembered more for his illustrations and postcards than for his films.

Other British animators struggled to adapt, until a couple of notable visitors set them on the right path. Jesse 'Vet' Anderson (who earned his nickname as a veteran of the Spanish–American War) was an American illustrator and cartoonist who had worked on *Mutt and Jeff* cartoons at the Bowers-Barré studio in New York before military service carried him to Britain. Anderson used clear celluloid cells for *The Smoke from Grand-pa's Pipe* (1920), made for Kine Komedy Kartoons, though only for the backgrounds. It was with the arrival in 1924 of another American animator, Dick Friel, that the

The Smoke from Grand-pa's Pipe (1920).

British industry switched to the 'Bray-Hurd process' that was used into the 1990s, as Joe Noble, who began his career around this time, recalled:

> Friel brought us many of the American tricks of animation. Previous to his arrival we made our animation on sheets of paper, placing a single sheet of celluloid, bearing any static scenery, on top. Friel reversed this order, putting a single sheet of paper with the static scenery on first, and the animation, on celluloid, above it. This is the method used today. It allows a greater freedom of movement. In the old method a character could not walk in FRONT of, say, a post without the post showing through.[34]

This overlay of background and character is evident in *The Smoke from Grand-pa's Pipe*, in Dudley Buxton's series *Memoirs of Miffy* (1920–21) and in the *Bonzo* series. It was Buxton, not the more celebrated Anson Dyer, who invested most in advancing the form in this period. His style made a natural transition from cut-out to cel animation, and his characters were recognisable in either mode. By contrast, when Dyer returned to the industry in the 1930s, he relied on the creative efforts of others, and the results displayed little continuity with his earlier style.

With such momentous changes afoot, the rivalry between Bonzo and Pongo was an unhelpful distraction. It was clear in any case that the two inhabited quite different social circles. Bonzo only had to evade the attentions of the parlour maid to sneak some sausages; Pongo was penniless, on the streets and contemplating the workhouse. Bonzo was known to hop on a plane to Paris, get drunk in a city bistro and flirt with the (human) barmaid. Pongo took boxing lessons to deal with a family of troublesome goats and wrestled with a crossword puzzle on a butcher's floor to win the price of a pork pie.

Bonzo's astonishing success in print allowed Studdy to fund at least 24 standalone cinema cartoons. Up-and-coming director and screenwriter Adrian Brunel (who played a key part in founding the London Film Society), wrote storylines which were animated by an inexperienced team run by cartoonist William Ward. Pongo, by contrast, appeared in just half a dozen shorter episodes, released within the *Pathé Pictorial* cinemagazine. The creator of this 'All-British cartoon' was uncredited, but from the style of the characters it's obvious that it was none other than Dudley Buxton.

In the event, the case of Bonzo v. Pongo was quickly dismissed, leaving Studdy to shoulder the costs. It should have been a lesson. Squabbling among British animators over who had first rights to copy American cartoons – this was no way to build an industry. Bonzo's newspaper celebrity should have been the perfect foundation for a real British animated success: if he couldn't stand on his own four paws, who could?

Meanwhile, a new generation was entering this dog-eat-dog world. One was Sid Griffiths, who taught himself to animate through close examination of film strips while working as a projectionist in Cardiff. Borrowing an idea from the Fleischer Brothers' *Out of the Inkwell* series (US, 1918–29), Griffiths appeared in his own *Jerry the Troublesome Tyke* series, interacting with his creation from his animation table. He gained a reputation as a technical wizard, and his long career in the industry would be built more on his engineering skills than on his drawing. But he made Jerry as loveable as he was troublesome, and his stories brimmed with imagination.

'Jerry's Wireless Whirl', *Jerry the Troublesome Tyke* series (Sid Griffiths, 1925–27).

A caricature of Joe Noble by cartoonist 'Tom Titt'.

In 'We Nearly Lose Him' (1926), Sid accidentally draws Jerry's dinner with poisonous indelible ink and has to rush to Dr Dope for an antidote. When Jerry, back from death's door, announces that the cure tastes worse than the poison, an exasperated Sid takes the sheet on which the 'ungrateful tyke' is drawn and scrunches it into a ball. Working at Pathé's Wardour Street studios with the help of cartoonist Brian White (who had gained experience on the Bonzo series), Sid delivered over 30 episodes for *Pathé Pictorial* between 1925 and 1927, making *Jerry* one of Britain's longest-running silent cartoons.

Another new player, Joe Noble, flitted between newsreel work and animation while picking up the basics from Dudley Buxton and Vet Anderson at Kine Komedy Kartoons. He drew on his contacts and experience to help bring the work of two very different print illustrators to the screen: caricaturist 'Tom Titt'[35] and popular *Daily Mail* sports cartoonist Tom Webster (whose 1925 series *Alfred and Steve* introduced Noble to Dick Friel). But Noble's biggest success was his own *Sammy and Sausage* series (1928–29), featuring a boy and his dog and made for *Eve and Everybody's Film Review*. The series' inventive blending of live action and animation surpassed even that of *Jerry the Troublesome Tyke* – thanks in part to some guidance from Griffiths himself. In 'Shadows!' (1928), Joe gets into a boxing match with his own shadow before it chases him down a local street, shapeshifting as it comes. In *Whatrotolis* (1929), Noble parodies Fritz Lang's sci-fi epic *Metropolis* (1927), letting himself get zapped with rings of energy by his characters in an 'Electro-pep Apparatus' before jumping out of the window, cleverly filmed in a POV shot that put the camera at risk.

'Shadows!', *Sammy and Sausage* series (Joe Noble, 1928).

By the late 1920s British cinema as a whole was feeling increasingly overwhelmed by transatlantic imports, and crying out for government help. In animation, Felix was king – and a still more fearsome foe lay just ahead. But the patronage of newsreel companies had shown what a little support could do. With guaranteed distribution and a license to innovate, Joe Noble and Sid Griffiths were able to produce some of the most creative work to date. The canine capers of the 1920s showed that if you threw British animators a bone, they would run with it.

3. THE SHADOW OF THE MOUSE

'It is quite remarkable to hear that for once, in one branch of an industry dominated by the U.S.A., Britain is first in the field,' gushed *The Sphere* in January 1929.[36] The cause of the newspaper's excitement was the debut of the cheekily-titled *The Jazz Stringer* at an exhibition of 'British Talking Films' at London's Tivoli Cinema on 17 December 1928. Joe Noble's film, featuring 'Orace the 'Armonious 'Ound, announced itself as the first talking cartoon, underlining the point with its titular nod at *The Jazz Singer* (1927), which launched the 'talkies' era just over a year earlier.

Well, it would have been remarkable, if it were true. In fact, Walt Disney's *Steamboat Willie*, which introduced a whistling Mickey Mouse to an astonished and delighted world, had debuted in New York nearly a month earlier, on 18 November 1928.[37] Mickey wasn't the first character to benefit from the marriage of tune and cartoon, but the perfectly synchronised soundtrack gave his engaging and mischievous personality an extra edge. Thanks to Disney's energy and business savvy, Mickey quickly spread across the globe, helped by the colonising of the children's Saturday morning cinema circuit by Mickey Mouse Clubs. And Mickey didn't just capture the hearts of children. His fourth outing, *The Barn Dance* (1929), screened at the prestigious London Film Society alongside John Grierson's landmark documentary *The Drifters* (1929) and Sergei Eisenstein's banned *The Battleship Potemkin* (Soviet Union, 1925).[38]

The arrival of sound exposed Britain's distinctive misfortune – sharing a language with the world's dominant film industry. And to a poorly-resourced British animation industry at a time of unprecedented decline, adapting to sound appeared as much a burden as an opportunity. Not that that deterred the valiant Joe Noble. In July 1928, he successfully patented a 'Method of

The Second Adventure of 'Orace the 'Armonius 'Ound (Joe Noble, 1929).

making a comic cartoon talking film'.³⁹ Noble's 'method' had the virtue of distinctiveness: it involved shooting live-action film, with synchronised sound, of actors 'dressed in colours contrasting with the background, the hands being whitened and the lips outlined in black'. This film would then be used as a guide for the animation. The technique offered a solution to the problem of synchronising sound and image, but it was cumbersome and uninspiring in practice. Actors, Noble explained, would be 'positioned facing the camera' and would 'emphasise their actions and lip movement.'⁴⁰ Why use animation to make a thin tracing of such an artificially-staged reality?

In the event, Noble's sound films appear to have skipped the convoluted live-action stage, but they are still distinctly clunky. *The Second Adventures of 'Orace the 'Armonious 'Ound* (1929) begins with Joe at the easel inter-

acting with his cartoon creation, but the addition of sound adds little to a routine that already feels tired. For both this film and for *Meet Mr York – A Speaking Likeness* (1929), an advertising short for Rowntree's York chocolate, Noble used not drawn lip synchronisation for his characters' mouth movements, but paper cut-outs, operated in real time, puppet-style. But his emphasis on speech was misjudged. Mickey didn't need to talk to win over audiences, and the absence of dialogue allowed him to leap over the language barriers that were proving such an obstacle to international film distribution.

By 1930's *Elstree 'Erbs*, Noble seems to have learnt some lessons, absenting himself and eliminating dialogue for dialogue's sake. The film introduces a new team: Poll the parrot, Piggie the pig and Teddie the bear – the last with a striking resemblance to Mickey Mouse. Teddie appeared in at least one other Noble cartoon for the *Pathé Sound Magazine*, but since poor Poll appears to have been eaten by his so-called friends at the end of *Elstree 'Erbs*, the trio's first adventure was presumably their last. Noble

The Elstree 'Erbs (Joe Noble, 1930).

continued working on Pathé newsreels into the 1940s, but he was by then a peripheral figure in the industry.

Sid Griffiths and Brian White were also experimenting with sound, producing the enjoyable *Tropical Breezes* in 1930. It featured Hite and Mite, a tall and short double-act based on caricatures of their creators. In a smart marketing gimmick, the duo were christened via a *News of the World* reader competition. Though possibly born of expediency rather than strategy, Griffiths and White's decision to steer clear of dialogue in favour of some good visual and aural gags paid off. Hite and Mite were an engaging pair, and the interplay between them is well thought through, but sadly they didn't reappear.

A little more successful was Bingo, a new cartoon canine who harked back to the dogged 1920s. Three episodes were trade-shown in January 1931, to be distributed by MGM, and a fourth title has been identified. The animation is credited to Norman Cobb, who had drawn animated introductions for the silent *Community Song* series (1926–27). Bingo's most striking feature is his large, circular ears which, like Teddie's, clearly ape the already iconic Mickey silhouette. A sympathetic *Kinematograph Weekly* review found that 'the music and sound effects synchronise well with the action',[41] but the BFI National Archive's copies of *Bingo the Battling Bruiser* (1930) are silent, suggesting that dual versions were released.[42]

It wasn't only animated films that were struggling against American competition. In the face of pressure from increasingly desperate British producers and distributors, the government had introduced the Cinematograph Films Act of 1927, which required film exhibitors to show a minimum quota of British films in their programmes. On its own terms, the Act was a success, reversing a decline in British feature film production from the mid-1920s, albeit with some unintended consequences.[43]

British animation, by contrast, actually experienced a downturn. Though this coincided with the arrival of the all-conquering Mickey, there were probably several contributing factors – not least the 1929 Wall Street Crash and subsequent global economic depression. But just as significant was British animation's overdependence on one distribution strategy. With rare exceptions, like the *Bonzo* films, the foundation of British cartoon distribution in the 1920s was the cinemagazine, with up to 20 productions finding release each year. So when the major newsreel companies like Pathé and Gaumont

dropped the half-reel cartoon from their cinemagazines in the early 1930s, the impact on the animation industry was devastating. The most comprehensive catalogue of British animation lists only two animated films released in 1931, and just one in 1932.[44]

Conditions for animated films were increasingly unfavourable. Short feature supplements like newsreels, documentary and interest films generally didn't count towards the Cinematograph Films Act quota and, with no incentive for the trade to support them, production more than halved between 1929 and 1935.[45] And though short entertainment films like cartoons did qualify, they still needed to find a place in the cinema programme. In a survey of producers and exhibitors in *Sight & Sound* in 1935, Harry Bruce Woolfe, director of British Instructional Films, explained:

> The two-feature programme has gradually ousted the short subject from the screens of the country; principally because the masses prefer seeing two feature pictures to a mixed programme of one feature film and various shorts.... Producers will not make short films because there is insufficient room for them, and exhibitors will not book them because they do not exist.

Woolf's proposed solution was to continue to make 'first class short films' which would force their way onto the screen through their sheer quality. His examples of such 'first class' films were his own nature series *Secrets of Life* (1934–50) and 'Walt Disney cartoons'.[46]

Adding sound to animation had proved something of a hurdle in Britain, and then hot on its heels came colour. Across the Atlantic, Walt Disney was again setting the standard. 'Flowers and Trees' (1932) brought colour to the *Silly Symphonies* series, and for a time Disney had an exclusive monopoly on the newly-improved three-colour Technicolor process – the standard by which all other competing technologies were invariably judged. Investing in colour production meant more than popping out to buy some paint. Printing and processing costs were considerably higher, and that money had to be found somewhere. Still, colour proved a real catalyst for growth in animation in the 1930s since filming through stop motion offered the controlled conditions to show experimental colour systems in their best light. After all the obstacles, here, finally, was a boost for animation.

Close-up: All Together Now

The harmonious partnership between animation and music predates the arrival of sound cinema, through the abstract visual music experiments of Hans Richter, Viking Eggeling and others, particularly in Germany. In Britain things began more conventionally. Luscombe All-British Productions' *Community Song Series* (1927) was a kind of karaoke for flappers, with a cartoon Orpheus leading cinema audiences through the lyrics of popular songs of the day, encouraging them to provide their own soundtrack – the films themselves were silent.

Len Lye's early sound films, such as the unfinished *Peanut Vendor* (1933) and the more abstract *A Colour Box* (1935), often used upbeat, popular Cuban songs to win over audiences who might otherwise have resisted their unconventional images. Both Franciszka and Stefan Themerson's *The Eye and the Ear* (1945) and John Halas's *The Magic Canvas* (1948) were badged as intellectual experiments. The Themersons' film mixed abstract imagery with a scientific analysis of the film's score, while Halas's film referenced ballet and painting in a bid to position animation as a synthesis of all the arts.

The Beatles feature cartoon *Yellow Submarine* (1968) was a landmark collaboration between music and animation. Tracks were assigned to a variety of artists, leading to a medley of visual styles as diverse as the music. Charlie Jenkins' muted photo-collage techniques perfectly complement the downcast 'Eleanor Rigby', while the boiling brushstrokes and colours of Bill Sewell's rotoscope sequences dazzlingly illustrate the rhapsodic 'Lucy in the Sky with Diamonds'.

For Pink Floyd, animation was a natural development from the psychedelic lightshows of their live shows. Ian Emes, whose *French Windows* (1972) used a Floyd track without permission, was commissioned to produce animated visuals for the band's 1973 LP *The Dark Side of the Moon*. Animation by political cartoonist Gerald Scarfe was core to Floyd's 1979 concept album *The Wall* and the subsequent feature film *Pink Floyd: The Wall* (d. Alan Parker, 1982). Scarfe's goose-stepping hammers remain an iconic image.

CLOCKWISE FROM TOP LEFT: 'Perhaps You'll Think Of Me' (*Community Song Series*, 1927); *Ruddigore* (Joy Batchelor, 1967); *Experimental Animation 1933* (Len Lye, 1933); *French Windows* (Ian Emes, 1972); *Pink Floyd The Wall* (Alan Parker, 1982); *The Magic Canvas* (John Halas, 1948) ; *The Eye and the Ear* (Stefan & Franciszka Themerson, 1945).

Pre-production artwork for *Fox Hunt* (Anthony Gross, Hector Hoppin, 1936).

With the depression beginning to loosen its grip, by 1934 things were looking up for the British film industry. Studios and distributors were coming to terms with quotas, and there were growing signs of an improvement in quality. Alexander Korda's *The Private Life of Henry VIII* (1933) won Britain its first Oscar for Best Picture and made money on both sides of the Atlantic, while the reputation of Alfred Hitchcock was on the rise.

This wave of confidence led to a rare example of a big British studio backing an animated short. It was a truly international production. London Films' flamboyant Hungarian supremo Alexander Korda had seen and loved the French cartoon short *Joie De Vivre* (1934). Spellbound by its independent spirit, balletic grace and modernist stylings, he invited its key creatives, Courtland 'Hector' Hoppin (American), Anthony Gross (British) and Lazlo Meitner (Hungarian), to his Denham studios to make a colour follow up. *Fox Hunt* was the first British cartoon to exploit three-colour Technicolor, and gave work to artists like future *Daily Express* cartoonist Carl Giles and Kathleen 'Spud' Murphy, who was beginning a six-decade animation career.

Fox Hunt (Anthony Gross, Hector Hoppin, 1936).

Reviews were enthusiastic. In *The Spectator*, Graham Greene hailed *Fox Hunt* as 'Undoubtedly the best film of many weeks'.[47] But its very originality ('no imitation of the inimitable Disney, a complete breakaway from the existing cartoon-technique')[48] made the film hard to market. In London, it was paired with the subtitled French feature *Mayerling* (1936), and although it remained in circulation, it seems to have been more at home in film society programmes than in cinemas. Early press suggested that *Fox Hunt* was to be the first of a series, but none materialised, and Gross and Hoppin returned to France, to begin an animated feature adaptation of Jules Verne's *Around the World in Eighty Days*.

They weren't the only talents attracted from overseas. Dennis Connelly came all the way from Australia to attempt a series of cartoons featuring a pair of cuddly koalas, Billy and Tilly. In an unusual mix of antipodean and olde England, *Robin Hood* (1935) saw the marsupials at Nottingham Goose Fair. The film appears lost, but Joy Batchelor, who gained her first animation experience with Connelly, remembered it as a 'terribly bad' film, which

was 'hooted off' by the audience.[49] Dennis Connelly Ltd went into receivership in January 1936.

While some careers stalled, others were reanimated. Anson Dyer seemed a figure of the past until 1935, when he was given funds to start a new, colour, cel animation studio. His benefactor was Birmingham industrialist Archibald Nettlefold, who had bought out Dyer's former employer Cecil Hepworth and financed the animator's *The Story of the Flag* (1927) series a decade earlier. This was investment on a whole new level, with a full colour animation studio kitted out at 109 Jermyn Street in London's West End. Adopting the banner Anglia Films, Dyer began a series of cartoons based on the popular comic monologues of Stanley Holloway and Marriott Edgar. 'The Lion and Albert' and 'Sam and His Musket' were already cross-media hits, so bringing them to life through animation seemed a sure path to success. It was a second chance for Dyer, but with some in the press hailing him as Britain's answer to Walt Disney,[50] he had a lot to live up to.

Carmen (Anson Dyer, 1935).

With no direct experience of cel animation, Dyer poached talent from other firms, most notably Sid Griffiths, who oversaw all aspects of production. The principal animators were two Danes, Jorgen Myller and Henning Dahl Mikkelsen.[51] The films were made in Dunning Color, a two-colour system[52] that resulted in slightly muddy images, which lacked the boldness of Technicolor. But the biggest problems arose from the source material. Stanley Holloway recorded the monologues and was even filmed to provide a live-action reference for lip-synch. But in *Sam and His Musket* (1935), his words fill less than half of the nine-minute running time, and no other dialogue is added. There is much pantomimed padding that adds little to the flow of the cartoon, and fails to cover the basic problem that the heart of the story is not action but inaction: Sam Small refusing to pick up his gun. Nine films in the series were made and released between 1935 and 1937, but the formula became something of a millstone. By early 1938 Anglia Films and Anson Dyer Productions were in voluntary liquidation, with debts of over £3,000.

One who was convinced he could do better was Roland Davies, creator of the 'Come on, Steve!' comic strip in the *Sunday Express*. He embarked on a self-funded enterprise to bring Steve, a mischievous but loveable horse, to the screen. Davies had clearly done some thinking about his rivals' strengths and weaknesses. 'From an artistic point of view their work is brilliant,' he said of Gross and Hoppin's *Fox Hunt*, 'but I'm afraid the cartoons will appeal only to a specialised audience.' When it came to the Sam Small films, he explained, 'Dyer's animation is very good. The cartoon contains humour and the synchronisation is perfect. But the trouble is that it depends too much on dialogue.'[53] Steve's actions would speak louder than any words.

Audiences' familiarity with his characters gave Davies a head start, and since readers were used to Steve in black and white newsprint he decided to reduce costs by filming in black and white (besides, 'anything but the best colour was more of a hindrance than a help')[54]. Davies resisted the gravitational pull of London, keeping his operation in his home town of Ipswich and relying on the relatively experienced Carl Giles to head his production team. The enterprise's modest resources allowed six episodes to be made, but despite some delightful silliness – for example Steve being taken to a horse show by his fairy godmother in 'Steve Cinderella' (1937)

'Steve's Cannon Crackers', *Come On Steve* series (Roland Davies, 1937).

– the films fell short of the 'speed and action' Davies was looking for to overcome their relatively poor animation. They were distributed to cinemas by low-budget specialists Butcher's Film Service, but they appear also to have been designed to work as silent cartoons for home cinema projection. The resulting pantomiming and written exposition – Close-ups of signs and letters to further the plot – further slows the action down. For all of his deep thinking, Roland Davies got no further than his contemporaries in developing a formula for theatrical success.

As the decade wore on, more and more producers began to recognise that relying on theatrical short cartoons alone wasn't going to pay the bills. The future lay not in the competitive uncertainty of the box office, but in the growing world of sponsored content that bought its way onto screens and gave its producers returns in advance.

4. SHELTER FROM THE STORM

In December 1929, Len Lye's *Tusalava* made its debut at the London Film Society. The New Zealand-born artist had spent two years producing over 9,000 drawings for his first film, doodling 'to assuage my hunger for some hypnotic image I'd never seen before'.[55] The result was perhaps the most original artistic expression of animation of its day, marrying Lye's fascination with the traditional arts and rituals of Aboriginal Australia with his uniquely kinetic vision. Even Lye himself struggled to find the words to explain his film, though he did gesture towards it in a compelling description:

> Tusalava opens with dots rising in a black panel, left, as the script writers say, while a cog-chain affair rises straight up in a black strip, right. In the white space centre, two grubs rise and assume a fertility pose (whatever that is), whereupon the dots in the panel become trapped in a cocoon which extrudes a huge grub... The grub divides. One half absorbs the other and then becomes metamorphosed into a cross between a huge spider and an octopus with blood circulating through its arms. Finally, this anxiety thing attracts an embryo token figure that has developed in the cocoon and the scene ends with dots and welling circles. Life's gone full circle. The End.[56]

Paradoxically, this fiercely independent work owes its existence to enlightened sponsorship and advertising. The film was completed with financial assistance from the Film Society and some of its key members. And it was at Publicity Pictures, the producer of advertising films where the New Zealand-born Lye worked for a time as a 'filler in',[57] that he was able to study 'the use of the rostrum camera and other aspects of animation', and the support

Tusalava (Len Lye, 1929).

of his enlightened employer even extended to letting him use the rostrum during studio downtime.

So when Lye wasn't hanging out with poet and novelist Robert Graves, or mixing with Ben Nicholson and other artists of the Seven and Five Society,[58] he would have been rubbing shoulders with the likes of Dudley Buxton and other animators seeking refuge from an often hostile commercial marketplace. Cinema advertising, alongside sponsored work for the growing non-theatrical film circuit, offered a more stable income for artists, and payment in advance for producers. And these more utilitarian commissions could sometimes offer surprising creative freedom within the brief. The result was some of the most iconic, enduring and artistically accomplished work of the 1930s and beyond.

Not all of these new patrons for animation allowed their artists such free rein. From 1923 to 1925, in between other assignments, Joe Noble spent time as a production manager at Visual Education, making 'animated diagram

films about such subjects as botany, biology, mathematics and, of course, endless "map and arrow" shots.'[59] Visual Education was one of a number of specialist producers in the now-burgeoning educational films market, as film's potential as a teaching aid became more widely recognised. With the arrival of 16mm 'safety' film, distributors were no longer bound by fire regulations which decreed that volatile nitrate film could only be played in licensed cinemas. No longer did schoolchildren have to traipse to the cinema to see a film; it could be delivered straight to the classroom. Animation's ability to show what can't be filmed – as proven a decade earlier by F. Percy Smith and others – made it especially valuable to educational filmmakers, and animators might be asked to demonstrate anything from plate tectonics to the reproductive life of the amoeba.

Education commissions helped pay the bills, but it was seldom creatively fulfilling work. Animation's power to entertain as well as instruct was reined in, and it's striking that, although some of the most creative British animators of the period were involved in making educational shorts, there was little character animation or humour to sugar the educational pill – presumably under strict instruction.

Advertisers, too, were waking up to the utility of animation, and were more appreciative of the animator's gifts for creating striking imagery with wit and universal appeal. The animator could put a product anywhere in time and space, and bring to life some of a brand's bolder claims. By the 1920s big national brands like Persil, Colman's, Shell and Kodak were buying into cartoon advertising in Britain, and established artists like H. M. Bateman and William Heath Robinson were brought in to provide key drawings. The logo of the Adlets production company boasts that their films circled the world from their London address, and features a self-portrait caricature of the artist who made them. Cartoonist-turned-animator David Barker had himself crossed the globe from his native Australia, and he was one of the few artists given an on-screen credit on these films. Surviving films by Publicity Pictures and the heroic-sounding Super-Ads are anonymous, but we know that Carl Giles was taken on as a trainee at Super-Ads in 1930, while Dudley Buxton, Sid Griffiths and Brian White all worked there without credit.[60]

Even here, though, there was no escape from foreign competition. Mickey Mouse co-creator Ub Iwerks shipped over two cartoon commercials for Boots

George Pal sits among his 'Dollywood' puppets c. 1936.

the Chemist, *See How They Won* (1935) and *Leave it to John* (1936),[61] while Germany's Oskar Fischinger made the stop-motion *Pink Guards on Parade* (c. 1934) for Euthymol toothpaste in Gasparcolor. London ad agency J Walter Thompson (hereafter JWT) commissioned work from the Hungarian George Pal, who had set up a studio in Holland to perfect his celebrated 'puppetoon' technique of replacement animation.[62] Pal did at least develop some British talent: JWT staff William Larkins and Alexander Mackendrick (the future Ealing director) were involved in producing and scripting his wonderful cinema ads for Horlicks, culminating in the mini-Western opera *Love on the Range* (1939).

When it came to putting film to political use, the Conservative and Unionist Party proved the most forward-looking of Britain's parties, investing in a fleet of mobile cinema vans, specially adapted to show films in daylight conditions. They traversed the country, often drawing large

Montage: Animated Ads

If you want to get ahead in advertising, it pays to get animated. Early cinema ads evolved from lo-fi cut-out animation for the local high street, to the polychrome sprees of Len Lye, to carbon copy cartoons with a branded punchline. On television, mascots like BT's Buzby and meerkat Alexandr Orlov spawned lucrative merchandising of their own.

CLOCKWISE FROM TOP LEFT: *Health Education Council: Superman III* (Richard Williams Animation, 1982); *Kelloggs' Frosties: Soccer* (1969); *A Colour Box* (Len Lye, 1935); *John Lewis: The Bear & the Hare* (Elliot and Yves Geleyn, 2013); *3M Scotch Videotape: Not Fade Away* (Bill Mather, 1986); *BT: Buzby – Snowman* (Dragon Productions, 1978).

crowds, with a programme including a loose trilogy of animated messages. *Red Tape Farm* (1927) personifies the opposition parties as Mr Nosey Parker, officiously and ignorantly stopping honest farmer John Barleycorn from getting the most from his land. *The Socialist Car of State* (1930) characterises Labour-led Britain as a broken-down car in need of a Tory MOT. The superior *The Right Spirit* (1931), which brings more depth to its backgrounds and characters, takes a pop at the Liberals, too, featuring a cuddly caricature of Lloyd George that is as cute as it is patronising. These films, which appear to be the work of Sid Griffiths and Brian White (by now working in partnership)[63], mark something of a return to the puns, allegories and caricatures of the WWI propaganda shorts.

Government was slower to adopt animation, and early results were mixed. *John the Bull* (1930), an official Ministry of Agriculture and Fisheries cartoon promoting home-grown beef, was, in retrospect, rather alarming – it features a carcass marked 'Foreign' being strung up from a lamppost. Technically, at least, these films were moving with the times: *John the Bull*

Love on the Range (George Pal, 1939).

John the Bull (1930).

was released in both silent and sound versions, an indication of significant financial investment.

More successful was a series of films commissioned by the independent Health and Cleanliness Council to spread its 'Where There's Dirt There's Danger' message. Giro the Germ appeared in four cartoon shorts between 1927 and 1935. The first film uses a version of the rotoscope technique, tracing live-action footage onto cartoon drawings – most noticeably in a repeated sequence of a germ dancing like a 1920s flapper. The next two Giro films are less adventurous in technique, but the fourth, *Giro Fast and Loose* (1935), shows a striking advance. It has shades of contemporary gangster movies and of James Whale's *Frankenstein* (1931), with a sneering, more masculine Giro locked away in a castle cell to the sounds of a baying lynch mob. He is released by the careless Slacky the Sloucher, a character who wouldn't look out of place in the 'alternative comix' of the 1960s. The Giro films are also anonymous, but the use of rotoscope in the earlier films suggests the

involvement of the ever-inventive Griffiths and White, while *Giro Fast and Loose* features character designs that appear to be the work of the British Utility Films crew, who were later picked up by Anson Dyer.

While such films might have allowed them to develop their techniques, animators can have had no illusions that they were creating art. Until the mid-1920s, a British 'art film' scene was in any case all-but non-existent. It was this lack that led to the establishment of the London Film Society in 1925, to screen and champion the kind of 'really artistic films'[64] that struggled to find a home in commercial cinemas. Members of this prestigious club, among them HG Wells and George Bernard Shaw, gathered to see films, particularly from Europe, that were unavailable elsewhere – including (sometimes) those barred by the censors.

One object of the Society's admiration was German animator Lotte Reiniger, who had advanced the technique of silhouette animation through a series of fairy tales and literary adaptations. Her marriage of shadow puppetry and cut-out animation became increasingly sophisticated, and with a creative team including Walter Ruttman and Berthold Bartosch she spent three years making an animated feature film, *Die Abenteuer des Prinzen Achmed* (1926). With her involvement, the film was adapted into English as *The Adventures of Prince Achmed* and screened by the Society in 1927, while in 1934 an exhibition of her artwork graced the Bristol Museum and Art Gallery and transferred to the V&A in London. Reiniger, with her husband and creative collaborator

LEFT: *Giro the Germ* (1929). **RIGHT:** *Giro Fast and Loose* (British Utility Films, 1934).

Carl Koch, was one of many artists to flee Hitler's Germany in the early 1930s. The pair moved between the UK and France, with Koch frequently working with French director Jean Renoir. Director and screenwriter Thorold Dickinson, closely involved in the Film Society, helped Reiniger find backing for an animated version of AA Milne's *The King's Breakfast*, completed in 1937. It was to be part of series of 'intimate film revues', funded on a co-operative basis, which would be marketed to newsreel theatres under the banner *Fact and Fantasies*.[65] Films by Len Lye, Carl Koch, Alexandre Alexeieff, Basil Wright and Berthold Bartosch were also announced, though Reiniger's film may have been the only one completed.

What was needed was not just a shelter for creativity but an infrastructure to nurture and exhibit it. Salvation came in the perhaps surprising form of the GPO Film Unit, *de facto* headquarters of the British documentary film movement and its founding father, John Grierson. At the GPO, and before it the Empire Marketing Board, Grierson was pursuing a mission to develop public relations filmmaking as an artistically and socially progressive form. The theatrical cinema trade had little interest in such worthy goals, but sponsorship helped build a non-theatrical network that carried the films to audiences across the country. Despite his rather austere reputation, Grierson presided over a broad church and had an eye for distinctive talent. Under him and his successor, Alberto Cavalcanti – who had left his native Brazil to immerse himself in the European avant-garde – the GPO became an unlikely sponsor for cutting-edge animation.

Reiniger made two films for the GPO.[66] The first, *The Tocher* (1938), was rendered in her characteristic style, and grafted a message about the virtues of the Post Office Savings Bank onto a Scottish fairytale romance. But *The HPO or Heavenly Post Office* (1938) was something very different: a bespoke advertisement for the telegram service with some delightful cherub messengers delivering greetings across the land. It gave Reiniger her first real opportunity to adapt her silhouette technique to the possibilities of true colour,[67] and is too often overlooked in the consideration of the GPO's animated achievements.

It was Len Lye who would ultimately benefit most from GPO sponsorship. Since his debut, Lye had struggled to find the means to continue his film work. With support from Sidney Bernstein, who ran the Granada cinema chain and was a key member of the Film Society, he had started

The HPO, or *Heavenly Post Office* (Lotte Reiniger, 1938).

work on *Peanut Vendor* (also known as *Experimental Animation 1933*), which featured a bug-eyed, stop-motion monkey miming to a popular song. Sadly, the film was never completed, so we'll never know what 1930s audiences might have made of its oddball charm, though as a proto-music video it was in many ways decades ahead of its time.

Lye now made a radical change of approach and began to experiment with drawing directly onto blank film stock. This 'direct animation' method enabled a single artist (albeit an exceptionally gifted and visionary one) to produce animation quickly and – especially important given his limited means – cheaply. His experiments coalesced into *Full Fathom Five*, an abstract direct animation inspired by lines from Shakespeare's *The Tempest*. John Gielgud was recorded especially for the film, and Jack Ellitt, a frequent and essential collaborator, helped break the recording down into visual signposts to which Lye could key his animation.

It was an avant-garde work that had no home in the theatrical market, but when it was brought to the attention of John Grierson at the GPO Film Unit, he saw its potential as a short, colourful tonic for audiences in the middle of a programme of black and white documentaries. Rather than add a commercial message to *Full Fathom Five*, Grierson commissioned Lye (for £30 plus expenses) to create a new piece, initially known as *Cheaper Parcel Post*. The film was briefly rechristened *La Belle Creole*, after its soundtrack, before finally being released as *A Colour Box*. Though Lye's services might have been relatively cheap, the overall production budget represented a significant investment, including music rights and colour film processing to make Dufaycolor prints of the hand-drawn original.[68] This was the backing that expanded Lye's audience from hundreds at private film societies to hundreds of thousands across the country and overseas, with the film winning an award in Brussels and notoriety in Venice.

Lye's unique gifts for marrying eye-catching avant-garde techniques with infectious energy, colour and rhythm won him a corporate license to experiment and a prominent platform for his work. At a time when colour film was still an expensive luxury for most filmmakers, he was able to try out a variety of different systems, including Gasparcolor and Technicolor. His late 1930s films for corporate or state sponsors – *Kaleidoscope* (1935) for Churchman's cigarettes, *The Birth of the Robot* (1936) for Shell oil, *Rainbow Dance* (1936) and *Trade Tattoo* (1937) for the GPO and *Colour Flight* (1939) for Imperial Airways – demonstrate the breadth of his restless imagination, which extended even to his live action work on the likes of *N or NW* (1938), again for the GPO, and *When the Pie was Opened* (1940), made at the Realist Film Unit for the Ministry of Information.

Early in 1936, while judging an amateur film competition in Glasgow, John Grierson stumbled upon another striking new talent, and was so impressed that he offered him a job. Norman McLaren was a student at the Glasgow School of Art when he made a series of innovative documentaries and abstract colour experiments with fellow students. *Hell Unltd* (1936), made with the sculptor Helen Biggar, used stop-motion among many other flourishes to hammer home its radical anti-war message, while *Polychrome Fantasy* (1935) demonstrated an extraordinary use of colour and camera effects despite its tiny budget.

The Birth of the Robot (Len Lye, 1935).

McLaren was just the kind of instinctive film artist and technician the GPO Film Unit needed, and he served a two-year apprenticeship across almost every department before producing his first animation classic. In *Love on the Wing* (1939), made to promote the Empire Air Mail service, his stream-of-consciousness sketches, drawn directly onto film, serve as a perfect illustration of his maxim, 'animation is not the art of drawings-that-move but the art of movements-that-are-drawn'.[69] Seeing the speed and energy of his illustrations, you can almost picture McLaren hunched over the film strip, fighting to move his pen as fast as the images in his mind. His racing horses, parting lips, dancing letters, candles and snails were combined with a surrealist-inspired background of stylised landscapes and cloud banks, filmed in stop-frame animation.

But by the time *Love on the Wing* had its limited release,[70] McLaren had left for New York, ultimately finding a home at the National Film Board of

Love on the Wing (Norman McLaren, 1939)

Canada – with John Grierson again putting him in a place to thrive creatively. Lotte Reiniger joined her husband Carl Koch in Rome before returning to Germany. Len Lye remained in London until 1944, but worked more in live action, moving on from the GPO Film Unit (reconstituted as the Crown Film Unit from 1940) to the *March of Time* newsreel. The wave of experiment in corporate animation was drawing to a close.

* * *

At the end of an eventful decade, a short promotional film, *You're Telling Me* (1939), served up a revealing portrait of British animation. Star of this behind-the-scenes look at an animation studio – shot in Technicolor – was none other than Anson Dyer, back in business despite the failure of his *Sam Small* series. But despite the on-screen presence of key staff like Sid Griffiths,

You're Telling Me (1939).

there is something about *You're Telling Me* that doesn't ring true. In the ink and paint department, rows of industrious women sit at immaculate white benches, dressed in matching silk blouses and scarfs. The truth is that this is no real British animation studio, but a stage set. The demands of shooting live-action Technicolor, with its bulky three-strip camera and exacting lighting requirements, made it simpler to build a replica studio than to film in the real one. And Technicolor's notorious control freakery (to ensure only the most vividly colourful images) meant that the staff were required to wear costumes of approved colours. In reality, Dyer's new studio was an altogether less glamorous affair at Riverside Studios in Hammersmith. The biggest change was that his new enterprise was strictly turning out animation for hire. In among the artifice, *You're Telling Me* reveals an uncomfortable truth about the industry of the time, not least when the cartoon we've watched being made is unveiled: a simple comic tale set at sea, which closes with a smoking parrot and a cigarette pack-shot. British animation had become hooked on advertising, just as the advertising industry was about to go up in smoke.

5. BACK TO THE FRONT

In the wartime Disney short *Der Fuehrer's Face* (1943), Donald Duck wakes to another day in 'Nutzi Land'. After being abruptly roused at four in the morning by an oom-pah band, he is marched to his daily 48-hour shift on a relentless assembly line at an arms factory. Happily for Donald, his Nazi nightmare turns out to be just that, and he awakes as an American citizen, hugging a replica of the Statue of Liberty in gratitude. *Der Fuehrer's Face* won the Academy Award for Best Animated Short, ahead of Tex Avery's *Blitz Wolf* (1942), a retelling of 'The Three Little Pigs' along military lines.

This kind of patriotic parody is still the prevailing image of animation during the Second World War. Similar examples can be found worldwide, from Soviet Russia to Italy and Japan. And Britain trod a similar path – at first. Anson Dyer released the first of his fleeting *War Cartoons* series three weeks into the war, taking up just 13 seconds of a Gaumont-British newsreel. Caricatures of Hitler and Von Ribbentrop goosestep past a doorway marked 'Czecho-Slovakia' towards a dormant British lion. As the lion awakes and chases them off, Hitler berates his foreign minister, 'But I thought you told me it was stuffed?'[71] Joe Noble's 45-second *Run Adolf Run*, in the *Pathé Gazette*'s 4 January 1940 edition, ends with Neville Chamberlain chasing off Hitler with his umbrella, while in *Adolf's Busy Day*, released independently in Summer 1940, newcomer Lawrence Wright[72] has *der Führer* begin his day shooting his alarm clock in irritation and end it by scuttling a brand new warship. But Wright's film was perhaps the last example of a wartime British cartoon with satire as its principal objective. Simplistic jokes about the Führer's incompetence rang false in the wake

of the Dunkirk evacuation and the German army's rapid advance across the continent. British animation's own call-up papers, when they came, assigned it a more functional role.

The war reshaped Britain's film industry, as it did so many others. The immediate decision to close all cinemas for safety reasons was quickly reconsidered, but the enlisting of key personnel and the requisitioning of many larger studios for military use drove down production output. On the plus side, there was a steep decline in imported films thanks to the Atlantic blockades, and audiences were hungry for films that reflected their own experience, putting a new premium on domestic releases.

The impact on British animation was more gradual, and in the short term there was still advertising work about. George Pal's decision to close his Dutch studio in late 1939 and head for the US was a headache for advertising agency JWT but good news for Anson Dyer, who picked up some of Pal's cel animation jobs. On the evidence of *Aladdin and the Junior Genie* (c. 1942), a Technicolor ad for Rinso washing powder, his studio was at its creative peak. The film opens with an atmospheric sequence featuring an ageing but characterful genie in a chiaroscuro cave of shadow and intrigue, based on drawings by future Ealing director Alexander Mackendrick.[73]

Another company to profit from Pal's departure was the newly-formed Halas-Batchelor.[74] Hungarian-born Janos Halasz (anglicised as John Halas) had been lured to London in late 1936 as art director for a new venture, British Colour Cartoon Films. He met Joy Batchelor the following year while hiring animators for a short film, *Music Man*, and she subsequently accompanied him to Hungary to begin work on an adaptation of *The Brave Tin Soldier*. When the funding ran out the duo returned to London, with the film unfinished but their personal and professional relationship blossoming. Building up from a variety of graphic design and illustration projects for print media, in 1940 they were given the opportunity to set up an animation studio alongside JWT's Bush House offices and begin production on Technicolor cinema commercials for the agency.

From their first productions, such as *Fable of the Fabrics* (1942), they demonstrated a professionalism that was at least a match for Dyer's. Joy Batchelor's distinctive character designs neatly complemented John Halas' modernist-inspired backgrounds. But it was the wrong time to get into

Adolf's Busy Day (1940).

advertising. The studio had to tack on a coda to their Rinso ads explaining that the product was no longer available due to the war effort, and asking audiences to remember it 'in the happy days when war is over.'

In the meantime, thankfully, there were many more official messages to communicate. The Ministry of Information was formally established[75] the day after the declaration of war to be the official voice of Government in wartime. Along with disseminating public information to get the country onto a war footing, it was charged with marshalling the press, overseeing censorship and supporting an official role for film in wartime. The MOI got off to shaky start. Changing leadership, political disagreements on the appropriateness of 'national propaganda', press resistance to editorial interference and the uncertainties of the 'Phoney War' all contributed to a lack of clear direction. The commercial film sector, meanwhile, had its own concerns about increasing government intervention in its business dealings. It wasn't

Fable of the Fabrics (1942).

until 1940, when its leadership passed to Jack Beddington (who as patron of the Shell Film Unit had commissioned Len Lye's *The Birth of the Robot*), that the MOI's film division really began to pull its weight.

The MOI's 'Five-Minute Film' initiative, rolled out in July 1940, went some way to restoring its reputation. These pithy official messages were designed to slot into cinema programmes without overstaying their welcome for paying audiences and, crucially, at no charge to exhibitors. They were commissioned from a range of commercial studios and documentary units, with results ranging from comic skits like Ealing Studios' *Go to Blazes* (1942), featuring Will Hay, to the inspirational poetry of Humphrey Jennings' *Words For Battle* (1940). But while five minutes was well within the reach of animation studios, the MOI was slow to use the medium in its public programme.[76]

A Few Ounces a Day, released in November 1941, was the first animated film released under the Five-Minute Films banner. It uses a then-new informational graphic language called 'Isotypes'[77] to demonstrate the importance

of nationwide salvage to replace the raw materials lost to German U-boats attacks in the Atlantic. At the start of the film the narrator introduces 'the Cast': seven graphical symbols, representing ships, their losses, different quantities of salvage, and families on the home front ('perhaps including your own,' adds the voiceover in a rare emotive touch). The *Documentary Newsletter* thought it 'Possibly the most effective short film the M.O.I. has commissioned. It has information and instruction on a vital issue, and is an effective call to us all to take action'.[78]

The drier, more diagrammatic approach had a precedent in such films as *Unemployment and Money* (1938) and, much earlier, Lancelot Speed's *Britain's Effort* (1918). Documentarist Paul Rotha continued to employ Isotypes in *World of Plenty* (1943) and other films. But future MOI commissions almost all took a lighter, more 'cartoony' approach, closer to cinema advertising. This suited Halas & Batchelor, who were discovering a gift for enlivening dry or difficult subjects. Even so, the studio's first MOI commission was slow to arrive and came indirectly (via John Taylor at the Realist Film Unit), 'because [the MOI] didn't quite trust us to produce anything', as Joy later recalled.[79] *Filling the Gap*, released in April 1942, was something of a hybrid, mixing Isotype-style graphics of milk and wheat sacks with a doe-eyed prize cow and anthropomorphised vegetables marching off to dig their own way to victory. *Dustbin Parade*, released in October 1942, jettisoned symbols altogether, illustrating the salvage drive through cartoon bones and assorted metal objects which sacrifice themselves to produce munitions for an all-out Allied offensive.

The Five-Minute Film scheme was phased out in the second half of 1942, in favour of a mixed menu comprising a smaller number of longer, more developed works and an array of shorter filmlets to be tacked onto newsreels. Animation companies were only commissioned for the filler work, but these bite-sized, eye-catching messages played to cartooning's strengths. Their shorter running times also helped some newer, less well-resourced companies to get a foothold in the industry. One beneficiary was Austro-Hungarian film producer George Hoellering's Film Traders, which produced a number of distinctive MOI shorts. Hoellering had met German printmaker Peter Strausfeld while both were interned as 'enemy aliens' on the Isle of Man. The pair's *T.I.M. Marches Back* (1944) is particularly noteworthy, featuring some inven-

tive animation of a couple dancing on telephone lines. The loosely sketched lines and shapes offer fleeting moments of abstraction that hint at other possibilities for the form.[80]

Halas & Batchelor produced a number of these newsreel filmlets, warning of the perils of clothes moths and stressing the importance of early digging for vegetable gardens, but they were also entrusted with some less public projects. A young boy called Abu featured in a series of four propaganda films, made for distribution in the Middle East. In *Abu and the Poisoned Well* (c. 1943), Hitler appears as a vicious snake, with Mussolini cast as his sidekick, a large toad. The poisoned water they give Abu transforms him into a skeletal Nazi slave who attacks his former friend, the British tank, until his is revived by an Arabic warrior on horseback. Rather less dramatic was the series *Handling Ships* (1944/45), commissioned by the Admiralty. Stop-motion of model ships was combined with short cel-animated sequences and diagrams to succinctly explain aspects of maritime navigation to new Naval recruits.

Abu and the Poisoned Well (c. 1943),

Animation's potential as a training tool for the armed services quickly became clear. Particularly prolific in this area was Analysis Films, which produced films for the army, navy and air force throughout the war. This new company was the product of a partnership between Anson Dyer and William Larkins. Larkins had studied etching before moving into advertising as an art director at JWT, where he worked on cinema commercials alongside Dyer and George Pal.

Sid Griffiths was soon put to work at Dyer's Riverside Studios in Hammersmith, making aircraft recognition training films for the RAF. But with the Blitz at its height, the glass-roofed studio was no place for a unit engaged in vital war work, so in summer 1940 they were whisked off to new headquarters in a former girl's school in Stroud. For Griffiths' young team, the palatial Stratford Abbey, parts of which dated back to 1699,[81] must have seemed a world away from the air-raids and smoggy Thames warehouses.[82] Animation, tracing, painting and camera departments dotted themselves around the first two floors of the building, while the aircraft recognition work found a home in a more recent addition to the estate – a gymnasium. Films such as *Spot That Tank: Introducing the Recognition of Armoured Fighting Vehicles* (1942) sat alongside a few lighter offerings like *Hush! Not a Word* (1943), which warned of the dangers of 'careless talk' in a style similar to the MOI shorts. These films were often produced rapidly and on a limited budget, but for key projects like Analysis Films' multi-part *Eye Shooting* (1942) and Halas & Batchelor's *Handling Ships* resources were found to enable shooting and distribution in Technicolor.

One of the prevailing images of the Home Front is of the once uniformly male industrial factory floor now populated almost entirely by women – defined in the US by the iconic figure of Rosie the Riveter, and in Britain in films like *Millions Like Us* (1943). A handful of women found a place in the animation room before the war: to Joy Batchelor we can add Kathleen 'Spud' Murphy, who worked on *Fox Hunt* (1936) and then at Dyer's Hammersmith studio,[83] and Rosalie 'Wally' Crook, an animator for Anson Dyer at Stroud. But these were rare exceptions; women were generally restricted to the ink and paint department, with the actual animation being an essentially male preserve. The sudden exodus of men to active service left studios with a shortage of experienced workers – which in turn opened up new career

The animators of Halas & Batchelor take a break outside 10A Soho Square:
(l. to r.) Stella Harvey, unknown, Wally Crook, unknown, Vera Linnecar.

opportunities for women artists from other fields. Jenny Reyn had lost her print advertising job when her agency closed at the outbreak of the war; a newspaper advertisement led her to a new job as an animator at Halas and Batchelor. Liz Williams (later Horn) joined around the same time, initially as Reyn's assistant. Though many of these women left animation behind after the war (including Reyn, who would make her living as an illustrator), for others it was the start of a lifelong career. Vera Linnecar, fresh out of art school when she took a 'temporary' job at Halas & Batchelor, had little idea that she would spend another 45 years in the industry.

With the industry undergoing such comprehensive change, it's perhaps no surprise that there is no outstanding example of British animation art in this period. Nor was there the investment to support a film as ambitious

as Disney's *Education for Death* or *Victory through Air Power* (both 1943). If George Pal had stayed in Britain rather than move to Hollywood he almost certainly couldn't have made a film like *Tulips Shall Grow* (1942). In Germany, the Nazi regime's insistence on a prestige film industry meant backing for accomplished shorts like Hans Fischerkoesen's *Verwitterte Melodie* (*Weather-beaten Melody,* 1942) and *Der Schneemann* (*The Snowman*, 1944). Even in occupied France, a ban on imported films from Allied countries gave Paul Grimault an open market for full-colour animations such as *L'Epouvantail* (*The Scarecrow*, 1943) – as long as they didn't trouble the censors.

But in many ways the industry that came out of the war was in a better shape than the one that went in. The flow of commissions from the MOI and the armed forces had sustained and stabilised it during an otherwise difficult time. The impact of conscription had brought new blood into animation teams, making them more diverse in outlook and modern in approach. Demobilisation would make them stronger still, and better placed to take advantage when advertising work began to flow again. And just as important, Whitehall had learned that animation could be a powerful communication tool, a lesson that would be remembered in the postwar years.

6. REBUILDING

For cinemagoers, the face of Britain's postwar rebuilding project was not a politician or a celebrity, but a cartoon character. *New Town* (1948) introduced floppy-fringed, cheerful everyman Charley, who cycles through his immaculate 'new town' home and remembers the bad old days of the unplanned, overcrowded city. It's an idealistic expression of one of the cornerstones of the new Labour government's ambitious plans for national renewal. Charley's man-of-the-people persona helps underline the message that the drivers for change are community based rather than centrally led, while the animation makes the process of rebuilding appear an effortless *fait accompli*. Through six further films, all made by Halas & Batchelor for the new Central Office of Information[84], Charley served as a guide to Labour's vision of a transformed Britain, with its new National Health Service, National Insurance and nationalised industries. The final film, *Charley Junior's Schooldays* (1949), enlisted our hero's unborn son to explain the restructuring of education.

For John Halas and Joy Batchelor, the Charley films were a stepping stone to their own brighter future. They had formed their company to make cinema commercials, and as branded products slowly returned to the shelves,[85] they renewed ties with JWT, making Technicolor ads for Kellogg's and Oxo. But government contracts required expansion, and with the COI expecting each full-colour Charley cartoon on an eight-week schedule, John and Joy calculated that the animation team would need to grow by 50%, from 20 to 30.[86]

At this stage, the studio's animation room remained an almost entirely female domain. Wally Crook and Vera Linnecar were the key animators on the Charley films (joined by Douglas Low on *Schooldays*), and although John and

Unused storyboard image for Halas & Batchelor's *Charley* series (1948–49).

Joy share the credits for direction, story and designs, the surviving scripts and storyboards suggest that it was largely Joy who shaped the films' narrative, look and voice, despite the arrival of two children between 1945 and 1949.

John's influence is felt more in *The Magic Canvas* (1948),[87] a non-narrative 'Study in Movement, Form and Colour', tackling such grand themes as 'the two aspects of man'. It was a return to the experimentalism of Lye and McLaren, though in proclaiming itself 'something different from the ordinary cartoon film,' it comes across as a little self-conscious and po-faced in comparison. This self-funded production was little seen, but it's striking that a leading company of an industry otherwise engaged in selling breakfast cereals and delivering government messages should simultaneously be looking to expand its art.

A further sign of expansion at Halas & Batchelor was a new second unit, initially referred to as a 'Diagram Unit' but in practice more ambitious. Former

naval commander Allan Crick had collaborated with John and Joy during the production of the *Handling Ships* series. He became a partner in the company, setting up base at 2 Soho Square to make films for clients like the Anglo-Iranian Oil Company (soon to become BP), and produce stop-motion model sequences for training series *Water for Firefighting* (1949). Alongside their technical accomplishment, these films boast many creative flourishes, and Crick was credited with co-directing (alongside Bob Privett)[88] the theatrical short *The Figurehead* (1953). Joy Batchelor adapted a 'salt-sea yarn' by Crosbie Garston into a beautiful watercolour storyboard, which Crick and his team brought to life with a complex mix of coloured lighting, puppetry and stop-motion. The film was selected for that year's Royal Command Performance, but Crick soon moved on to set up under his own steam.

Postwar Britain was seeing a boom in sponsored film commissions. Government austerity measures included a tax hike on corporate profits, and many firms preferred to invest in prestige promotional films than hand their surplus cash to the Treasury. The new Larkins Studio[89] also grew to specialise in this area, building on William Larkins' runing Analysis Films

The Figurehead (1953).

Montage: The Larkins Studio

Under the influence of art director Peter Sachs, the Larkins Studio was Britain's most innovative post-WWII animation studio, despite working entirely in sponsored filmmaking. Its early black-and-white shorts were barely animated and yet still distinctive. Handed increasingly bigger budgets, they produced a string of films that pushed at the boundaries of animation design.

CLOCKWISE FROM TOP LEFT:
Full Circle (1953); *Men of Merit – A Lantern Lecture* (1948); *River of Steel* (1951); *Summer Travelling* (1945); *River of Steel* (1951); *"T" for Teacher* (1947).

Can anyone suggest a better title please?

Bob Godfrey drew several cartoon portraits of the Larkins Studio animation department for the Film Producers Guild in-house magazine. Here Peter Sachs sits at the head of the table, with Vera Linnecar and Nancy Hanna to the right.

with Anson Dyer. Larkins' own role in the whole enterprise is opaque, but by mid-1941 he had reconnected with Peter Sachs, who he'd encountered as a key assistant to George Pal. A German artist and animator of Jewish heritage, Sachs had followed Pal to Holland before arriving in Britain in 1939. Here he had to register as an 'enemy alien' and after a brief period in domestic service, was interned on the Isle of Man from 1940 to July 1941. With Sachs on his team, Larkins now had the confidence and skills to break from Dyer and Analysis and set up his own studio in London. Certainly, though it was Larkins' name above the door, it was Sachs who was the studio's creative powerhouse. An enthusiastic profile later wrote, 'Peter insists on the label "Art Director", but this is inadequate. Think of him as a spider, weaving the threads of ideas, words, voices, music, drawing, colour and continuity into the final web which will enmesh us.'[90]

The Larkins Studio's wartime commissions had included some aircraft recognition film work inherited from Analysis and a series of 1943 shorts for

a diphtheria immunisation drive, in which Sachs' distinctive design is already evident. The studio's first films after the war reflect its stretched finances, and feature very little actual animation. *Summer Travelling* (1945; a late MOI commission) and *Widdicombe Fair* (1947; for the British Council), rely more on the graphic appeal of pen-and-ink or pencil sketches. But by 1948, the studio was part of the mighty Film Producers Guild,[91] and occupied offices in fashionable Mayfair. Larkins was now big enough to encompass three units: sponsored films, under Sachs; cinema advertising, run by Phyllis 'Phil' Windebank (William Larkins' sister); and a diagram department in a rear yard. Bill Larkins himself was increasingly distant, with health issues taking him overseas.

The Larkins Studio produced no self-funded shorts, nor more independent statements like Halas's *The Magic Canvas*. Yet Sachs' unit turned out a string of innovative short films that pushed at the boundaries of design and movement in animation. In the Tea Bureau-sponsored *"T" For Teacher* (1947), the characters – more shapes than lines – leap from one impossible pose to another, with no concern for gravity. *River of Steel* (1951), for the steel industry, turns a foundry into a modernist playground, bending perspective to break each frame into colourful geometric shapes and lines. There was no house style: each film felt like a new start, and a fresh opportunity to experiment. Sachs surrounded himself with a gifted young team of recruits. Nancy Hanna, who came to London from Belfast on a Ministry of Education scholarship, became a key foil to Sachs on the design side. Vera Linnecar jumped ship from Halas & Batchelor in search of greater creative freedom. Bob Godfrey was hired as a background artist, but keenly observed the work of the animation room that got in the way of his own drawings. This crucible of creativity proved shortlived, but when the studio was broken up with the arrival of commercial television in 1955, Larkins' talented graduates would keep its influence alive for decades to come.

Elsewhere Gerald Holdsworth, another an ex-JWT man, was also hoping to benefit from the sponsorship bonanza. Demobbed after an illustrious but clandestine wartime career with the Special Operations Executive, Holdsworth was determined to get into film. Tracking down some of George Pal's former staff in Holland, he brought them (with their families) to Britain to establish the Signal Film Unit, quickly garnering commissions for commercials and sponsored films.

Close-up: Bob Godfrey

Maverick, prankster, teacher, inspiration... nobody left their mark on British animation like Bob Godfrey. Born Roland Frederick Godfrey in 1921, he went from art school to the graphics department of an advertising agency, with a wartime break including a D-Day role as a Royal Marine. Dreaming of a film career, he took a lowly job painting merchandise at Gaumont-British Animation. He soon found a better role as a background artist for Peter Sachs at the Larkins Studio, but Godfrey was ambitious, with his own film ideas. He gravitated to the amateur film circuit, before seizing the moment of the arrival of ITV to set up a new studio, Biographic Films.

Though he created Biographic in his own image, it wasn't just 'his' company; his partners all made vital technical and creative contributions, and developed their own work.

Godfrey made *The Plain Man's Guide to Advertising* (1962), *The Rise and Fall of Emily Sprod* (1964) and *Alf, Bill & Fred* (1964). But in 1965 he headed out on his own. At Bob Godfrey Films he was more content to be 'King of a pile of dung... than part-owner of a pile of diamonds.'

He was independent in spirit, but never short of collaborators. With Grange Calverley he created the series *Roobarb* (BBC, 1974) and *Noah and Nelly in... SkylArk* (BBC, 1976). Colin Pearson scripted one of his first independent films, *The Do-it-Yourself Cartoon Kit* (1961), one of his last, *Millennium the Musical* (1999), and many in between. His collaborations with Stan Hayward, from *Kama Sutra Rides Again* (1971) to *Henry's Cat* (BBC, 1983–93), highlighted their unique creative chemistry.

He thrived in the early 60s pop culture scene, intersecting creatively and socially with the worlds of art, music and comedy. Biographic produced animated sequences for the Richard Lester-directed ITV series *Son of Fred* (1956), featuring Spike Milligan and Peter Sellers, and Godfrey appears uncredited in Lester's two Beatles films, *A Hard Day's Night* (1964) and *Help!* (1965). His screen presence enlivened John Daborn and Gerald Potterton's amateur pixilation short *Bride and Groom* (1955), and he directed and appeared in several absurdist live action shorts, from *The Battle of New Orleans* (1960) to *Bang!* (1967).

But his most striking feature as a performer was his voice. In truth, there was little to distinguish his bored, bowler-hatted fantasist in *Henry 9 'til 5* (1970) from the famished feline of *Henry's Cat*, but both are irreplaceable. And his creative output had

no such limits. Between 1974 and 1975 he was simultaneously working on the groundbreaking children's series *Roobarb*, creating an ultimately Oscar-winning musical biopic of Isambard Kingdom Brunel, *Great* (1975), and appearing in an adult learning series, *The Do-It-Yourself Film Animation Show* (BBC, 1974) – all while making assorted TV commercials and teaching a new generation of animators at an art school.

Godfrey's playfulness shouldn't eclipse his sense of purpose. He took animation very seriously, and often used it politically. He remade his 1960 film *Polygamous Polonius* as a caustic portrait of Margaret Thatcher for *Polygamous Polonius Revisited* (1985), and skewered both the Iron Lady and Tony Blair's New Labour in *Margaret Thatcher: Where am I Now?* (1999), made with political cartoonist Steve Bell. He hanged an effigy of Thatcher from his studio roof.

After his death in 2013, obituaries labelled him the 'Godfather of British animation', but that doesn't feel quite right; he was perhaps more the cool uncle. His 50-year career testified to his unique personality, invention and vision, but also his openness to change, collaboration and the support of others. He knew that a joke could be just as funny, if not funnier, with three rough sketches as with 30 perfect ones – and cheaper, too. His work rate and his faith in animation's power to inform, provoke and entertain never wavered, and he will remain an inspiration for generations to come.

The Story of Time (1951).

At first glance, the characters in National Savings promo *The Silver Lining* (1947) seem very similar to those in Pal's films. But it's clear from their movements that they are built around flexible armatures, not the prefabricated swappable parts of Pal's resource-heavy 'replacement animation' process. Signal's characters may have lost some dynamism and elasticity as a result, but the films were still of exceptional quality, as demonstrated by the Academy Award nomination for *The Story of Time* (1951). Commissioned through JWT for Rolex, the film charts the many ways humans have tracked the passage of time, beginning with ancient sundials and water clocks, and culminating in the latest Rolex watch. Sadly, the unit couldn't find funding for a projected feature film of Antoine de Saint-Exupéry's children's favourite *Le Petit Prince*. Though the company name survived into the 1970s, its animation

team barely made it into the 1950s, with most of the Dutch talent heading home to work at Joop Geesink's Dollywood studio. Britain's hopes to establish itself as a home of high quality stop-motion animation would have to wait.

Just as sponsored animation was adjusting to peacetime, in the mainstream cinema a giant was stirring. By the early 1940s the former flour magnate J. Arthur Rank controlled the lion's share of Britain's film production, distribution and exhibition networks. Rank was a devout Methodist, and his drive to break Hollywood's hold on British cinema reflected his moral mission as much as economics or national pride. He was particularly determined to produce and exhibit films that would 'do the children good',[92] and in 1944 he set up the Children's Film Department (later Children's Entertainment Films), to commission short films, including the cornerstone of any children's programme: cartoons. Its first animation project was *Robbie Finds a Gun* (1945), in which a cartoon rabbit discouraged children from playing with firearms. The assignment went to the stalwart Anson Dyer, still based in Stroud, who also won commissions for cartoon mystery *Who Robbed the Robins?* (1947), and a three-part *Squirrel War* series (1947), all made in Technicolor.

Rank, though, had something more ambitious in mind. In April 1945 he had unveiled a new division, Gaumont-British Animation[93], based at Moor Hall in Cookham, about 30 miles west of London.[94] With a staff of over 200, including 147 artists and technicians,[95] GBA dwarfed anything British animation had yet seen. In a major coup, Rank reached across the Atlantic to appoint a Disney high-flier to run the studio. David Hand had been supervising director on *Snow White and the Seven Dwarfs* (1937). He took a quarter stake in GBA, importing former Disney colleagues – animators John Reed and Ray Patterson, and story man Ralph Wright – to help him train and develop the crew. In August 1946, in the first in a series of weekly lectures to his core animation team, Hand set out his ambition:

> Our only job in England, so far as I can see, is to bring out a different kind of cartoon. [...] It has to be a British cartoon, British in aspect, British in flavour, is marketable, is a good cartoon. It can be done here, and you fellows can do it.[96]

The first fruits of Rank's venture emerged late in 1948.[97] The business plan was based around two series, with 'funny animal' cartoon series *Animaland* at the

forefront. The first releases centred on single unnamed characters – *the Lion, the House-cat, the Platypus* – and featured heavy narration in a mocking, 'voice of God' style. Perhaps to support merchandising, later releases give greater prominence to recurring character Ginger Nutt, a red squirrel. But for all the ambitions to make something distinctively British, even the provincial press complained that, at their best, the films had 'established a comprehensive facsimile of what Disney has been doing for years more than adequately.'[98] At their worst, they seemed pedestrian beside the new, pacier American cartoon shorts, as exemplified by *Tom and Jerry* (1940–58); and naive when compared to the streetwise sass and narrative modernism of Warner Bros' *Looney Toons* (1930–69).

Less conventional was the *Musical Paintbox* series (1948–50), a ten-film animated travelogue series profiling parts of the British Isles (Wales, Scotland, Ireland, but also the Thames, Somerset and the Canterbury Road). Branded as 'sketches' and 'fantasies', the films are hard to categorise now, and were hard to market then. Their most interesting feature is their design, which feels distinctly European. The animation was much more limited than in *Animaland*, allowing the characters to be more idiosyncratic in their design. But although the films were aimed at adult audiences, their humour was often juvenile; not always a bad thing, but at odds with the graphical sophistication. Ultimately, the series feels like a succession of whimsical regional stereotypes with some nice backdrops.

What finally scuppered GB Animation, however, wasn't the quality of its films, but the size of Rank's overdraft. The 75% *ad valorem* tax placed on imported American films in August 1947, and Hollywood's retaliatory boycott of Britain, put huge strain on the organisation. Rank's studios benefitted from the withdrawal of competition for domestic films in cinemas, but its distribution and exhibition arms faced a dearth of programming, American films having occupied over two-thirds of British cinema screens in the preceding years.[99] The studio invested heavily in domestic production to fill the void, but the subsequent compromise struck by new Chancellor of the Exchequer Harold Wilson to end the Hollywood boycott twisted the knife. By 1949 the Rank Organisation was £16,286,581 overdrawn[100] – more than £500 million in today's money. It was the writing on the wall for projects that were more aspirational than profitable – such as an animation studio. Staff were gradually released from their contracts or laid off, and Moor Hall was sold in 1950.

Meanwhile another American émigré was attempting to make his mark on British animation. George Moreno Jr had worked on shorts and the feature-length *Gulliver's Travels* (1939) at the Fleischer Studios. Serving in Britain during WWII with the American Army Pictorial Unit, he made the acquaintance of Walthamstow-based button and belt manufacturers Leonard and Henry Moring,[101] and in December 1945 this unlikely trio founded British Animated Productions.[102]

The company's future was to be built on a new cartoon double act: Bubble, a portly taxi driver, and Squeek, his trusty vehicle. Their debut, *The Big City* (1946), begins with characteristic lunacy, as anxious expectant father, Bubble, chain-smokes in a hospital waiting room before being presented with a swaddled newborn taxi – Squeek. BAP's progress was similarly fraught, with distribution problems forcing an abrupt shedding of staff in 1947, and a belated attempt to rehire them after a deal was struck with Pathé. The company completed five cartoons (four featuring Bubble and Squeek and one spin-off), but failed to win over audiences. In May 1949, one exhibitor wrote to Pathé complaining that punters judged the films 'the worst cartoons they

Ginger Nutt's Forest Dragon (1950).

Press publicity still of Bubble the taxi driver and his car Squeek, from George Moreno's *Bubble & Squeek* series (1946–49).

have ever seen.'[103] This seems harsh. Though patchy, films like *Fun Fair* (1947) distinctively combine American-style oddball animation with British set dressings, and their bizarre images, such as the taxi and its driver sharing a pantomime horse costume, make them rather enjoyable today. Even so, the Walthamstow cartoon industry was over almost before it began.

Since the end of the war, the two animation sectors – sponsored messaging and commercial entertainment – had pulled in different directions. To achieve the monumental task of Britain's first animated feature film, they would have to pull together. For though it was hidden at the time, Halas & Batchelor's landmark was, in its way, no less a sponsored work than the Charley films. Published in 1945, *Animal Farm*, George Orwell's allegorical 'fairy story' in which a farmyard rebellion stands in for the Russian revolution and its subsequent betrayal, acquired a new resonance in the nuclear age. So it was that – unknown perhaps

even to its makers – its cartoon adaptation came to be financed by agencies of the American government, including the CIA, as part of a 'cultural Cold War'.[104]

The agent between the mysterious sponsors and the production company was Louis de Rochement, an American film veteran best known for the *March of Time* newsreel (1935–51). In 1950 Halas & Batchelor had made *The Shoemaker and the Hatter,* an extended short about the Marshall Plan, for the US Economic Co-operation Administration. It put the studio on the radar of de Rochement and his associates, who were looking for a company to realise *Animal Farm* as a film. Making the film in Britain was crucial to the project's credibility, and after the demise of G-B Animation, Halas & Batchelor was the only real candidate.[105] Production began in November 1951.

Adapting any book into a film presents problems, but the political pressures were a further complication. John and, particularly, Joy went through numerous

Edric Radage, one of five key animators on *Animal Farm* (1954).

drafts of script and storyboard, incorporating countless suggestions and demands from their sponsors while trying to safeguard their integrity – and the book's. Most notoriously, they changed Orwell's pessimistic ending. In the book, the animals' revolt against the neglectful, abusive farmer is betrayed by the corrupt pigs who, at the last, become indistinguishable from the humans. In the film, the neighbouring farms' acceptance of the pigs' totalitarian leader, Napoleon, and his cronies – representing Stalin and the Communist Party leaders – is downplayed, and a note of optimism is raised with a second animals' revolt.

Gearing the studio up to make a feature-length animation presented more practical challenges. Producing over 70 minutes of quality cel animation would need more hands, but the timing proved auspicious. The closure of Gaumont-British Animation had put a number of trained animators on the market and they were quickly snapped up – with Arthur Humberstone, Edric Radage, Ralph Ayres and Frank Moysey brought in as key animators. Many other artists worked on the project uncredited, including pioneer figures like Brian White, who had been out of the industry since the early 1930s. Halas & Batchelor temporarily expanded their premises, converting an 'ageing, but still handsome, Edwardian house'[106] in West London into a makeshift studio, and looked beyond the capital for more facilities and staff.

Original poster for *Animal Farm*.

Anson Dyer's studio had been living hand to mouth since the Rank work dried up, and had become heavily dependent on one animator, Harold Whitaker. Having worked briefly as a background artist for Dyer in 1940 before getting his call-up papers, Whitaker had returned to Stroud in 1946, working on the *Squirrel War* films and quickly becoming the studio's leading animator despite his inexperience. He features prominently in *Cartoonland* (1948),[107] a second documentary portrait of Dyer's studio, which documents the conception and creation of a new animated character, Ronnie Rabbit. However, Ronnie never appeared in a finished film, and Whitaker recalled that at the end of the week's filming on *Cartoonland*, Dyer confessed he wasn't sure where next week's wages would come from.[108] Dyer was still game but now in his late seventies, and efforts to supplement the company's income, including leasing the studio's facilities for rostrum photography on some European animated features,[109] only delayed the inevitable. The vultures were circling, and when key personnel at Stroud learnt that Halas & Batchelor was recruiting, they found their loyalty to Dyer sorely tested. In the end, John Halas's offer proved too tempting,[110] and a new Halas & Batchelor subsidiary, Animation (Stroud) Ltd., was born in a three-storey residential property on the other side of town. Dyer and his long career as a pioneer, entrepreneur and statesman of British animation were left abandoned in the elaborate but crumbling surroundings of Stratford Abbey. The building was condemned and demolished in 1961, and Dyer died the following year.

With the new outfit quickly absorbed into production on *Animal Farm*, Whitaker became the film's fifth credited animator, joining a team under the direction of John Reed – one of the ex-Disney men brought to Moor Hall by David Hand. A studio whose animation room had been dominated by women now found itself with an all-male team of lead animators – albeit one partly overseen by Joy Batchelor as co-director and co-producer. This was hard to avoid: the most qualified animators available were all men, thanks chiefly to the animation training programme at Gaumont-British Animation, which – by practice if not by policy – wholly excluded women. Since these same men would appear in the credits of almost every significant animated British film into the 1980s, it was a practice with lasting consequences.

Despite the new personnel, *Animal Farm*'s release date slid back from the end of 1953, and through the summer of 1954. A BBC television adaptation

of Orwell's *1984* beat it to Britain's screens in December 1954, but the controversy raised in press and parliament over that transmission acted as valuable publicity for the cartoon feature. One upshot of its American backing was that Britain's first animated feature had its première at New York's Paris Theatre on 29 December. Its British debut came over a week later, on 7 January 1955.

US critics who saw the New York preview branded it 'not for children [because] the cruelties that occur from time to time are more realistic and shocking than any of the famous sadisms that have occurred in Disney films'.[111] Back at home, criticism was focused more on the political impact of the story changes than on the film's aesthetics, and supportive voices weren't loud enough to make it a box-office success.

Given its difficult journey to the screen, the film remains a considerable achievement, and it still engages audiences today. John and Joy were certainly more sympathetic to the socialist programme of the Charley films than to the fierce anticommunism of *Animal Farm*'s sponsors. But in a story embracing tragedy, action, satire and a complex narrative spanning several years – told through a sizeable cast of barnyard animals – the directors manage the tightrope walk of mood and tone admirably. The animation is of variable quality, probably due in large part to last-minute adjustments demanded by their sponsors. But where time was given for proper development, including farm visits, mood boards, story conferences and animation line-tests, the scenes stand up well.

Despite a serialised comic-strip version, wallpaper stickers and ceramic figurines, it was a hard film to market. The fact is that without its unusual financing the film would never have been made, since the commercial industry was in no state to support it. John and Joy's ambitions for a follow-up included adaptations of *A Pilgrim's Progress*, *A Midsummer Night's Dream* and *Charlotte's Web*[112] but all came to nothing, and more than a decade would pass before Britain's second animated feature. Meanwhile, a very different revolution was looming.

7. NEVER HAD IT SO GOOD

On 22 September 1955, millions listened in horror as Grace Archer was trapped in a barn fire. The fact that she was a fictional character didn't make her death any less traumatic for fans of the radio soap *The Archers*, for whom she was almost family. But despite the BBC's attention-grabbing efforts, something far more momentous was happening elsewhere. That evening's launch of a second – commercial – television service transformed Britain's media landscape forever.

The arrival of Independent Television – ITV – not only terminated the BBC's long television monopoly, it signalled a new consumer revolution. Rationing had finally come to an end in 1954, and by 1957 prime minister Harold Macmillan could confidently proclaim that 'most of our people have never had it so good'. With austerity in the rear-view mirror, unemployment at record lows and a young generation with money in its pocket, the stage was set for a succession of social revolutions during the following decade. Though the 1960s took some time to swing, progressive trends in art, popular culture and society were the backdrop for a golden age for British animation.

If, back in 1955, the new ITV represented a threat to the BBC, for British animation it offered a 'new and improved' route to success. The channel had a glut of advertising airspace to sell, and agencies looked to animators to sweeten the pill of their hard-sell marketing while condensing complex messages into short 'TV spots'. As a typical commercial needed less than sixty seconds of animation, new, compact studios could compete for work with minimal investment. Elaborate artistry was wasted on the compact, monochrome 405-line screens of the time, so studios no longer required vast teams of animators, a bustling ink and paint room or a camera department equipped to process beautifully rendered drawings in their tens of thousands.

At the start of the 1950s you could count the number of operational British animation companies on one hand; by 1960 they had mushroomed to over 20.[113] For the survivors of Gaumont-British Animation it was a chance to put their training to use on their own terms. Bert Felstead, Frank Moysey and Jack Stokes were among a team of about 40 working on a collective, profit-sharing basis at Griffin Animation. On a smaller scale were the Edric Radage Group and Nick Spargo's Nicolas Cartoons.

The older, bigger studios recalibrated. Halas & Batchelor slimmed itself down from its *Animal Farm* days, but still led the industry, making over 100 ads in ITV's first year. The impact on the Larkins Studio was more dramatic, with the Film Producers Guild deciding to cleave it in two. A core part of the studio became an animation team at the new Guild Television Services, while the rump of Larkins was left to work on cinema commercials under the direction of Richard Taylor, Beryl Stevens and Denis Gilpin.[114] Peter Sachs and other key players jumped or were pushed.

One who jumped eagerly was Bob Godfrey. Few were more at home on animation's new wild frontier, and nobody so embodied its lawless spirit. Godfrey established Biographic Cartoon Films, joined by two former Larkins colleagues, Keith Learner and Jeff Hale. They were young and inexperienced, but their equipment had been around the block. Their first commercials were filmed on a 1909 Moy & Bastie camera, its lens poking through a hole cut into one of two tables fixed on top of each other, with the shutter operated via a mechanism improvised from bits of Meccano. But it was enough to get them an advert on ITV's opening night, and to see them prematurely hailed as a 'British UPA' (the American studio then riding high with *Mr Magoo* and *Gerald McBoing Boing*).[115]

Two other Larkins refugees, Vera Linnecar and Nancy Hanna, had been headhunted by one of the founders of the real UPA, David Hilberman, now setting up an animation unit within cinema advertising company Pearl & Dean. Hilberman arrived in London in 1954 with quite a reputation. He had worked alongside David Hand on *Snow White*, been denounced as a communist by Walt Disney and left UPA to build another successful animation company, Tempo Productions, only to see it fall victim to a McCarthyist boycott. His stay at Pearl & Dean was short and by the end of 1955 he was back in the US. Linnecar, for one, felt the atmosphere at the studio quickly

Nancy Hanna (left) and Vera Linnecar in Bob Godfrey's *The Plain Man's Guide to Advertising* (1962).

soured. It was the only time in her long career when she experienced outright sexism.[116] She and Hanna left to join their former Larkins colleagues Bob Godfrey and Keith Learner at Biographic, helping fill the gap left by the Canada-bound Jeff Hale. The growing studio had moved on from sharing cramped premises with a Soho jeweller to leasing a superior five-story building nearby, at 90 Dean Street.

Having conquered the commercial break, animation now looked to infiltrate other parts of the schedule. A smattering of British animation appeared in the listings after the television service returned from its wartime hiatus but, perhaps surprisingly for the ad-free BBC, this largely comprised sponsored films such as Halas & Batchelor's *We've Come a Long Way* (1951), for BP, and Larkins' *Men of Merit* (1948), for the Electricity Council. An enviable mix of Hungarian, Polish, Russian and French animated shorts were televised, and silent *Felix the Cat* shorts were a staple, just as they had been in 1920s'

Figures used in *The Star of Bethlehem* (1956), Lotte Reiniger.

cinemas. The lightning sketch had an unexpected revival, with Mancunian artist Harry Rutherford a regular of children's programming. But it would be some time before anyone took up the challenge of making new animation on a television budget.

One of the first to try was Lotte Reiniger, with a series inspired by Grimms' Fairy Tales, co-funded by the BBC and American television. The BBC had been broadcasting her earlier films, but in 1953 new works like *Snow White and Rose Red* made their debut. This was one of the most productive phases of her career, but although her artisanal cut-out methods made production affordable, the schedulers' relentless hunger for new content proved too much. Cut-down sections from *The Adventures of Prince Achmed* (1926) and other early films helped keep up the momentum, but after 1955 production came to an abrupt halt.

More common were string puppets, with the likes of Andy Pandy, Muffin the Mule, Bill and Ben, and Pinky & Perky as prevalent in early children's television as cartoons are today. The puppetry of Gerry and Sylvia Anderson grew

ever more sophisticated between their debut *The Adventures of Twizzle* (ITV, 1957) and the advanced 'Supermarionation' hit *Thunderbirds* (ITV, 1964–66), carving a niche for fantastical series that would have been unaffordable in either live action or animation. In 1957 John Ryan adapted his *Captain Pugwash* comic strip into a TV series (BBC, 1957–66; 1974–75), with puppeteer Gordon Murray as the series' producer. Ryan brought together puppetry and cut-out animation techniques to create a sort of 'live animation', manipulating cardboard figures against painted backdrops with ingenious levers. Much craft and effort went into the production of the characters and set-ups (or 'captions', as Ryan called them), but filming in real time rather than frame-by-frame made it cost-effective for television.

At the impeccably named Smallfilms, Oliver Postgate and Peter Firmin stripped animation back to its essentials. They realised that a good story well told didn't need lavish presentation; the audience's imaginations would fill in the magic and detail. Smallfilms' first creation, *Alexander the Mouse* (1958), was 'animated' live, by sticking magnets onto cut-out figures and moving

Captain Pugwash (John Ryan, 1957-66; 1974-75).

Close-up: Grasshopper Group

Amateur filmmaking thrived in postwar Britain, with a growing network of local societies, national awards and dedicated magazines. Animation was a key part of the scene, although the boundary between amateur and professional was often blurred. John Daborn worked at Gaumont-British Animation and on *Animal Farm* (1954). In his own time he made the short films *The Mill Stream* (1950) and *The History of Walton* (1952), initially on the amateur 9.5mm format, garnering some 'Ten Best' awards.

At Halas & Batchelor, Daborn met Gerry Potterton and Rich Cox, and together they made *Two's Company* (1953), a comic short that used pixilation – animating real people and objects with stop-motion techniques – likely inspired by Norman McLaren's *Neighbours* (1952). At the same time they set up their own society, the Grasshopper Group (with McLaren himself as its first president), holding regular screenings at London's Mary Ward Centre. Grasshopper provided support and distribution for other amateur animations, including *Watch the Birdie* (1954), made by Bob Godfrey, Keith Learner, Vera Linnecar and Richard Taylor under Godfrey's Biographic Films banner. Although all four were working professionally as animators, as a self-financed work made in their own time the film qualified for, and won, a number of amateur awards.

With £120 from the BFI Experimental Film Fund, Grasshopper made a second, colour pixilation short, *Bride and Groom* (1955), starring Bob Godfrey as a newlywed harried by a persistent salesman. More ambitious was the nine-minute, cel-animated *The Battle of Wangapore* (also 1955), which involved many months of animated drawings and sequences passing back and forth by post. The key animator was one-time Halas & Batchelor man Richard Horn, who would go on to Melendez Films in the 1970s and 1980s.

By 1958 Grasshopper was flush enough to rent premises in Covent Garden, with space for a studio, a screening room and even a bar. Peter Sellers loaned them a 16mm Arriflex

The Battle of Wangapore (1955).

(l. to r.) John Daborn, Stuart Wynn Jones, Richard Horn, Ken Clark (from *Let Battle Commence*, 1957).

camera with variable shooting speeds, with which they made the abstract *Chiffonery* (1962), filming the movements of fabric in a breeze.

The group's greatest impact was as a support network for aspirational and experimental animated (and occasionally live-action) shorts. With their own system of shares, they funded a variety of productions, made sure they were available across the nation's film societies and helped get them into international festivals.

Professionally, Stuart Wynn Jones worked on several sponsored shorts for Halas & Batchelor; with Grasshopper's support he produced several often abstract shorts, many drawn directly onto film. In *The Spark* (1963), he scratched a special effect frame by frame onto live-action scenes of a satirical story about creativity and commerce. Errol Le Cain worked professionally at Pearl and Dean, but the Grasshopper Group helped with soundtracks and distribution for his independent shorts *Victoria's Rocking Horse* (1962) and *The Knight and the Fool (1967)*. He became a key designer at Richard Williams Animation before finding acclaim as a book illustrator.

With membership declining through the 1960s, the Group moved to less deluxe accommodation. A core, including John Daborn, took on sponsored work, and formed a commercial limited company, Teamwork, which paid the rent and provided a home for meetings. But the impetus waned, and in the early 1970s the Grasshopper Group sadly folded.

them invisibly from behind with another magnet. Postgate, however, was dissatisfied with the results, and for his next project, *The Journey of Master Ho* (1958), he experimented with stop-motion animation in his spare room. It opened up a creative world as boundless as Postgate's own rich imagination, and Firmin made the perfect travelling companion.

The cut-out animated series *Ivor the Engine* (1959) and *Noggin the Nog* (1959–65) harked back to the heyday of Lancelot Speed in the early 1920s. For *The Pingwings* (1961–65), Postgate and Firmin filmed knitted puppets in stop motion in and around Firmin's Kent home – even outdoors in fluctuating sunlight, in a way that recalled Melbourne-Cooper's *Dreams of Toyland* (1908). It was free-range, organic animation, with the unpretentious flavour of children's play.

Smallfilms' next stop-motion puppet series, *The Pogles*, debuted in 1965, the same year that BBC began to transmit *The Magic Roundabout* (1965–77). Eric Thompson was given free rein to completely re-script a French stop-motion series created by Serge Danot, *Le Manège enchanté*, and succeeded in creating something that felt both distinctly British and very contemporary. Gordon Murray cut the strings on his puppets and created *Camberwick Green* (1966), the first of a 'Trumptonshire Trilogy' continued by *Trumpton* (1967) and *Chigley* (1969). The series were animated by Bob Bura and John Hardwick who had filmed *Captain Pugwash*, but were also experienced puppeteers. They had the perfect mix of skills for stop motion: technical ingenuity, patience and the ability to perform by proxy.

Riding the same puppet wave was Anglo-French artist Ivor Wood, who had worked closely with Danot on *The Magic Roundabout*. Independently, Wood partnered with a European offshoot of American animation firm FilmFair to make *The Herbs* (BBC, 1968), based on stories by Michael 'Paddington' Bond. Wood animated his puppets on a kitchen table in his Paris flat. Paradoxically, the more artisanal stop motion using cut-outs or puppets – long sidelined as antiquated and inefficient – was proving better suited to TV budgets and deadlines than the production-line cel animation that had supplanted it.

OPPOSITE: *Camberwick Green* (Gordon Murray, 1966).

Early attempts to make British 'cartoons' for UK television had proved unsuccessful. Halas & Batchelor was the first to try, with the six-part series *HaBa Tales* (ITV, 1959). The macabre 'I Wanna Mink' uses rhyming verse to relate the tale of a humble, make-do-and-mend couple whose loving marriage turns sour when the wife suddenly demands a mink coat. The husband finally shoots his wife with a shotgun and dissolves her body in acid, before the credits reveal – unsurprisingly – an all-male crew.

To cut costs, the animators drew directly onto cels with wax pencils, eliminating the need to trace from paper originals, and kept backgrounds to an absolute minimum. The more family-friendly *Foo-Foo* (ITV, 1960) used the same technique. In over 30 episodes, Foo-Foo, Go-Go and Mimi were re-cast in a succession of different roles, each a subtle variation on their basic characteristics, in a series that evoked silent cinema comedies. One episode, 'The Stowaway' (from a storyboard by Peter Sachs), was filmed in colour, perhaps aiming for the American market, where colour television was already making headway.

'Goodwill to All Dogs' (*Snip and Snap* series, 1960); a rare venture into stop-motion for Halas & Batchelor.

John Halas sketches Foo-Foo for a publicity photograph.

Other than a short BBC series, *Tales from Hoffnung* (1964), Halas & Batchelor now increasingly sidestepped British television's miserly budgets in favour of contract work from American studios, who, thanks to the huge US domestic market, could afford to be more generous. The likes of Popeye, the Lone Ranger and the Jackson 5 were brought to cartoon life in London and Stroud.

Closer to home, at least in inspiration, was an adaptation of Gilbert & Sullivan's *Ruddigore* (1967). Though commissioned for American television, a limited theatrical release in the UK qualifies it as Britain's second animated feature film. But this was a modest enterprise compared to *Animal Farm*. Joy Batchelor, who scripted, designed and directed, struggled with a tight budget, and the need to squeeze the convoluted libretto into less than an hour of screen time. *Ruddigore* features some nice designs, particularly a group of bridesmaids who periodically merge into a multi-headed chorus, but it disappointed Gilbert & Sullivan fans and felt behind the times.

Halas & Batchelor's busy schedule convinced ITV franchise Tyne Tees Television to pay £240,000 for a 60% stake in the company in October 1968.[117] Tyne Tees' ambition was to develop the company's export record 'not only in films, but in merchandising, publishing and toys in national and international markets.'[118] John and Joy must have had mixed feelings about the deal, but in truth the company that bore their name was overstretched. In 1967 an independent financial consultant's report had delivered some sobering home truths. The company had 'too much money tied up in film [sic] which depend on future revenues to recover the cost and then may-be make a profit,' and 'must reduce expenditure quite soon,' limiting future work to 'Television series for children in the USA, provided the price will show a clear profit [...] sponsored films, industrial training films and loop films for industry and schools'.[119] It was sound advice for the industry as a whole: no independent shorts, no experiments and no self-initiated projects. There was no production funding to make them, and no network to distribute them. Fortunately, it was advice that was generally ignored, resulting in some of the most creative work to date.

Bob Godfrey's maverick impulse had led him down unorthodox paths to make distinctive films like *Watch the Birdie* (1954) while still employed at Larkins (see 'Close-up: Grasshopper Group', pp. 94–5). With the success of Biographic, Godfrey was able to use superior studio facilities for his own restlessly inventive work, and fund it with profits from TV commercials. Offbeat love story *Polygamous Polonius* (1959) doesn't just demonstrate the progression of Godfrey's unique sense of humour, but also his ambition to disrupt conventional cartoon narrative techniques. The more graphically ambitious *The Rise and Fall of Emily Sprod* (1964) bears comparison to the surrealist work of cult Polish animator Walerian Borowczyk, while staying true to Godfrey's comic roots. *The Do-it-Yourself Cartoon Kit* (1961), collectively produced by the Biographic team from Colin Pearson's script, is a more straightforward Goonish skit, but stands as something like a manifesto of Bob's animation philosophy. Dressed up as an illustrated lecture on cartoon creation, the film succeeds in celebrating the art form while simultaneously poking fun at its pretentions with a proto-punk spirit.

These short films were often picked up to accompany feature-film releases, particularly through British Lion, albeit with limited financial

The Do-it-Yourself Cartoon Kit (Biographic, 1961).

returns. But the animators themselves found a more enthusiastic audience at the newly emerging animation festivals, notably at Annecy in France. Increased exposure to a more diverse selection of animation from across Europe, Asia and the Americas, backed by the network of the international animation association ASIFA,[120] inspired British animators to push at the boundaries of their art. Despite relying on the likes of BP and Shell to pay the bills, even Halas & Batchelor bared its teeth: *Automania 2000* (1963) took satirical aim at the motor industry and 'never had it so good' consumerism, winning international acclaim and an Academy Award nomination.

The culmination of this flowering of independent creativity was the feature film *Yellow Submarine* (1968), which managed to carry some of animation's more experimental visions to popular audiences. It was directed by Toronto-born animator George Dunning, who had worked with Norman McLaren at the National Film Board of Canada, with Berthold Bartosch in Paris, and at UPA in New York. Late in 1956, with UPA

Montage: Animation Art

These images deserve a gallery wall, but look closer and there's something missing. Every still bears out Norman McLaren's maxim: 'animation is not the art of drawings that move but the art of movements that are drawn'. From abstract lines to human figures, it's between the frames that the magic happens.

CLOCKWISE FROM TOP LEFT:
A Colour Box (Len Lye, 1935); *Rainbow Dance* (Len Lye, 1936); *Stressed* (Karen Kelly, 1995); *Xeroscopy* (Tony White, 1970); *Dresden Dynamo* (Lis Rhodes, 1971); *Calypso* (Margaret Tait, 1955); *Feet of Song* (Erica Russell, 1988).

CLOCKWISE FROM TOP LEFT: *Thirteen Cantos of Hell* (Peter King, 1955); *Now* (Denys Irving, 1969); *The Queen's Monastery* (Emma Calder, 1998); *Taking a Line for a Walk* (Lesley Keen 1983); *Animated Genesis* (Joan & Peter Foldes, 1952); *Street of Crocodiles* (Brothers Quay, 1986); *Mutations* (William Latham, 1991); *Painter and Poet* (Halas & Batchelor, 1951).

Automania 2000 (Halas & Batchelor, 1963).

scenting opportunity in Britain's new commercial TV landscape, Dunning was dispatched to London to join a new operation in a swanky Mayfair building. UPA's venture proved 'an unfortunate and expensive mistake',[121] but Dunning opted to stay in London, finding a business partner in the enterprising John Coates, a nephew of J Arthur Rank who had dabbled in film distribution and commercial television. The pair's new company, TV Cartoons Ltd, opened in 1957, taking over much of UPA's abandoned business and some of its personnel.

With the assistance of his uniquely talented and prolific compatriot Richard Williams, Dunning quickly turned TV Cartoons into one of Britain's leading studios. TVC branched into sponsored film (through offshoot Industrial Animation) and even opened a shortlived Italian arm in 1959. Amid the commercials and safety films for the National Coal Board, Dunning directed a remarkable series of independent shorts that stripped back the process of animation to its barest bones while lifting it to new creative heights.

Like Halas & Batchelor, the renamed TVC London also took on work for American television, including, fatefully, cartoon series *The Beatles* (1965–67). It was commissioned by Al Brodax, a New York producer who had acquired rights to make an animated series to cash in on the outbreak of Beatlemania that greeted the Fab Four's blockbusting 1964 US tour. Episodes were also farmed out to Australia, Canada and Holland, but TVC was the creative hub, and in 1967 it was hired to making an animated Beatles feature film to help the band fulfil their three-picture contract with United Artists.[122]

The television series was built around caricatures of John, Paul, George and Ringo in their lovable moptops-and-matching-suits phase.[123] But by 1967 the band had moved on, growing their hair and embracing psychedelia, drugs and the counterculture in their extraordinary sequence of albums from *Rubber Soul* to *Sgt. Pepper's Lonely Hearts Club Band*. For many of the artists assembled for *Yellow Submarine*, the Beatles had been the soundtrack to their own artistic and personal journeys.

Yellow Submarine (George Dunning, 1968).

Close-up: Richard Williams

Richard Williams' prodigious animation talent manifested early. After a detour painting and playing jazz in Ibiza, the 22-year-old Canadian arrived in London in 1955 with an idea for an animated film but no means to make it. With ITV just launching, he was in the right place at the right time, and he plied his skills around London studios, scavenging time in camera departments to make *The Little Island* (1958), an extended abstract allegory fizzing with invention. British animation hadn't seen anything like it since John Halas's *The Magic Canvas*, a decade earlier (though Williams' film is wittier). A truly independent work, more akin to artists' film than commercial cinema, it was selected for an International Experimental Films competition in Brussels in 1958.

The Little Island won Williams a BAFTA, but almost broke him financially. The shorter, more whimsical *Love Me, Love Me, Love Me* (1963) was successful enough to enable him to start his own studio, Richard Williams Animation. A 1963 profile described an elite team, including Tony Cattaneo, Charlie Jenkins and Ron Wyatt, and an ambitious slate of projects, from half-hour Cinemascope shorts to a children's television series – almost none of which came to fruition.

Alongside shorts and advertising work, Williams demonstrated his versatility with arresting title sequences for feature films *What's New Pussycat* (1965) and *Casino Royale* (1967), and prolonged animated sequences for *The Charge of the Light Brigade* (1968). US broadcaster ABC teamed him with legendary Warner Bros duo Chuck Jones and Ken Harris for Dickens adaptation *A Christmas Carol* (1971). Golden Age animators like Art Babbitt and Grim Natwick also crossed the Atlantic to visit Williams' Soho Square studio, helping out on title sequences, commercials and Williams' epic feature, *Nasrudin* (later *The Thief and the Cobbler*) – a 30-year project doomed to appear only in butchered form.

Ron Wyatt and Tony Cattaneo decamped in the mid-1960s to their own successful studio, Wyatt-Cattaneo. But Williams' studio remained a crucible for talent. Richard Purdham, a vital ally on the Oscar-winning *A Christmas Carol*, would go on to have his own leading company. Roy Naisbitt, an artist at Larkins and on *2001: A Space Odyssey* (1968), would became Williams' right-hand man, often billed as production supervisor but also the mastermind of vast, complex backgrounds with deliberately warped perspectives.

Williams' first feature film experience, as director of *Raggedy Ann & Andy: A Musical Adventure* (1977), was marred by clashes with producers. More satisfying was his role as animation director on Robert Zemeckis's *Who Framed Roger Rabbit* (1988), which innovatively inserted classical animated characters into a live-action detective story. Williams insisted that the animation be done at Elstree studios, to the long-term benefit of the British industry.

The turmoil surrounding *The Thief and the Cobbler* took Williams away from production. His popular masterclasses at Disney and Pixar led to the indispensable handbook The Animator's Survival Kit, first published in 2001. From studio space at Aardman, he toiled like a master craftsman on a feature-length adaptation of Aristophanes' *Lysistrata*, which he jokingly gave the working title *Will I Live To Finish It?* Sadly the project was incomplete on his death in August 2019. But a 2015 release of the film's astonishing pencil-drawn opening, simply titled *Prologue*, earned him BAFTA and Academy Award nominations and served as a reminder of his extraordinary skills.

German art director Heinz Edelmann, with a background at the cutting edge of graphic design, was the perfect choice to fuse together the film's myriad of stylistic approaches. Taking its tone from the Beatles' music and from the pop-art collage of Peter Blake and Jann Haworth's cover art for the *Sgt. Pepper* LP, *Yellow Submarine* felt like a fusion of all of its era's most progressive cultural trends. Its kaleidoscopic mélange takes in surrealism, op art, psychedelia and more, all at the service of an imaginative narrative journey inspired but never constrained by the songs. Characters and imagery sprung from the Beatles' own lyrics – the melancholy Eleanor Rigby, the lonely 'Nowhere Man', Lucy in her sky of diamonds and, of course, the titular submarine – were supplemented with bespoke inventions – Blue Meanies, Apple Bonkers and the bizarre denizens of the 'Sea of Monsters'. As well as somehow holding together the whole complex project, with its 200-strong team of artists, Dunning brought his own playful approach to the film frame and cartoon physics, notably in the 'Sea of Holes' sequence.

To John Coates fell the unenviable task of keeping the production on track and on budget. His failure in the latter objective was a cross he was happy to bear for the sake of the film and the vision of its artists. For TVC – which received a fixed fee and saw none of the profits – the reward for its efforts was very nearly bankruptcy. TV Cartoons would survive and even flourish again, but almost two decades would pass before its next feature, *When the Wind Blows* (1986).

Like the Beatles' music, *Yellow Submarine* was distributed across the world, and despite mixed reviews and box-office results at the time, the film is rightly considered a milestone today. It has been repeatedly re-released to mark various anniversaries and has stood the test of the time, acknowledged both as part of the Beatles' rich legacy and as a dizzyingly innovative work of art in its own right.

In the decade after commercial television was launched, the art and industry of animation in Britain flourished in a way it hadn't since the era of Len Lye and Norman McLaren in the 1930s. There were new opportunities, a new level of recognition and new networks. Television budgets might have been uncomfortably small, but with perseverance and ingenuity animators could inspire and delight a generation of children – and their parents, too. Sponsored filmmaking not only paid the bills but frequently offered

unusual creative license, as did television commercials, while animation was in favour with advertising agencies. In later life both Bob Godfrey and John Halas looked back on this era as a golden age,[124] and whether gilded or not, it certainly saw the emergence of a British animation industry that would be recognisable to many of those employed in it today. Across the world, animation was asserting itself as a unique and different art form to be supported and celebrated, and British animators sat at its heart.

8. KIDS' STUFF

The stuff of science fiction became reality in July 1969, when the first men walked on the moon. The images of Armstrong and Aldrin – miraculously beamed live into millions of homes via satellite – excited the imaginations of a generation of British children, inspiring countless tinfoil-and-cardboard space helmets and slow-motion 'moonwalks'. A few months later, young audiences were whisked back out to space to meet the latest creations of Oliver Postgate and Peter Firmin's Smallfilms. *The Clangers* (BBC, 1969–72) were knitted, mouselike creatures who spoke in whistles and walked their own, rather smaller moon. They were worlds apart from the homely Pingwings and Pogles, but the storytelling charm was reassuringly familiar. And these broadcasts boasted something that left even NASA standing – colour.

Colour television came to Britain in 1967, and it had a particular impact in the bright, polychrome world of children's television. As with the cinema programmes of the 1930s, the arrival of colour ignited a new era of energy and experiment in domestic animation.

Budgets for animated children's programming were built around repeats; episodes could be rescreened almost indefinitely without trying young audiences' patience. But the transition to colour necessitated a refresh.[125] The BBC put a call out for new ideas, and the first episode of *The Clangers* was ready for BBC1's second day of colour broadcasting on 16 November 1969. Smallfilms' creations were charming in any colour, but the Clangers, like *Bagpuss*,

OPPOSITE: *The Clangers* (Smallfilms, 1969-72)

the 'saggy old cloth cat' who followed in 1974, were resplendent in pink. *The Magic Roundabout* had made the switch to colour at a time when both French and British television were still monochrome, so when its key animator, Ivor Wood, was invited to start his own series, *The Herbs* (1968), he filmed it in lush, appropriately leafy colours even though it was first broadcast in black and white. Working for a London offshoot of US company FilmFair, Wood was a busy man. Alongside *The Adventures of Parsley* (1970), a spin-off of *The Herbs* for the BBC, he made *Hattytown Tales* (1969–1972) for ITV. But it was his adaption of Elisabeth Beresford's stories into *The Wombles* (BBC, 1973–75) that became a pop culture phenomenon, with a spin-off group scoring four top ten hit singles and a 1977 feature film using costumed actors, *Wombling Free* (d. Lionel Jeffries).

Stop-motion still ruled the television roost. But could colour finally make 2D cel animation work on British TV budgets? Early attempts largely dodged the question. David McKee's drawings for *Mr Benn* (BBC, 1971–72), first screened in the *Watch with Mother* slot in February 1971, were filled with details and textures that cried out for colour and the high-quality pictures of the still new 625-line standard.[126] But the stories, in which a plain man is whisked via a mysterious fancy-dress shop's changing room to fantastical, colourful adventures, were barely animated. McKee, adapting his own books, felt too much movement would distract from the storytelling. Unlike Smallfilms' similar *Noggin the Nog* and *Ivor the Engine*, whose black and white origins curtailed their shelf life,[127] the all-colour *Mr Benn* remained in regular rotation into the 1990s. BBC employees Hilary Hayton and Graham McCallum's came up with the dialogue-free but visually boisterous *Crystal Tipps & Alistair* (BBC, 1971–74), the adventures of a bushy-haired girl and her dog. Clever storytelling merged with a contemporary aesthetic well-tuned to colour broadcasting, but its cut-out animation techniques harked back to the days of Buxton and Dyer in the 1910s.

The first successful colour series to use cel animation techniques in the UK came from outside the industry's London heart. Brian Cosgrove and Mark Hall had met at art college in Manchester, and crossed paths again in Granada TV's graphics department. Seeking independence, in 1971 they founded Stop Frame Productions and made two series of *The Magic Ball* (ITV, 1971–72), with stories written and voiced by Eric Thompson. The characters

Chorlton and the Wheelies (Cosgrove Hall, 1976–79).

were drawn in thick, bold lines reminiscent of Dick Bruna's *Miffy* or Roger Hargreaves' *Mister Men* books, and the animation was cleverly limited to keep costs down. It was a significant step forward, but Cosgrove and Hall switched to stop-motion puppets for *Sally and Jake* (1973–74). After a rearrangement of affairs, a new enterprise, Cosgrove Hall Films, was founded on New Year's Day 1976 as a subsidiary of Thames Television, an arrangement that would prove a mixed blessing. Here, they were able work on the cel-animated *Jamie and the Magic Torch* (1976–79) and the stop-motion *Chorlton and the Wheelies* (1976–79) – successfully bridging both working models.

Like *Mr Benn*, *The Magic Ball* was rich in detail, but a little stilted. The arrival of Bob Godfrey's *Roobarb*, the green dog, in 1974, galloping towards his audience in a riot of line and colour, signalled something new. Godfrey

Bob Godfrey artwork for *Roobarb*,

brought Grange Calveley's stories and designs to vivid life by drawing them directly onto paper with felt marker pens. Although characters and backgrounds had to be redrawn for each frame, by filming in repeated loops Godfrey not only cut down the number of drawings, but made a virtue of it: the subtle changes in lines and colour 'boiled' on the screen.

Some of the most creative animation for children appeared within the BBC's groundbreaking magazine series for deaf children, *Vision On* (1964–76). Typically short and gag-based, as in Bill Mather's *The Digger*, these animated sequences mixed earthiness with a surreal wit. *Vision On* proved a stepping stone for artists ranging from Vera Neubauer to Peter Lord and David Sproxton, who experimented with animating plasticine through stop motion and submitted some cel-animated scenes of a superhero named Aardman. Lord and Sproxton's real break came with *Take Hart* (1977–83), featuring *Vision On*'s presenter Tony Hart. Their engaging, mischievous plasticine creation, Morph, began an unprecedented run of successes for the Bristol-based Aardman Animations.

While colour was reinvigorating children's television, the public information film – itself now largely a small-screen form – was enjoying something of a golden age of its own, and animation supplied some of its biggest and most enduring hits. Probably the most iconic was *Charley Says* (1972), a series of six shorts featuring a boy and his risk-savvy cat Charley, unforgettably voiced by Kenny Everett. They were produced by Richard Taylor, a graduate of the Larkins Studio and another disciple of Peter Sachs. Taylor had animated the artwork of others for *Crystal Tipps and Alistair*, and he brought Charley to life with the same cut-out method, this time using his own designs, adding shading and features with felt markers. Taylor's striking films, repeated into the 1980s, burnt themselves into the memories of millions, and were further immortalised in The Prodigy's 1991 rave hit 'Charley'. Like Larkins itself, Taylor never made the independent shorts that might have won him greater recognition.[128] Yet his work is constantly innovative, with clean graphic designs and bold colours. He had a particular impact as a tutor at the Royal College of Art from the 1970s into the 1990s.

Charley Says (Richard Taylor, 1972).

The character of Tufty the squirrel was developed for the Royal Society for the Prevention of Accidents in 1953 to teach younger children about safety. Tens of thousands joined the Tufty Club, and the mascot was animated in a series of COI shorts from the end of the 1960s into the 1970s, voiced by *Jackanory* (BBC, 1965–96) favourite Bernard Cribbins. It was a rare example of stop-motion animation in public information filmmaking in the period. Another COI hit was Nicholas Spargo's *Joe and Petunia* series (1968–73), featuring an engagingly dim couple whose witlessness endangered all around them. Spargo was a veteran of Gaumont-British Animation, *Animal Farm* and many successful TV commercials, but he is best known for his BBC children's series *Willo the Wisp* (1981).[129]

Falling demand for animation among television advertisers in the late 1960s made life difficult for many established companies. In 1971 a rechristened Halas & Batchelor Animation relaunched its advertising services with a promotional film, *Animation Has Changed*. It was part of a refresh under new majority shareholders Trident, which threw the historical work of the unmentioned John and Joy under the bus[130] in an attempt to reposition the company for a post-*Yellow Submarine* world. The film even featured coloured rotoscope scenes by Bill Sewell, reprising techniques he'd used for *Yellow Submarine*'s 'Lucy in the Sky with Diamonds' sequence. A provocative poster for the company's services used a section of Wally Wood's 'alternative comix'-inspired drawing 'Disneyland Memorial Orgy' (featuring Mickey shooting up and Minnie getting down with Goofy) accompanied by a reference to the contemporary obscenity trial of the underground *Oz* magazine. Rebranding did little to change the financial course of the company, or to combat the impact of the OPEC oil crisis, rocketing inflation and the resulting 'Three-day Week', which all hit advertisers hard. Regardless, John and Joy had the last laugh, buying back their company in 1975 for over £200,000 less than they had sold it for.

But a number of the artists who passed through Halas & Batchelor in this period would go on to make a significant impact on the industry. Higher quality television pictures and the critical success of *Yellow Submarine* created a demand for a more graphically rich animation style. Artists like Sergio Simonetti, Oscar Grillo, Alison De Vere, Charlie Jenkins and Geoff Dunbar were able to move on from the established companies to set up dynamic new studios: Grand Slamm, Dragon Productions and Trickfilm.

Alongside Richard Williams Animation and its off-shoot, Wyatt-Cattaneo, they took advantage of steadily increasing production budgets to make cartoon television commercials of unprecedented quality. Williams' studio in particular was producing miniature epics, ranging from a Frank Frazetta-style barbarian for Jovan's aftershave 'Sex Appeal' to a risqué Disney princess for Limara bodyspray – the latter drawn by future *Aladdin* (d. Ron Clements/John Musker, 1992) animator Eric Goldberg.

The industry was welcoming a stream of new talent who had experimented with animation techniques at art school, even if they often lacked the equipment and support of a dedicated animation course. Such courses were rare worldwide, but by 1972 animation was being taught at the West Surrey College of Art and Design[131] under the guidance of the impressively multitasking Bob Godfrey. It developed into a full-time degree course, ultimately including Mark Baker, Michael Dudok De Wit, Chris Shepherd, Suzie Templeton and Cyriak among its illustrious graduates.

The industry sent these new graduates in different directions. Paul Vester made the shorts *Anima* and *Repetition* (both 1968) while at Central St Martins and the Royal College of Art. They earned him a place among the new wave of graphic animators at the rebranded Halas & Batchelor, who released his abstract narrative collage, *Football Freaks* (1971). Vester was soon able to start his own company, Speedy Cartoons (later Speedy Films) making commercials and animated elements for a Yorkshire TV children's programme, *Mr Trimble* (ITV, 1971–77).

Derek Hayes and Phil Austin were studying at Sheffield Polytechnic when they made *Custard* (1974), a charming and hugely ambitious 22-minute story about a custard-factory worker whose innocent affection for the product leads to accusations of deviancy. It won the duo a place at the National Film School (where they had to scrabble around to find people to teach them), and ultimately led to the still more epic *Max Beeza and the City in the Sky* (1977), which skilfully walked a tightrope between satire and silliness. After producing animated sequences for the Sex Pistols film *The Great Rock 'n' Roll Swindle* (1980), they formed Animation City, a leading light in commercials, title sequences and short films during the 1980s and 90s.

But while this new wave of art-school animators included a number of talented women, they trod notably different paths. Vera Neubauer made anima-

tion at the Royal College of Art at the start of the 70s, but notwithstanding her *Vision On* work, her career didn't really take off until the reinvigoration of arts funding for animation. Neubauer's extraordinary *Animation for Live Action* (1976) and *The Decision* (1981), both funded by the BFI Production Board, are works of depth and vision, which unpick the forms and practices of animation, storytelling and reality in ways both provocative and playful.

Thalma Goldman made the object animation short *Transition* (1969) while at Central St Martins, and later made drawn animation at London Film School. Films like *Green Men, Yellow Woman* (1973) and *Amateur Night* (1975) marked her out as a distinctive and provocative new talent. Antoinette Starkiewicz's LFS short *Putting on the Ritz* (1974) won her BFI backing for the well-received *High Fidelity* (1976). But whether due to their independence and ambition, their want of opportunities and support, or plain discrimination, women animators didn't break into the commercial industry as easily as many of their male counterparts.

The personnel of animation studios remained largely all-white, with only a few exceptions.. The Indian-born Len Lewis worked at Richard Taylor Cartoon Films, Halas & Batchelor and Grand Slamm from the late-1960s and founded his own Shootsey Animation studio to make commercials in the 1980s. Ian Moo-Young was a Jamaican-born Chinese artist whose distinctive work enlivened a number of Bob Godfrey's shorts before he too began his own firm, Moo Movies. The growth of animation in art schools was one factor behind a marginal improvement in cultural and ethnic diversity in the industry, with artists like Mike Smith and, later, Osbert Parker and Maybelle Peters graduating from courses in Farnham and Middlesex to find commercial success and broadcast commissions. Progress in this area, however, remained painfully slow.

The decade's gradual increase in arts funding for animation was welcome, but results were mixed. Like many later schemes, the BFI Production Board's animation commissions were targeted at emerging animators or artists from other media, resulting in too many underdeveloped and inconsequential films. Even for a successful short like *High Fidelity*, there was no next step within the commercial sector to move onto, and little chance of a second commission as there was always more emerging talent. Vera Neubauer was one lucky enough to get repeated support, and the commission of *Nocturna*

Green Men, Yellow Woman (Thalma Goldman, 1973).

Artificialia (1979) from the Philidelphia-born twins the Brothers Quay was another considered move that would more than pay off.

The Arts Council proved more sympathetic to experienced animators, backing two films from Geoff Dunbar: the multi-award winning *Ubu* (1978), an appropriately obscene adaptation of Alfred Jarry's notoriously scatological absurdist play, followed *Lautrec* (1974), which bought the French artist's sketchbooks to life. Tony White, another former Halas & Batchelor animator, performed a similar service for a Japanese legend in *Hokusai – An Animated Sketchbook* (1978). Into the new decade, the Arts Council would be another active supporter of the Quays and Neubauer, but until the 1980s both Arts Council and BFI support for animation remained sporadic and often poorly targeted.

One group of animators, did, however, manage to turn limited public funding into art and action. In 1976 a group of women in Leeds (including Gillian Lacey, who had worked professionally on *Yellow Submarine* and at

Halas & Batchelor) came together to make *Who Needs Nurseries? We Do!*, an accessible 11-minute cartoon highlighting the importance of pre-school care provision. In 1978 they formed women-only collective Leeds Animation Workshop, and for over 40 years they have overcome numerous financial challenges to make film after film exploring such issues as sexual harassment, nuclear energy, the arms race and the exploitation of migrant domestic workers. With founder members like Terry Wragg still on board, LAW survives as an active producer and inspiration for activist animators.

Funding for animated feature films proved scarcer still. For all their other successes, Richard Williams, Bob Godfrey and George Dunning all saw cherished feature projects run aground. Williams started his 'Nasrudin' project in the mid-1960s, but after 30 years the renamed *The Thief and the Cobbler* was taken out of his hands and released in a botched form by Miramax as *Arabian Night* (1995). After winning his Oscar for *Great* (1975) (see 'Bob Godfrey: Close-up', pp. 94–5), Godfrey spent several years trying to launch an animated musical about the circus elephant Jumbo. 40 minutes of dialogue and songs were recorded with Frankie Howard, but the project failed to get beyond the filmed storyboard 'animatic' stage. George Dunning's Shakespeare adaptation, *The Tempest*, was left unfinished when he died, aged 59, in 1979. The few completed scenes, together with line-tests and some of the recorded audio, were compiled by colleagues as *Sketches for The Tempest* (1979). It hinted at what might have been, but also revealed how difficult such an offbeat, uncommercial project would have been to finance to completion.

The features that did get completed were a mixed bag. Former UPA animator Bill Melendez had found success through his television adaptations of Charles Schulz's *Peanuts* cartoons. He established a London branch of his studio, initially producing commercials for British Rail and others. In 1975 he directed the feature-length *Dick Deadeye, Or Duty Done*, with the celebrated Ronald Searle doing character designs. Like *Ruddigore*, it was a bargain-basement Gilbert & Sullivan adaptation that presumably seemed a good idea at the time. Animation director Dick Horn[132] felt stifled by the

Original poster for *Nocturna Artificialia* (Brothers Quay, 1979).

Pretend You'll Survive (Leeds Animation Workshop, 1981).

budget, the film failed to find an audience, and the experiment appears to have been more of a setback than a step forward for Melendez's company.

Watership Down (1978) was altogether more fortunate, raising a £2 million budget from UK financiers on the back of the stunning Transatlantic success of Richard Adams' book.[133] Producer Martin Rosen had never worked in animation before,[134] but that didn't hold him back: before long he had fired the project's original director, John Hubley, and taken on the mantle himself. While it's tempting to imagine what an animation legend like Hubley[135] might have produced (the abstracted symbolism of the opening sequence may offer a hint), you have to admire Rosen's determination to bring his vision of Adams' difficult novel to the screen. Press coverage ahead of the film's release assumed that it would present cuddly rivals to Thumper and Bugs Bunny. Rosen was convinced the film was suitable for children, but never saw it as a 'children's film', resisting any temptation to market it that

way. The BBFC gave it a U certificate and reassured filmgoers that 'Animation removes the realistic gory horror in the occasional scenes of violence and bloodshed'.[136] Not everyone who saw the film felt the same.

Critics were generally enthusiastic and, significantly, *Watership Down* was frequently the lead film in that week's newspaper reviews, not tucked away at the end (the typical fate of *Dick Deadeye*, for example). And it was enough of a hit to persuade Rosen and his new company, Nepenthe Productions, to follow it with an adaptation of Adams' *The Plague Dogs* (1982). Animation work on the second film was split between San Francisco and London, but former Harold Whitaker assistant Tony Guy was animation director on both films. *The Plague Dogs'* got some positive reviews, but was even further from the typical mould of a family animated feature film and struggled to find distribution support, not helped by the BBFC's 'Advisory' (now PG) certificate.

The automatic pigeonholing of animation as 'kid's stuff' was a constant frustration for animators wanting to tell different kinds of stories or speak to more mature audiences. In the early 1970s, almost the only animation on 'grown-up' television was Terry Gilliam's work for *Monty Python's Flying Circus* (BBC, 1969–74).[137] The American-born Gilliam had worked with *Mad*

Watership Down (Martin Rosen, 1978).

Montage: Animated Opposition

Animation has proved a powerful means of protest, following the traditions of cartoon satire and political poster art. Where WWI's 'animated sketchbooks' took a patriotic line, *Hell Unltd* (1936) fused art and activism to pacifist ends. As the Cold War raged, a number of animators delivered terrifying warnings of Armageddon.

CLOCKWISE FROM TOP LEFT: *Hell Unltd* (Norman McLaren and Helen Biggar, 1936); *Dreamless Sleep* (David Anderson, 1986); *The Jellyfish* (Peter Roberts, 1974); *A Short Vision* (Joan & Peter Foldes, 1956); *Animated Genesis* (Joan & Peter Foldes, 1952); *When the Wind Blows* (Jimmy Murakami, 1986); *Pretend You'll Survive* (Leeds Animation Workshop, 1981).

magazine founder Harvey Kurtzman, and arriving in London found another mentor in Bob Godfrey. But Gilliam's surreal comedic vision was all his own, and his distinctive titles and interstitials – by turns oddball, irreverent, scabrous, grisly or rude, but always madly inventive – made him every bit as vital to Python's phenomenal success as the rest of the team.

Around the same time, Bob Godfrey was pursuing his own provocative course. *Henry 9 til 5* (1970) and *Kama Sutra Rides Again* (1971) are witty, comic short films that are upfront about sex, nudity and relationships, and found an audience despite their BBFC 'AA' certificate (suitable for over 14s). More troubling were *Sinderella* (1972) and *Snow White and the Seven Perverts* (1973) from pornographer David Grant's Oppidan Film Productions. The second was directed by former Terry Gilliam assistant Marcus Parker-Rhodes (credited as 'Marcus Prodes'), and uses Gilliam-esque airbrushed cut-out animation and photo collage. It was passed uncut with an X certificate by the BBFC, but it's less the explicit content that offends than its racism and sexism. Oppidan is also credited as co-producer on Bob Godfrey's next sex comedy cartoon, *Dear Margery Boobs* (1977), also X-rated but thankfully in better taste.

Terry Gilliam's work for *Monty Python's Flying Circus* (BBC, 1969–74).

Close-up: Alison De Vere

The films of Alison De Vere are among the most honest expressions of humanity to appear on screen. Her extraordinary trio of independent shorts, *Café Bar* (1975), *Mr Pascal* (1979) and *The Black Dog* (1987), are infused with fantasy and magic, but her characters have an authenticity to life that is all too rare in animation.

Born in India into an army family, she returned to Britain aged three, but her childhood remained peripatetic. After graduating from London's Royal Academy of Arts, she drifted into animation, initially working in trace and paint. At Halas & Batchelor her skills were recognised, and for two decades she built a reputation as a designer on a variety of animated shorts. By necessity or design, she rarely settled long with any one firm, but her numerous engagements speak to her good standing. She married German artist Karl Weschke in 1948 and they had a son in 1956, but divorced two years later. Despite their complex relationship, they remained friends and collaborators; Karl is credited with designs on her last independent short, *Psyche & Eros* (1994).

Though she continued to work as a designer, this phase of her career culminated with her work as a background supervisor on *Yellow Submarine* (1968), working closely with designer Heinz Edelmann. But two other films she made in this period would mark a new beginning. *False Friends* (1967) is a short film warning of the dangers of drug addiction commissioned by the World Health Organisation for audiences in Asia. Dialogue free and minimally funded, it was a tough brief for a directorial debut, but De Vere delivered her first striking study of the human condition, drawing out real character and emotion with minimal animation – the artwork almost certainly all her own. It was a better indication of her course than her first independent short, *Two Faces* (1968), which mixed her paintings and poetry, but used no animation.

She spent much of the 1970s working at Wyatt & Cattaneo on adverts for crisps, tea and tyres, but the studio, and producer Lee Stork, were supportive of her own short films. *Café Bar*, ostensibly the story of a couple meeting in a rainy Soho coffee shop, paints a vivid dreamscape rich in symbolism. *Mr Pascal* tells of a widowed cobbler who brings a figure of Christ down from a cross when struck by its cruelty. The evening of community and warmth that follows in this brave film is expressed less as a Christian miracle than simple earthly kindness. Her greatest

Café Bar (1975).

achievement, *The Black Dog*, was an expression of De Vere's own soul journey, filled with all the life, art and experience she had crammed into her six decades on Earth.

The Black Dog was her second Channel 4 commission, following a slightly too compressed adaptation of George Eliot's *Silas Marner* (1983). Thereafter she worked increasingly in children's television. A fruitful relationship with influential producer Joy Whitby and her company Grasshopper Productions led to many charming series and specials including *The Angel and the Soldier Boy* (BBC, 1989), the anthology *East of the Moon* (Channel 4, 1988), and *Mouse and Mole* (BBC, 1997–98). Her last Grasshopper production, *A Small Miracle* (ITV, 2002), was completed by Ben De Vere Weschke from his mother's storyboards; Alison had died the previous year, aged 76. Often described as modest, quiet and serene, she left a body of work that makes clear she was an artist of uncommon insight, and an infectious passion for life.

Dear Margery Boobs (Bob Godfrey, 1977).

But 'adult' didn't have to mean 'prurient'. On Christmas Day 1976, a small audience brushed off the mince pie crumbs to catch the charming five-minute animation *Audition* on BBC2. Made by BBC Bristol employee Bill Mather, it was based on a sound recording of his son's audition for the local church choir. With producer Colin Thomas, Mather encouraged the BBC to commission a series of similar films in which animators 'eavesdrop on real conversations and let their imaginations run riot', as *Radio Times* put it.[138] Eventually aired in 1979, the six-part *Animated Conversations* is a landmark in British animation history. Alongside Derek Hayes' *Albion* and Mather's own *Hangovers* were two stop-motion films by Aardman's David Sproxton and Peter Lord: *Confessions of a Foyer Girl* and *Down and Out*, the latter based on conversations recorded at a local Salvation Army hostel. The series not only developed a new genre – a kind of animated fly-on-the-wall documentary[139] – but demonstrated that the form could carry serious, even weighty themes for an appreciative, grown-up television audience.

9. TOP OF THE WORLD

On 29 November 1990 – the day after Margaret Thatcher's 11-year reign as prime minister came to an abrupt halt – an unusual animation screened in a late-evening slot on Channel 4. In *Going Equipped*, directed by Peter Lord for Aardman, a young man relates his experiences of petty crime and prison in a soft, West-Country accent. The following day, in a similar slot, came *Creature Comforts*, a film by Aardman's rising star, Nick Park, in which a Brazilian student tells of his difficulties in adjusting

Creature Comforts (Nick Park, 1990).

to life in Britain: the pokey apartments, lousy weather and unavailability of fresh meat. Both films were rendered in plasticine, using the interview-based approach so effectively pioneered more than a decade earlier in *Animated Conversations*. But where *Going Equipped* was a poignant tale told by a solemn young man in a ragged denim jacket, *Creature Comforts* comically undercut its own protagonist by characterising him as a homesick mountain lion. *Going Equipped* was critically well-received, but *Creature Comforts* won British animation its first Academy Award since 1975, was adapted into a string of adverts for electric heating, and was remembered well enough more than a decade later to return for two 13-part ITV series (2003–06) that were screened around the world.

The 1980s and 90s ushered in by Thatcher and Ronald Reagan was an age of stark contrasts: of market-driven revolution and rapid deindustrialisation, of rocketing salaries and spiralling unemployment, of boom and recession. In its own way, the world of British animation was no less divided, but far less easily sorted into winners and losers.

Even as Britain wallowed in recession at the dawn of the 1980s, British animation was on the up. It started with a mouse: *Danger Mouse*, made by Cosgrove Hall for ITV (1981–92). This shrewd mix of parody and action followed an intrepid rodent superspy and his laughable but loveable sidekick Penfold, a hamster. Taking its name from stylish early-60s series *Danger Man* (ITV, 1960–68), it incorporated elements of James Bond and Sherlock Holmes with knowing wit and a seemingly inexhaustible supply of fantastical plots. Clever scripts and brilliant voice characterisation from David Jason and Terry Scott made it a hit with adults and children alike, helping it to remarkable viewing figures for a children's programme. It enjoyed a previously unheard-of 10-series, 11-year run and sold across six continents. It was the first cartoon acquisition by American cable channel Nickelodeon.[140]

As the international market heated up, money flooded into children's animation. In 1982, Cosgrove Hall counted itself lucky for the £400,000 budget[141] for its feature-length stop-motion adaptation of *The Wind in the Willows* (ITV, 1983).[142] Half a decade later, its *Danger Mouse* spin-off *Count Duckula* (1988–93) enjoyed a £5.5 million budget for its first series, financed through £1 million in pre-sales to Nickelodeon and what was billed as the country's biggest merchandising rights deal.[143] Over £3 million was lavished

Danger Mouse (Cosgrove Hall, 1981-92). Terry Scott and David Jason, the voice talents for Penfold and Dangermouse.

on a feature-length adaptation of Roald Dahl's *BFG* for ITV's Christmas offering in 1989. This was investment at an unprecedented scale, built on the expectation not of box office returns but of overseas television and domestic video sales.

In Cardiff, the new Welsh-language channel Sianel Pedwar Cymru (S4C) made a big investment in Mike Young's *SuperTed* series (1983–86), importing the high production values and animation quality of 1970s TV commercials into children's television. S4C's gamble more than paid off: *SuperTed* became the first British series to air on the Disney Channel in the US, unexpectedly turning the Welsh capital into a leading centre of British animation.

The budget inflation even reached the BBC. Like its predecessor, *Roobarb*, Bob Godfrey and Stan Hayward's *Henry's Cat* was drawn with marker pens on paper to keep costs down. The title character's more sedate nature justified animation so minimal that it sometimes resembled a filmed picture book. But by its third series in 1986, *Henry's Cat* had grown from five to 15 minutes an episode, and increasingly used cel animation. It was broadcast

BFG (Cosgrove Hall, 1989): over £3 million was lavished on a feature-length adaptation of Roald Dahl's classic.

on the Showtime cable channel in the US, and later stories capitalised on the transatlantic appeal: in 'The New President' (1993), Henry's Cat tries to get his face on Mount Rushmore.

Exports to the US were still a drop in the Atlantic compared to the torrent of series coming the other way. A rash of '30-minute commercial' cartoon series, based on toys like He-Man, Transformers and My Little Pony, was fuelling a new craze for American cartoons. But merchandising tie-ins were increasingly important to the financing of British series too, and the rise of home

video brought valuable new distribution revenue. Children's animation was hot economic property, and 'IP' (intellectual property rights) was gold dust.

Around 1980, writer John Cunliffe was invited by the BBC to come up with stories for a children's series set in the countryside. He created the amiable *Postman Pat*, who was brought to life through stop-motion by Wombles animator Ivor Wood. An initial 13 episodes, broadcast from September 1981, were enough to turn the character into a mini-industry through repeats, world television sales, home video releases and an increasing range of merchandising. The rights were worth a fortune – but not to Cunliffe, who had signed them over to Woodland Animations. Woodland, with its all-important IP portfolio, was subsequently bought by Entertainment Rights, then sold on again. Modern series still centre on Pat and his ever-faithful cat, Jess, but he now pilots a fleet of vehicles, including a helicopter and an aeroplane – all available at toy stores.

In theory, Channel 4, launched in 1982, was protected from this frenzied market. Although a commercial channel, all its advertising revenue went to ITV in return for a guaranteed income – an arrangement that kept the young channel safe from fluctuations in the advertising market. What's more, Channel 4 had a statutory obligation to 'appeal to tastes and interests not generally catered for by ITV' and to 'encourage innovation and experiment in the form and content of programmes'.[144] This licence to be different applied as much to animation as to any other part of the schedule. 'We cannot simply offer children's cartoons,' explained animation commissioner Clare Kitson in 1990, 'ITV does this. We must be different. That is our remit.'[145]

Such clarity of thinking wasn't always obvious at first. The only attraction for animation fans in the opening weeks was *Cartoon World*, a weekday programme of short films from around the world. Two bought-in British works – Alison De Vere's *Mr Pascal* (1979) and Chris James' *About Face* (1978) – turned up in the second week, but there was little sense yet that the channel would soon transform British animation. An early breakthrough came with the première of *The Snowman*, a half-hour animated adaptation of Raymond Briggs' picture book that was a centrepiece of Channel 4's first Christmas Day schedule. It was produced by TVC London, which had been treading water since the death of creative head George Dunning. His business partner, John Coates, quickly recognised the opportunities the new channel offered, and

raised funds to make a high-quality film that has famously been screened every Christmas since. But Channel 4's non-commercial remit saw it miss out on the all-important IP and any share in the merchandising bonanza that the film created.

With no dedicated commissioner for animation at the start, the channel's first animated films came from disparate departments – drama, current affairs, youth, education. In some ways this was refreshing; supporting the view that animation is not a genre, but a medium capable of enlightening all genres. It ensured a diversity of projects and prevented animated projects from being pigeonholed.

But there were downsides. Animation production needs understanding and careful stewardship, as demonstrated by the year-long delay in delivering what should have been one of the highlights of the channel's opening week. Chief executive Jeremy Isaacs was impressed by *Animated Conversations*, and requested ten similar films from Aardman to help launch the new channel. Scarred by the experience of producing 26 episodes of the altogether simpler *The Amazing Adventures of Morph* for the BBC between 1980 and 1981, Peter Lord and David Sproxton talked him down to five, but they had still bitten off more than they could chew. *Conversation Pieces* finally appeared in time for Channel 4's first birthday in 1983. Under pressure from the industry, Isaacs added animation to the brief of Paul Madden, 'commissioning editor for odd and sods',[146] who despite little experience with the form proved an astute choice.

Under Madden's stewardship, animation blossomed on the channel over the next few years: TVC followed up *The Snowman* with a feature-length adaptation of Raymond Briggs' apocalyptic *When the Wind Blows* (1986), developed and part-funded by Channel 4 for theatrical release;[147] Derek Hayes and Phil Austin's *Skywhales* (1983) and *The Victor* (1985) continued the ambition of their student works with amplified production values; Lesley Keen followed her homage to Paul Klee, *Taking a Line for a Walk* (1983), with a delve into mythology for the three-part epic *Ra: The Path of the Sun God* (1990); the Quay Brothers' films on composers Leoš Janáček and Igor Stravinsky preceded their first masterpiece *Street of Crocodiles* (1986); Alison De Vere made the phenomenal *The Black Dog* (1987) following a lower-key adaptation of *Silas Marner* (1983).

The Snowman (Dianne Jackson, 1982), based on Raymond Briggs' book.

The number of repeat commissions is striking. Animators were stunned at being prompted to include a profit margin in their budgets to support development of their next projects (a key element of the channel's brief to develop an independent production sector). They were encouraged to be provocative. For *Sweet Disaster* (1986), a series of animated shorts on the theme of nuclear apocalypse, Aardman made the ambitious 13-minute anti-arms-trade film *Babylon* (1984), while National Film School graduate David Anderson contributed the heartbreaking *Dreamless Sleep (1986)*. In some ways, 1989's *Lip Synch* series delivered the extra five films requested from Aardman years earlier, but their greater ambition (and budgets) marked the progress in between. Alongside *Creature Comforts* and *Going Equipped* was Barry Purves' virtuoso debut, *Next*, which squeezed references from every Shakespeare play into five minutes without dialogue, and unveiled an astonishing new talent.[148]

What was missing was a dedicated space for animation. Addressing this gap was one of Clare Kitson's first priorities following her appointment as the channel's first full-time animation commissioner in 1989.[149] *Four-Mations*,

launched in 1990, brought together thematic selections of short animated films, filling out the programmes with insightful interviews with animators. There were series on stop motion (*Bizarre Puppet Animation*, 1990), comedy (*Aspects of Comedy*, 1993), computer animation (*Electric Passions*, 1996) and European work (*Continental Passions*, 1996). Though often relegated to late-night slots, the programmes inspired and educated a new generation of animators. To attract younger audiences and those who weren't necessarily interested in form and process, Kitson also invested in cartoon comedy series, pitched (not always successfully) at primetime slots (see 'Close-up', pp. 150–1).

But commercial imperatives were catching up with Channel 4. Changes to its funding formula from 1990 ultimately cut the channel loose from its ITV subsidy, leaving it dependent on advertising revenue. So it's a testament to the individuals involved that at the same time the channel partnered with the Arts Council to launch a new funding scheme that would support some of the most experimental and challenging animation to date. The

Next (1989), Barry Purves' virtuoso debut.

animate![150] initiative was kicked off by Phil Mulloy's *Cowboys* series (1991), which provocatively punctured the masculinity and morality of the Western genre with crude but deadly ink drawings. Former Cambridge Animation Festival programmer Dick Arnall, the scheme's production advisor and guiding light, worked hard to support a wide variety of filmmakers and to promote diversity in style and technique. So great was Arnall's commitment to the art form that, in a combative 2005 essay, 'Death to Animation', he argued that the very name 'animation', with its connotations of children's entertainment, was preventing it from fulfilling its potential.

Another significant development was Animator-in-Residence (AIR), a collaboration between Channel 4, the Arts Council and the BFI, offered to animators who had graduated in the previous five years. From 1992, four animators a year were selected to spend three months in a glass-walled studio at the BFI's Museum of the Moving Image (MOMI), as a kind of living exhibit. Their time was spent on development work for an idea and, all being well, Channel 4 would provide a budget to make the film in a more professional set-up. The first tranche of animators included Sam Fell, who would go on to co-direct the features *Flushed Away* (2006) and *ParaNorman* (2012), while one of the last participants, Will Becher, co-directed *Shaun the Sheep Movie 2: Farmageddon* (2019). Among many remarkable films produced through the scheme, standouts included Ruth Lingford's *Death and the Mother* (1997), a stark story of motherhood and loss which continued her experiments with woodcut aesthetics and computer graphics, and Iain Gardner's all-analogue *Akbah's Cheetah* (2000), a seamless marriage of character animation and complex layers of colours and textures. After MOMI closed in 1999, the studio moved to the BFI IMAX, where Rob Morgan remembers being bombarded with popcorn while developing the gothic *Cat with Hands* (2001). Substantial changes at Channel 4, the Arts Council and the BFI all posed threats to the longevity of AIR, and despite a valiant attempt to transplant the scheme to the National Media Museum in Bradford from 2004, it had folded before the decade was out.

But Channel 4 was far from the only game in town. Thanks to its success with *SuperTed* and *Fireman Sam* (1987–94), by 1990 S4C's £1.2 million commissioning budget for animation was bigger than even Channel 4's.[151] Head of animation Christopher Grace attracted numerous animators to Cardiff or

nearby, with Joanna Quinn, Candy Guard, Vera Neubauer and Phil Mulloy all moving there, at least temporarily. The channel developed a particularly impressive line in adaptations of classic literature, starting with *Shakespeare: The Animated Tales* (1992–94), which was produced in partnership with the state-run Russian animation studio, Soyuzmultfilm – an unexpected consequence of Perestroika. Two six-film series were overseen by *SuperTed* director Dave Edwards, who spent years commuting between Cardiff and Moscow.

The S4C/Soyuzmultfilm partnership made quality animation possible at budgets that undercut British studios, but later literary series supported more local talent. For the 1995 series *Operavox*, made in collaboration with the BBC, Graham Ralph, Mario Cavalli, Gary Hurst and Barry Purves all contributed films from the UK, alongside two from Russia. The two-part, Oscar-nominated *The Canterbury Tales* (1998) included contributions made in London, Cardiff and Moscow. A move into feature films followed, with Derek Hayes and Stanislav Sokolov co-directing *The Miracle Maker* (1999), which told the story of Christ, and *Y Mabinogi (Otherworld*, 2002), based on ancient Welsh tales.

In partnership with Channel 4,[152] S4C funded Joanna Quinn to complete her Middlesex Polytechnic graduation short *Girls Night Out* (1987) which screened in a prominent slot on Channel 4 with Alison De Vere's *The Black Dog*. A celebration of riotous femininity following a gang of women off to see a male stripper, *Girls Night Out* introduced the character of Beryl, a feisty Welsh housewife who Quinn would flesh out in a series of subsequent short films in the following decades. Quinn also brought her prodigious drawing skills to the more caustic political satire, *Britannia* (1993), and directed the Oscar-nominated *Famous Fred* (1996), a half-hour adaptation of a Posy Simmonds children's book.

The BBC also played a part in the British animation renaissance. Years before Channel 4, it rounded up films from the Cambridge Animation Festival for the 12-part *Animation at Cambridge* (1979), shown in early-evening slots on BBC2.[153] In 1985, the 'International Year of Animation', it introduced an *Animation Now* strand, to carry a variety of shorts, including films from RCA students. And in 1988 BBC2 devoted a week's worth of youth slot *DEF II* to British and international animation, screening entries to the student animation competition First Bite, alongside a selection of classic and contemporary

work, as well as interviews with the likes of Alison de Vere and Geoff Dunbar. What was missing was commissioning. But by the Christmas of 1993, the BBC was ready to unveil the first fruits of a new investment, after a mischievous raid on Channel 4.

As a student at the National Film and Television School in the early 1980s, Nick Park had embarked on an ambitious plasticine animation short, and reached out to the *Morph* men, Peter Lord and Dave Sproxton, for advice. Realising his talent, they soon invited him to join Aardman, where he was put to work on a variety of projects while they helped him complete his student short. Finally released in 1989, *A Grand Day Out*, which followed a man and his dog on a trip to the moon in search of cheese, quickly began to make waves on the festival circuit. Channel 4 introduced the wider world to Wallace and Gromit on Christmas Eve 1990 – only to see its star signings poached by the deeper-pocketed BBC.

Britannia (Joanna Quinn, 1993).

Close-up: Money for Nothing

From the early 1960s, record companies made bespoke short 'promo' films to stand in for artists who couldn't (or wouldn't) appear in person on TV programmes like *Top of the Pops*. These promos (later 'videos') took on a creative life of their own, eventually winning a dedicated platform with the launch of MTV in 1981. As budgets rose, more animators were able to get in on the action.

Steve Barron's video for 'Money for Nothing' (1985) featured groundbreaking computer graphics, and constant rotation on MTV helped Dire Straits to a US no. 1. The same year, Norwegian band A-Ha broke through thanks much to Barron's video for 'Take on Me', which brought a comic strip to life by tracing parts of a live-action sequence in pencil and cleverly combining the two. But it wasn't just the musicians who benefited. The wildly inventive video for Peter Gabriel's 'Sledgehammer' (1986) did much for the reputation of its producers, Aardman.

A distinctive video could turn a record into a chart topper, even by accident. Jackie Wilson's 1957 single 'Reet Petite' became an unexpected hit three decades after its original release when a Claymation accompaniment to the song, made for a showreel by fledgling London-based company Giblets, was shown on the BBC.

Online video and social media have put music distribution increasingly into the hands of consumers. File-sharing and online streaming platforms have transformed the music industry, including its use of pop promos. YouTube has supplanted music channels, with the most popular uploads clocking up views in the billions, and the resulting ad revenue now a key element of today's often fragile music economy.

Emerging media are opening up new territories for visual music to explore. In a century that has already seen a virtual cartoon band, Gorillaz, become one of Britain's most popular acts, it seems certain that animation and music still have a long way to travel together.

CLOCKWISE FROM TOP LEFT: Peter Gabriel - 'Sledgehammer' (Stephen R. Johnson, 1986); Dire Straits - 'Money for Nothing' (Steve Barron, 1985); A-Ha - 'Take on Me' (Steve Barron, 1985); Radiohead - 'Burn the Witch' (Chris Hopewell, 2016); Art of Noise - 'Close (to the Edit)' (Matt Forrest, 1984); Gorillaz - 'Clint Eastwood' (Jamie Hewlett and Pete Candeland, 2001).

A Grand Day out won Park a BAFTA and a nomination for the Best Animated Short at the 1990 Academy Awards – where it was beaten by Park's *Creature Comforts* (Park's biggest concern at the ceremony was in making sure he didn't read out the wrong acceptance speech). But it was Wallace and Gromit's second, BBC-funded film, *The Wrong Trousers*, first broadcast on Boxing Day 1993 that helped turn the plasticine duo into global superstars. Its success more than justified the doubling of budget to £1.3 million for its 1995 follow-up, *A Close Shave*.[154]

Park's gently surreal films inhabited a cosy, reassuringly old-fashioned provincial England, drawing on a heritage of Ealing comedies, *Beano* comics and the long-running sitcom *Last of the Summer Wine* (BBC, 1973–2010) – one of whose stars, Peter Sallis, provided the voice of Wallace. It was a recipe that was phenomenally popular at home but also proved highly exportable.

Academy awards for both *The Wrong Trousers* and *A Close Shave* took Britain's Oscar tally for the decade to five – three of them for Park. Aardman – and UK animation – was on top of the world. Park's creations had launched Aardman to new heights, and Wallace and Gromit have become the studio's public face. But Lord and Sproxton brought invaluable support in the form of animation skills, experience, technical knowledge and business acumen, without which Park's characters might never have made it to wider audiences.

The long tradition of the animated Christmas special was now firmly in the hands of the BBC, but with each new Wallace and Gromit short years in the making, finding an animated centrepiece for the festive edition of the *Radio Times* wasn't always straightforward. The television debut of the bolexbrothers' feature-length *The Secret Adventures of Tom Thumb* was grouped with *The Wrong Trousers* in trailers for the 1993 Christmas schedule, but this was a very different beast. Mixing claymation with pixilated human actors under the direction of Dave Borthwick, the film had grown out of a ten-minute short, *Tom Thumb*, funded and screened by the BBC in 1988. But its dark, uneasy atmosphere and grotesque humour marked it out for cult status rather than a mainstream audience, and the extended version was only completed with additional funding from La Sept in France and Manga Entertainment, who banked on revenue from home video sales. It was an anomaly in the BBC's animated output, but one to be grateful for. Daniel Greaves' *Flatworld* (1997),

The Secret Adventures of Tom Thumb (1993), the bolexbrothers' feature-length Christmas film.

a clever mix of stop-motion, cut-out and cel animation, was a better fit for the family audience the BBC had in mind, but it couldn't begin to match the enduring appeal – or merchandising potential – of Wallace and Gromit.

As the new millennium approached, broadcasting was undergoing seismic shifts. The rise of private satellite, cable channels and digital terrestrial broadcasting had led to a proliferation of channels and growing competition for audiences. Public service broadcasters were increasingly priced out of the market for top talent, and in 1997, off the back of the worldwide popularity of Wallace & Gromit, Aardman announced that it was making the leap to cinema. Armed with a killer elevator pitch – '*The Great Escape* – but with chickens!' – the studio had secured developments funds from Pathé and Hollywood big guns DreamWorks to make its first animated feature, *Chicken Run*, to be co-directed by Nick Park and Peter Lord.[155]

A brash new arrival and a quiet departure encapsulate the contrasting fortunes of British animation on the cusp of the 21st century. 12 April 1999 saw the BBC One debut of *Bob the Builder,* introducing a cheery, can-do construction worker and his fleet of talking diggers, cranes and cement mixers, developed from an idea by Keith Chapman with funds from British-American company Henson International Television (HiT Entertainment). Production had begun at Cosgrove Hall before HiT reassigned it to its own production company, Hot Animation. Within a year, international distribution deals and merchandising had quadrupled the company's value to around £400 million.[156] Just a few months after Bob's first build, Clare Kitson stepped down after a decade at Channel 4, having felt herself increasingly out of step with a channel moving ever further from its founding principles in pursuit of the larger, younger audiences prized by advertisers. Animators united in grief at the news. Although Channel 4 maintained a more limited commitment to animation, its days as a steadfast champion of animation art seemed gone forever.[157]

Even Aardman wasn't immune to the changing weather. Since the mid-1990s, Darren Walsh had been working with the company to develop a series about an obnoxious, sweary and downright hilarious teenage boy with an extremely inquisitive mind. The *Angry Kid* films were fresh and distinc-

Angry Kid (Darren Walsh, 1999).

tive, combining the techniques of pixilation and replacement animation: real actors were filmed frame by frame wearing a series of interchangeable masks that allowed for lip synching and gurning expressions. Aardman felt the films had primetime potential; Channel 4 aired them after 1am. But these bite-sized, punky shorts were perfect for a new method of distribution – the internet. *Angry Kid* launched on the Atom Films[158] platform from May 2000, with each 83-second episode taking approximately six minutes to download on a then-standard 28.8k modem.[159] Within seven weeks the films had reportedly reached a million people, a third of whom emailed them on to friends and spread the word, as they were actively encouraged to do.[160] Could 'going viral' cure independent animation's millennium bug?

10. OK COMPUTER

One of the more low-key contributions to 'Cybernetic Serendipity', a landmark 1968 exhibition of computer programming and contemporary art at London's ICA, was Tony Pritchett's *The Flexipede* (1967). This rather humble film, in which a centipede is troubled by some rogue body parts, was an engaging, if unusually simple piece of character animation, but it used no drawings, cut-outs, puppets or cels – instead it was made entirely on the ATLAS supercomputer at University College London.

The handful of ATLAS supercomputers in the UK became the focus of most early computer animation developments, with creatives drawn in to develop works that varied from utilitarian architectural diagrams to avant-garde art. Artist filmmaker Malcolm Le Grice spent months coding an eight-second sequence of moving ellipses in the FORTRAN programming language. The images were exposed onto film negative by recording a computer monitor, and could then be looped and combined with other imagery using an analogue optical film printer. Alan Kitching used a similar method for a computer-generated logo at the end of *The Dream of Arthur Sleap* (1972), a promotional film for the BFI. Kitching was an accomplished programmer with some animation experience, and developed software that could be used by artists without them having to learn to code themselves. His ANTICS programme, launched in 1972, was a huge step forward, and although it was ultimately little used by the commercial industry, it served as a signpost to the future.

Getting the animation industry to take computers seriously – or just not to see them as a threat – was no easy feat. From the late 1960s, Stan Hayward, who had worked on scripts and storyboards in the commercial and

The Flexipede (Tony Pritchett, 1967).

independent animation industry and collaborated with Bob Godfrey, Richard Williams and George Dunning, became a vocal advocate for the use of the computer to save time and effort in the production of cel animation. Though no programmer himself, Hayward practiced what he preached, establishing Video Animation Ltd and contributing an animated blueprint of Isambard Kingdom Brunel's Great Eastern steamship for Bob Godfrey's Oscar-winning *Great* (1975). With funds from the BFI Production Board, he made *The Mathematician* (1976), which successfully realised his characteristic brand of absurdist comic pessimism through computer animation – but took some four years to finish.

For this film the output of the computer was inked by a plotter arm onto clear cels, which were then painted and photographed traditionally. A similar method was used on sequences of Halas & Batchelor's *Autobahn* (1979), an extended music promo for the German electronic band Kraftwerk. However, animator Roger Mainwood found the technology cumbersome and

Autobahn (Halas & Batchelor, 1979).

preferred to bypass the process where possible. John Halas used computer animation on *Dilemma* (1981), which converted a minimal number of drawings by Hungarian artist Janos Kass into computer images and then used software to 'morph' between them. *Dilemma* shared themes with other Halas films questioning the human impact of scientific advances.[161] Unusually, the computer images were rendered directly to videotape.

The wider media industry's interest in computer-generated imagery was mostly limited to animated logos and special effects. The Channel 4 logo, realised in 1982 by Tony Pritchett from designs by Martin Lambie-Nairn, was a notable landmark. The wireframe animation was originally rendered out using a plotter and hand-coloured, as on Hayward's *The Mathematician*, but the results felt a little old fashioned. Information International Inc in Los Angeles, which had produced the graphics for the Disney feature film *Tron* (1982), was brought in to add colours digitally. Pritchett had helped develop the graphics for the computer display screens in Ridley Scott's *Alien* (1979) – a small but significant step forward in digital effects. A decade earlier, Stanley Kubrick had to engage a team of artists to traditionally animate all of the

computer displays in *2001: A Space Odyssey* (1968), back-projecting onto the multiple screens from individual 16mm film strips during filming.

The slow development of computer graphics in the 1980s meant that filmmakers often turned to fakery. Rod Lord laboured for months on the eyecatching 'computer graphics' that featured prominently in the television adaptation of *The Hitchhikers Guide to the Galaxy* (BBC, 1981) – entirely without computers. Actor Matt Frewer spent hours in the make-up chair to bring the 'computer-generated' presenter Max Headroom to life – although Lord did contribute actual computer animated displays for *Max Headroom: 20 Minutes into the Future* (1985), which launched the character. The cycling vector backgrounds behind Max were also traditionally animated in the original version, thanks to the analogue alchemy of Peter Tupy, and the quality noticeably dropped when it switched to real computer animation.

Film and video post-production facilities began to ramp up their processing power through the 1980s, with companies like Rushes Postproduction and

The Mathematician, (Stan Hayward, 1979).

Close Up: Search for the British *Simpsons*

Britain didn't have to wait long to meet *The Simpsons*. Matt Groening's series was broadcast in the US from 1989, and brought to the UK the following year by satellite broadcaster Sky, which has aired it ever since.[*] Springfield's most famous family spawned countless American imitators, from *Family Guy* (1999–) to *American Dad* (2005–), and established a lucrative market for animated series aimed at adult audiences. So where was the British *Simpsons*?

Under animation commissioner Clare Kitson, Channel 4 made a number of attempts at animated sitcom series. Both Sarah Ann Kennedy's grungy stop-motion series *Crapston Villas* (1995–97) and Candy Guard's aesthetically simple but comically astute *Pond Life* (1996, 2000) garnered critical praise and ardent fans, but were hampered by scheduling and managed just two series each. *Bob and Margaret* (1998–2000) was an extension of David Fine and Alison Snowdon's award-winning short *Bob's Birthday* (1993). The original film and first two series were both made as co-productions with Canada but, in a sign of Channel 4's diminishing support for animation, the final two series were made without British backing and never aired on the channel.

The BBC commissioned two series of Richard Starzak's *Rex the Runt* (1998–2001) from Aardman, building on a character who had appeared in three short films since his debut in Channel 4's *Lip Synch* slot. The first series of *Stressed Eric* (1998) was a co-production between Absolutely Production in the UK and Klasky Csupo, the US company that had made the original Simpsons shorts for Groening. It was also broadcast by NBC in the US with an Americanised soundtrack by Simpsons regular Hank Azaria, but a second, UK-only series in 2000 marked its end. *Aaagh! It's the Mr. Hell Show!* (2001–02) roadtested the animated sketch show format, but felt old fashioned compared to the darkly distinctive *Monkey Dust* (2003–05), whose three series of pitch-black, surreal comedy recalled the work of Chris Morris. Its anthology structure enabled work to be shared across multiple production companies.

ITV commissioned three series of Aardman's *Creature Comforts* (2003–06), but made a riskier move in backing *2DTV* (2001–04), a computer-animated topical satire in the mould of *Spitting Image* (ITV, 1984–96). Launching barely a month after the September 11 attacks, the series pulled few punches despite the tempes-

[*] *The Simpsons* arrived on BBC2 in 1996.

Crapston Villas (Sarah Ann Kennedy, 1995–97) and *Bob's Birthday* (David Fine/Alison Snowdon, 1993)

tuous political times. President George W Bush was portrayed as a giggling fool whose advisors explain complex politics using sock puppets, while Osama Bin Laden appeared as one of the 'Talibannies', in the vein of the *Teletubbies* (BBC, 1997–2001). But while it could sometimes approach *The Simpsons*' satirical bite, *2DTV* lacked its universal appeal.

Ultimately, no British breakthrough into the popular field of adult animation is likely to come through imitating American cartoon imports. Instead, perhaps, the international success of highly distinctive – and very British – live-action series like *Black Mirror* (Channel 4, 2011–) and *Fleabag* (BBC, 2016–19) offer a better example for British animators willing to take risks and innovate.

Monkey Dust, (2003–05),

the Moving Picture Company producing increasingly complex title sequences, illustrated diagrams, simulations and interstitials. But it was the music video for Dire Straits' *Money for Nothing* (1985), which got heavy rotation on the nascent MTV, that introduced 3D computer animation to popular culture. Made by Ian Pearson and Gavin Blair at Rushes for director Steve Barron, it combined their Bosch Computer Graphics system with the British Quantel Paintbox software.[162] With the release of Pixar's *Toy Story* (1995) the public understanding of and expectations from computer animation changed. Considerable investment would be needed to make the British industry competitive, certainly in the sphere of feature-length CGI. And when they did arrive, they either looked a little bargain basement, like *Valiant* (2005), or were heavily dependent on an American infrastructure, like *Flushed Away* (2006).

In 1990, Ruth McCall was one of a trio of computer graphics artists who recognised that animation was 'an industry that cried out for automation'[163] and established Cambridge Animation Systems a stone's throw from Cambridge University. By the end of the decade, their digital ink and paint system Animo was used in more than 200 studios across the world, including the key animation markets of USA and Japan, by individual artists and giants like Dreamworks. Neville Astley and Mark Baker worked with another software firm to develop bespoke software to produce the animated television series *The Big Knights* (1999). It enabled animation to be made by smaller teams and at greater speed, and was released as CelAction 2D. Though *The Big Knights* didn't take off, the pair, teaming with producer Phil Davies, went on to create the world-conquering *Peppa Pig* (2004–).

Alongside Flash and Toon Boom, CelAction kept Britain's animation industry going through an austere period in the late 2000s and changed the structure of animation studios. With children's channels demanding series of up to 52 episodes, it helped animation to be produced at volume and speed. The series *2DTV* was able include a limited amount of highly topical satire animated almost up to the time of broadcast. Series like *Charlie and Lola* (CBeebies, 2005–08), based on Lauren Child's collage-style picture books, were cut-out animation in a digital age – harking back to *Mr Benn* in the 1970s, and Anson Dyer and Dudley Buxton in the 1910s. Grant Orchard's *Hey Duggee* (CBeebies, 2014–), based around simple shapes animated in Flash, is reminiscent of Victor Hicks' *A Geni and a Genius* (1919).

Peppa Pig (Astley Baker Davies, 2004–).

With the rapid improvement of graphics pen tablets, hand-drawn animation now rarely approaches paper. The removal of paint and physical acetate sheets from cel animation has enabled complex layering of multiple arts sources without any degradation of colour or quality. Perhaps unexpectedly, high-definition scanning and photography have made analogue textures ever more visible in a digital workflow, bring the look of pre-production concept art and the finished film ever closer together.

Following the example of Malcolm Le Grice, a number of experimental artists have used computer animation software to create extraordinary art. William Latham studied at Oxford University's Ruskin School of Drawing and the Royal College of Art. Such was the technical precision and complexity of his art and animation that only computers could realise his visions. He became a kind of artist-in-residence at IBM, where his interest in natural history led him to explore evolutionary art – works that use mutation to create artworks that are a dialogue between artist and machine. He also worked in computer games and collaborated with the rave band The Shamen, creating album art and stage visuals. He became Professor of Computing at Goldsmiths, and continues to explore evolutionary art in VR and other new media.

The arrival of the desktop PC and 'home computers' like the Atari ST and the Commodore Amiga put graphics and animation software within reach of colleges, schools and consumers for the first time. Ruth Lingford used Amiga's Deluxe Paint software to make *What She Wants* (1994), a sensational journey into fantasy and desire on the London Underground funded by the animate! scheme. Keith Piper used the same software for *Go West Young Man* (1996), collaging archive film, photographs and illustrations to explore stereotypes of race and gender.

The spread of the internet, broadband connectivity and Macromedia's Flash software[164] fuelled an explosion of animated web film. The B3ta community website became a popular forum for sharing short films from enterprising 'amateurs' – a Grasshopper Group for the digital age. Cyriak Harris studied animation at Surrey Institute of Art & Design [165], using traditional rostrum techniques on his graduation film *Robotic Mutation* (1998). In the mid-2000s

What She Wants (Ruth Lingford, 1994).

Go West Young Man (Keith Piper, 1996).

he began posting his experiments with Adobe After Effects on B3ta under the name Mutated Monty. As Cyriak, he now has more than two million YouTube subscribers, while the most popular shorts like *Cows & Cows & Cows* (2010), have notched up tens of millions of views.

Britain has become a world centre for computer graphics, from visual effects to computer games. London's Framestore created the images that put Sandra Bullock in space for *Gravity* (2013), and helped make a new generation fall in love with Paddington Bear in *Paddington* (2014) and *Paddington 2* (2017). The country is a major player in the global computer games industry, with over 2,000 active games companies across the UK.[166] Dundee was the unlikely birthplace of the *Grand Theft Auto* franchise, with its eventual owner, the New York-based Rockstar Games, operating a number of studios across Britain.

Just as Len Lye picked apart the three-strip Technicolor process to create extraordinary new works like *Trade Tattoo* (1937), so Cyriak and others have

Z (Alan Warburton, 2012).

subverted commercial graphics software in unexpected ways. While the commercial VFX industry strives to make the imaginary seem ever more real, independent artists have set up camp in the 'uncanny valley' – that instinctual human aversion to the *almost* human that software developers and robotics engineers work so hard to overcome. Alan Warburton's *Z* (2012), commissioned by Animate Projects, offers a phantom ride through a spectral, abandoned city rendered only through 'z-depth' monochrome shading. It was his first attempt to use cutting-edge software's own characteristics to pick at the cracks of the virtual worlds it can create. Warburton is just one of a loose network of artists sharply interrogating the aesthetics and ethical implications of photoreal CGI and its implications for the real world. Or, as his social media handle more pithily puts it, CGWTF.

11. BRITISH ANIMATION IN THE 21ST CENTURY

'It is the determined policy of this Government that we keep Wallace and Gromit exactly where they are!', proclaimed chancellor of the exchequer George Osborne in his annual budget statement on 21 March 2012.[167] Osborne was unveiling a new tax credit scheme to boost animation production in the UK, though the roars of delight from the government benches were probably less to do with the chancellor's generosity than his cheap gag at the expense of opposition leader Ed Miliband for his supposed resemblance to Nick Park's plasticine hero. But in a budget otherwise dominated by austerity measures and political grandstanding, it was rare good news for the British animation industry. For at least a year lobbyists had been warning that domestic production of animated TV series was declining so quickly that 'We have about two to three years before it is all gone.'[168]

British animation had seemed to enter the new millennium on a high. Aardman's five-feature deal with Hollywood big-guns Dreamworks got off to a dream start with the release of *Chicken Run* (2000), which remains Aardman's biggest box-office success and the highest-grossing stop-motion feature of all time.[169] But it was a tough act to follow. Next up was to be *Tortoise vs. Hare*, directed by Richard Starzak,[170] which would combine Aesop's fable with the mock-documentary style of *Creature Comforts*.[171] But production was abruptly put on hold in July 2001, with 90 of the 170-strong crew made redundant.[172] A proposed six-month freeze became a permanent halt, due to intractable story and character problems. It was a painful reminder

Chicken Run (Nick Park/Peter Lord, 2000).

that the step up from shorts to features didn't just mean more animation and higher budgets; it meant crafting stories and characters complex and engaging enough to capture audiences for 90 minutes or more.

In the event, Aardman's 'difficult second album' was Wallace & Gromit's feature debut, *The Curse of the Were-Rabbit,* directed by Nick Park and Steve Box and released in 2005. The film earned almost $200 million worldwide, won a bevy of awards including an Oscar, and beat a host of live-action nominees to take the Best British Film award at the BAFTAs. Only in Hollywood could such a performance be considered a disappointment, but it fell far short of Dreamworks' expectations. However it was Aardman's third feature that would break the partnership. In a decision that raised some eyebrows, *Flushed Away* (2006) used computer-generated imagery (CGI) rather than

stop motion.[173] This was seen as necessary given all the tricky water animation required for its story of a privileged but lonely pet rat who is flushed down the toilet into London's sewers. But these aesthetic concerns were soon outweighed by financial worries as the budget ballooned to $142.9 million – nearly five times the bill for *The Curse of the Were-Rabbit*. Though it made $178 million at the box office, Dreamworks was unhappy with its profit margins, and Aardman had resented the torrent of suggested script changes aimed at cracking middle America. Both parties were content to terminate the partnership early in 2007, and the BBC was happy too, since Nick Park was now free to make another half-hour Wallace & Gromit special, *A Matter of Loaf and Death* (2008) – at a fraction of a Hollywood budget.

Others in the UK would dream of making a $178 million 'failure'. In the early 2000s *Shrek* co-producer John H. Williams struck a deal with Disney to fund and distribute a series of CGI features made by his Vanguard company. The first, *Valiant*, told the story of a flock of passenger pigeons turned unlikely WWII heroes, and featured the voices of Ewan McGregor, Ricky Gervais and John Cleese. The film was to be made in Britain at a resurrected Ealing Studios and backed by the UK Film Council – all good pedigree. Vanguard's pitch was to make CGI features for under $40 million, in half the usual time, but the corner-cutting was all-too visible on-screen. Compared with *Flushed Away*'s bustling crowd scenes, *Valiant*'s backgrounds felt lifeless, particularly in recognisable locations like an almost empty Trafalgar Square. Sculpting CGI feathers on a budget proved a serious headache that had been little considered at the concept stage – there was a reason Pixar opted for smooth-surfaced toys to start its empire. The 'great white hope of the UK animation industry'[174] proved a great big flop.

Britain's rise as a centre for animated feature production rested on more traditional animation skills. Ian Mackinnon and Peter Saunders learned to craft increasingly sophisticated stop-motion puppets at Cosgrove-Hall, working on series like *The Wind in the Willows* (ITV, 1983–90). Their own company, Mackinnon & Saunders, came to the attention of Hollywood A-lister Tim Burton, who hired them to work on *Mars Attacks!* (1996). Burton ultimately decided to render the aliens in CGI, but his later stop-motion features, *The Corpse Bride* (2005) and *Frankenweenie* (2012), were both filmed at London's 3 Mills Studios – using Mackinnon & Saunders puppets. Wes

Anderson, too, used the Manchester firm – among other British talent – for his own stop-motion films *Fantastic Mr Fox* (2009) and *Isle of Dogs* (2018). Both were also made at 3 Mills, taking advantage of a tax break introduced in 2007 to lure in overseas feature productions.

Sylvain Chomet, French director of critical hit *Belleville Rendevous* (2003), arrived in Scotland in 2007 with an ambition to make it a new European home for 2D hand-drawn animation. He railed against the assumption that the success of Pixar had rendered more traditional forms of animation obsolete: 'Saying 2D is dead is like saying that a car race is the future of the Tour de France'.[175] He had come to make his second feature film, *The Illusionist* (2010), based on an unproduced Jacques Tati script about a stage magician travelling to increasingly distant locations to find an audience for his 'old-fashioned' act.[176] Chomet relocated the story from Czechoslovakia to Scotland after he visited the Edinburgh Film Festival in 2003 and fell in love with the Georgian terraces and the quality of the light. But as production wore on, Chomet grew frustrated at local bureaucracy and the difficulty of finding skilled animators.

Despite these challenges, an often beautiful film emerged and, although the hoped-for Scottish animation renaissance never materialised, *The Illusionist* helped build the skills for a revival of hand-drawn animation. It fed into features like *Ethel & Ernest* (2016), perhaps the last in a series of adaptations of Raymond Briggs' illustrated books begun with *The Snowman*. The project had been initiated a decade earlier by *Snowman* producer John Coates, and was continued after his death by co-producers Camilla Deakin and Ruth Fielding at Lupus Films. Roger Mainwood was the perfect choice as director, having worked on *The Snowman*, *When the Wind Blows* and many other TV specials. The film, which tells the story of Briggs' parents, married hand-drawn computer animation with scanned watercolour backgrounds and painted textures. Many scenes were mapped onto 3D CGI backgrounds to create depth and more complex moving elements.

Women are increasingly in the driving seat of UK animation. Lupus Films' high-quality adaptations – which also include *We're Going on a Bear Hunt* (Channel 4, 2016) – have made Deakin and Fielding major players, with an ambitious development slate of features. Locksmith Animation was founded in 2014 by *Arthur Christmas* (2010) director Sarah Smith and

The Illusionist (Sylvain Chomet, 2010).

long-term Aardman producer Julie Lockhart, staking its claim as 'the UK's first dedicated high-end CG feature animation studio' by partnering with VFX powerhouse Double Negative. In October 2019 Locksmith announced a multi-picture deal with Warner Bros.

Aardman, meanwhile, put its Dreamworks woes behind it. After two features with Sony Pictures, the CGI *Arthur Christmas* and the stop-motion *The Pirates! In an Adventure with Scientists!* (2012).[177] Aardman looked to Europe, with *Shaun the Sheep Movie* (d. Mark Burton/Richard Starzak, 2015)[178] and Nick Park's *Early Man* (2018) both backed by StudioCanal, the latter also receiving support from the BFI Film Fund. It was a healthy sign that production on a second Shaun the Sheep feature, *Farmageddon*, (2019) commenced immediately after completion of *Early Man*.

But even Shaun was outshone by the global phenomenon of *Peppa Pig* (2004–). Following the exploits of a four-year old pig and her family, the series served up episode after episode of gentle but acute observation, all delivered with understated charm and smart dialogue by an impeccable voice cast. Production company Astley Baker Davies made clever use of bespoke 2D animation software that made production at scale newly affordable. The

simple, almost childlike style felt refreshing and new, and the landscape and characters of the series built on Mark Baker's independent shorts *The Village* (1993) and *The Hill Farm* (1989). It was a hit with children and parents alike, but no-one could have anticipated the heights it would scale. Theme parks, stage productions, merchandising and a 180-territory market helped the Astley Baker Davies trio earn £140 million when they sold 70% of their company to eOne in 2015.

These success stories obscured the troubles besetting much of the rest of the industry. In 2011 Oli Hyatt, of London studio Blue Zoo, warned that the volume of UK-originated animation had collapsed from more than 80% to just 23% in five years.[179] *Bob the Builder* producer HOT Animation announced redundancies in 2007, then went into receivership after production on a new CGI series of the show moved to the US. The once mighty Cosgrove-Hall wound up operations in 2009, blaming 'increasing difficulties with financing children's programmes.'[180]

The decline had multiple causes. A 2007 ban on 'junk food' advertising around children's programmes led to a rapid reduction in slots for children's programming on mainstream channels. The arrival of dedicated children's channels (CBeebies and CBBC launched in 2002, followed by CITV in 2006, and subscription channels like Nickelodeon and The Disney Channel) meant that while more children's content was being broadcast it was reaching smaller and increasingly segregated audiences. Only the BBC's pre-school channel, CBeebies, was commissioning animated content from British companies at any scale, and even an ostensibly UK-originated series like *Octonauts* (2011–) was being animated in Ireland to benefit from tax breaks and other financial incentives. A lack of work sent existing talent overseas, and new graduates found fewer opportunities to gain early experience, leading to a skills shortage when projects did come around. The global recession that followed the 2008 financial crisis only rubbed salt in the wounds.

It was time for action. Animation UK, a new industry lobbying body set up by Oli Hyatt and others, commissioned a 64-page report, 'Securing the future of UK animation'.[181] It outlined the industry's economic and cultural contribution to the nation, and its handicap when competing with state-supported international rivals. The key demand was a tax break similar to the one given to feature films (which offered a 16–20% rebate on UK qualifying expendi-

ture),[182] and the report predicted a bleak future for the industry without it. But it was the alarming suggestion that the nation's animated favourites might be lost overseas that finally seemed to draw a response. A November 2011 headline in *The Times*, warning that 'Wallace & Gromit may emigrate over tax breaks,' was followed just four months later by George Osborne's surprise tax concession. Advertising and music videos were exempt, but any other production that qualified as sufficiently 'British' and passed a cultural test would recoup a quarter of its qualifying budget.

The impact was dramatic: spending on animation production doubled, from an estimated £46 million in 2011 to £97.1 million in 2016 (with a £4.44 return to the taxpayer for every £1 given in relief).[183] More compelling evidence came with the success of new all-UK produced series like Karrot Animation's *Sarah & Duck* (2013–17) and Studio AKA's *Hey Duggee*. Also UK-made was *The Clangers* (2015–), which returned in a new stop-motion series that retains the style and charm of the original. The CBeebies-developed *Go Jetters* (2015–), initially produced at Boulder Media in Ireland, was handed to Blue Zoo in London for its second series.

For independent short film producers, however, Osborne's offer felt empty: what use is tax relief on a miniscule budget? Animation Alliance, founded in 2011 as a voice for individual artists, painted a grim picture of the state of the creative animation sector, citing the closure of the animation units in BBC Bristol and S4C and of the Animator-in-Residence scheme and the slashing of broadcast budgets. In 1998, 36 UK animated films were in competition at Annecy's International Film Festival. By 2011 there were just three.[184] The Government's austerity mania had slashed grant-in-aid and tightened the purses of public bodies like the Arts Council. The UK Film Council was axed in 2011, with its funding role handed to the BFI. 'Independent animation,' complained Animation Alliance, 'seems to languish in a chasm between the responsibilities and remit of Arts Council England and UK Film Council/BFI.'[185] The few available funding schemes targeted new and emerging artists, offering profile and a platform instead of profit and a career, and no next step to move onto. Established animators were forced to look overseas for funds, go into teaching or change careers. *Plume* (2010), Barry Purves' first independent short since 1998's *Gilbert & Sullivan – The Very Models*, was funded and produced in France; his follow-up, *Tchaikovsky –*

an Elegy (2011) was funded from Russia. The only work on offer to him in the UK was children's television, such as *Toby's Travelling Circus* (2013).

In 2011, all three films nominated for Best Short Animation at the BAFTAs were made by students – as were 12 of the 21 nominated films from 2012 to 2018. While a testament to the quality of Britain's animation courses – notably at the Royal College of Art, the National Film and Television School and the Edinburgh College of Art – it also highlighted the lack of professional competition. Few studios felt able to invest in in-house projects, and emerging animators found it easier to find a scholarship to go to art or film school and make an animated short there than to secure funding to make one independently.

Yet much of the work coming out of postgraduate animation courses was well worth the prizes. Suzie Templeton's RCA graduation film, *Dog* (2001), told a staggeringly poignant tale of grief through stop motion, and was followed by an Oscar-winning adaptation of *Peter and the Wolf* (2006). Ian Gouldstone's hyper-intelligent *Guy 101* (2006) used the device of an internet chatroom to tell a provocative story about a violent gay encounter. A new generation of graduates from courses in Glasgow and Edinburgh, including Ross Hogg, Cat Bruce, Will Anderson and Ainslie Henderson, has made Scotland one of the most exciting centres for original creative work. And despite the challenging environment, two of the 2011 BAFTA 'all-student' nominees have gone on to set up successful commercial animation studios: Mikey Please at Parabella, and Dave Prosser at Moth Animation.

The Animate scheme (renamed Animate Projects in 2007 after the death of Dick Arnall), remained a shining example of creativity and enlightened support. Chris Shepherd's *Dad's Dead* (2002) mixed live-action and animation in a story that walked a tightrope between pitch black comedy and real horror. Run Wrake's *Rabbit* (2005) used imagery from a set of 1950s children's spelling flashcards in a strikingly original, twisted fairy tale about a girl, a boy, a magical idol, countless jars of jam, some precious jewels and a knife. Despite waning support from Arts Council England and Channel 4, under the enterprising direction of Gary Thomas and Abigail Addison the scheme has continued to work on commissions and exhibitions 'at the intersection of animation, film and art'. One particularly striking initiative was the *Silent Signal* project, started in 2013, which paired six artists with biomedical scientists to explore

Johnno's Dead (Chris Shepherd, 2016).

new ways of thinking about the human body. Sam Moore's remarkable *Loop* (2017), produced in partnership with Dr Serge Mostowy, brought scientists' conflicting visualisations of 'the complex and secret world of septin cytoskeleton dynamics'[186] to life, with both educational and artistic rewards.

Overall, the animation industry has become a more inclusive and diverse workplace than many other sectors of the screen industry, but a 2019 survey initiated by the UK Screen Alliance identified a number of 'priorities for action'.[187] Women represent 51% of animation workers, yet are still less likely to be in senior management roles. 14% of those employed in animation were from BAME backgrounds – in line with the proportion of working-age people of colour in England and Wales as a whole, but well below the figure for London and the South East, where 78% of jobs are based. Few people of colour were in key creative or senior management roles. More positively, 21.5% of those working in the industry identified as LGBT+, with a general feeling of a supportive environment across the industry. The report expressed hope that 'a new wave of diverse, inspired, emerging talent will sweep through our industry', something that is also important in representation on-screen.

In August 2019, after a long consultation involving Animation UK and Animation Alliance, the BFI announced a new funding scheme for short

Cartoon (2002), an NSPCC advert.

animation, specifically targeted at experienced animators, offering budgets comparable to Channel 4's in the 1990s. But while such developments can certainly make the immediate future of animation in Britain a little brighter, they can't alone guarantee its longterm survival. If this history teaches us anything it is that the industry can only hope to thrive with a constant flow of commissioned work, in the form of commercials, sponsored films, educational shorts and music videos.

And as we've seen, enlightened sponsorship can be the lifeblood of creativity. From his unpromising origins in an advert for a price-comparison website, aristocratic Russian meerkat Aleksandr Orlov has become one of Britain's most popular and recognisable cartoon characters. What began as a rather stretched pun to promote comparethemarket.com with the slogan 'compare the meerkat' has snowballed into a pop-culture phenomenon, forcing rival companies to up their ad spend to compete.[188] Since 2009, the CGI campaign has been directed by *Angry Kid* creator Darren Walsh at Passion Pictures, one of Britain's leading commercial animation houses since 1987. Passion was founded by Andrew Ruhemann, a one-time trainee producer at Richard Williams Animation who worked on *Who Framed Roger Rabbit*. This

lineage is evident in successful campaigns such as the hardhitting anti-child abuse NSPCC advert *Cartoon* (2002), which evoked *Roger Rabbit* by inserting cartoon violence into a live-action domestic setting. Passion has also been behind the cartoon band Gorillaz, born in the late 1990s as a collaboration between musician Damon Albarn and illustrator Jamie Hewlett. Adapting with the times, the band have been rendered through 2D flash animation, CGI and holographic projections at live stage shows, and in a 360° interactive music video, *Saturnz Barz (Spirit House)* (2017), developed in partnership with Google's *Spotlight Stories* initiative.

Aardman has continued to take on sponsored work, creating the world's smallest stop-motion character animation for *Dot* (2010), filmed using the Nokia mobile phone it was selling. It used 3D printing techniques to create a series of 'puppets' in different poses, which were painted by hand and filmed with replacement animation – a microscopic version of George Pal's 1930s techniques. The studio went to the opposite extreme for *Gulp* (2011), filmed on the same phone but suspended 36 metres above a South Wales beach. Maintaining the tradition of animated public information films, Aardman produced a series of claymation shorts for Public Health England's Change4Life campaign – including several short 'couch gags' screened before *The Simpsons* on Channel 4 from 2009. Though the COI was closed at the end of 2011, animation remains a staple of government, charity and political appeals.

The dream of a modern commercial campaign is to 'go viral', with ads enthusiastically distributed through social media by the target audience. But the growth of online video has offered mixed fortunes for British animation. Simon Tofield was a freelance animator at Daniel Greaves' Tandem studio when he made a short film, *Cat-man-do*, while teaching himself to animate on a computer. Since he uploaded it to YouTube in March 2008, it has been viewed over 60 million times. *Simon's Cat* has become a mini-industry, with over 100 episodes and various spin-offs, plus books and merchandising tie-ins. But while a lucky few animators can attract crowdsourced funding or transactional fees, animation fans who once shelled out for VHS and DVD collections have been reluctant to pay for online viewing. Subscription services like Netflix and Amazon Prime have encouraged binge-watching of cartoon series, but independent short films get lost in the mix. Prizewinning

shorts feted at animation festivals around the world are typically posted online for free, with minimal fanfare, after a two-year tour window.

A handful of 'net-native' UK animators have become genuine online superstars. The films of Cyriak and Lee Hardcastle reach audiences of millions worldwide, far exceeding the cultural impact of the latest animation award-winner. Some independent filmmakers have been able to monetise their uploads through pop-up advertising, although it is rare for financial returns to break into the hundreds, let alone thousands. Typically, an online platform serves best as a shop window, a route to time-honoured commissioned work.

The advertising, educational and other commissioned filmmaking that have sustained animators since the 1920s remain crucial. Our lives are increasingly saturated by moving images – not just on screens and smartphones, but also on signs and billboards in public spaces. With ever more 'content providers' competing for dwindling attention spans, animation's long-proven ability to compress complex messaging into bite-size visual nuggets is back in favour. Excellent work deserves to be celebrated wherever it appears.

Simon's Cat (Simon Tofield, 2008).

MOO! (Cyriak, 2007).

The internet, together with archives' mass digitisation initiatives and new academic interest in the form, have made the past and present of British animation more accessible than ever. But what of its future? In the form of CGI and VFX, animation has colonised mainstream film and television as never before, building the landscapes and settings of stories, and increasingly augmenting and even replacing the actors who populate them. Augmented and virtual realities – powered by animation – promise to transform our relationship with the world.

Though he would scarcely recognise today's industry, Anson Dyer's 'tough proposition' still holds true: the industry remains under the shadow of US animation, and the astonishing breadth and variety of animation art in Britain are still underappreciated. The rise-and-fall cycles of British animation make for an eventful history, but also, probably, offer the clearest guide to its future. Though times are often hard, animation is perfectly equipped to imagine its way out of the stickiest situations. From even the slimmest means, it can conjure up the most fantastical worlds and give visual expression to hidden truths. Over more than a century, British animation has shown its mettle. Starve it and it will adapt to survive. Give it a chance and it will flourish.

RECOMMENDED READING

ANIMATION HISTORY

Paul Brown, Charlie Gere, Nicholas Lambert and Catherine Mason (eds), *White Heat Cold Logic: British Computer Art 1960–1980* (London: Birkbeck College, 2008).

Elaine Burrows, 'Live Action: A Brief History of British Animation' in Barr, Charles, *All Our Yesterdays: Ninety Years of British Cinema* (London: BFI, 1986).

Malcolm Cook, *Early British Animation: From Page and Stage to Cinema Screens* (Basingstoke: Palgrave Macmillan, 2018).

Malcolm Cook and Kirsten Moana Thompson (eds), *Animation and Advertising* (Basingstoke: Palgrave Macmillan, 2020).

Clare Kitson, *British Animation: The Channel 4 Factor* (London: Parliament Hill Publishing, 2008).

Rachel Moseley, *Hand-Made Television: Stop-Frame Animation for Children in Britain, 1961–1974* (Basingstoke: Palgrave Macmillan, 2016).

Jayne Pilling, *Women and Animation* (London: BFI, 1992).

Van Norris, *British Television Animation 1997–2010: Drawing Comic Tradition* (Basingstoke: Palgrave Macmillan, 2014).

ANIMATORS AND ANIMATION STUDIOS

Suzanne Buchan, *The Quay Brothers: Into a Metaphysical Playroom* (Minneapolis: University of Minnesota Press, 2011).

Nicola Dobson, *Norman McLaren: Between the Frames* (London: Bloomsbury Academic, 2019).

Vivien Halas, and Paul Wells, *Halas and Batchelor Cartoons: An Animated History* (London: Southbank Publishing, 2006).

Annabelle Honess Roe, *Aardman Animations: Beyond Stop-Motion* (London: Bloomsbury, 2020).
Peter Lord and Dave Sproxton, *Aardman: An Epic Journey: Taken One Frame at a Time* (London: Simon and Schuster, 2018).
Roger Horrocks, *Len Lye: A Biography* (Auckland: Auckland University Press, 2002).
Oliver Postgate, *Seeing Things* (London: Sidgwick & Jackson, 2000).

ANIMATION PRACTICE

Bob Godfrey and Anna Jackson, *The Do-it-Yourself Film Animation Book* (London: BBC Publications, 1974).
Barry Purves, *Stop Motion: Passion, Process and Performance* (London: Routledge, 2008).
Andrew Selby, *Animation in Process* (London: Laurence King Publishing, 2009).
Paul Wells, Les Mills and Joanna Quinn, *Basics Animation: Drawing for Animation* (Lausanne: AVA Publishing, 2008).
Richard Williams, *The Animator's Survival Kit* (London: Faber, 2001).

USEFUL WEBSITES

Cartoon Brew (www.cartoonbrew.com/): one of the best animation websites worldwide, it features good coverage of British animation stories thanks to London-based associate editor Alex Dudok de Wit.
A History of British Animation (http://s200354603.websitehome.co.uk/main/BAHpreface.htm): Peter Hale's labour of love benefits from his assiduous research into obscure corners of British animation history.
Skwigly (www.skwigly.co.uk/): a touchstone of the British animation community through its website, podcasts and screenings.
Toonhound (www.toonhound.com/): great reference for lots of British animated series and shorts, as well as comics.

A BRITISH ANIMATION PLAYLIST

Some 300 British animated films, including many listed here or referenced elsewhere in this book, are available to view for free (UK only) in BFI Player's *Animated Britain* collection (player.bfi.org.uk/free/collection/animated-britain), curated by the author; a number are also on the BFI's YouTube channel (youtube.com/BFIfilms). Many more are on DVD/Blu-ray. Others can be found online, though not necessarily legitimately.

(Key: * BFI Player; † DVD/Blu-ray)

Dreams of Toyland (Arthur Melbourne Cooper, 1908) *
Ever Been Had? (Dudley Buxton, 1917) *
The U-Tube (Lancelot Speed, 1917)
Oh'phelia A Cartoon Burlesque (Anson Dyer, 1919) *
A Geni and A Genius (series) (Victor Hicks, 1919)
Bonzo No. 5 (WA Ward, 1925)
Tusalava (Len Lye, 1929)
Tropical Breezes (Sid Griffiths and Brian White, 1930) *
A Colour Box (Len Lye, 1935) * †
Fox Hunt (Anthony Gross and Hector Hoppin, 1936)
The H.P.O. (Lotte Reiniger, 1938) †
Love on the Wing (Norman McLaren, 1939) *†
Dustbin Parade (John Halas and Joy Batchelor, 1942)
The Magic Canvas (John Halas, 1948) †
River of Steel (Peter Sachs, 1951) †
Animal Farm (John Halas and Joy Batchelor, 1954) †

Calypso (Margaret Tait, 1955)
The Little Island (Richard Williams, 1958)
The Do-it-Yourself Cartoon Kit (Biographic, 1961)
Automania 2000 (John Halas, 1963) †
Yellow Submarine (George Dunning, 1968) †
Kama Sutra Rides Again (Bob Godfrey, 1972)
Damon the Mower (George Dunning, 1972) *
Green Men, Yellow Woman (Thalma Goldman, 1973) *
Great (Bob Godfrey, 1975)
Animation for Live Action (Vera Neubauer, 1976)
Ubu (Geoff Dunbar, 1978)
Watership Down (Martin Rosen, 1978) †
Autobahn (John Halas, 1979) †
The Snowman (Dianne Jackson, 1982) †
Street of Crocodiles (Brothers Quay 1986) †
The Black Dog (Alison De Vere, 1987)
Girls Night Out (Joanna Quinn, 1987)
Cowboys (Phil Mulloy, 1991) †
Screen Play (Barry Purves, 1992)
The Kings of Siam (Ged Haney, 1992)
Bob's Birthday (Alison Snowden and David Fine, 1993)
The Wrong Trousers (Nick Park, 1993) †
The Village (Mark Baker, 1993)
The Secret Adventures of Tom Thumb (Dave Borthwick, 1993)
What She Wants (Ruth Lingford, 1994)
Go West Young Man (Keith Piper, 1996)
The Queen's Monastery (Emma Calder, 1998)
Father and Daughter (Michael Dudok De Wit, 2000)
The Man with the Beautiful Eyes (Jonathan Hodgson, 2000)
Dad's Dead (Chris Shepherd, 2002)
Rabbit (Run Wrake, 2005)
cows & cows & cows (Cyriak Harris, 2010)
Bobby Yeah (Robert Morgan, 2011)
The Flounder (Elizabeth Hobbs, 2019)

NOTES

1. Robert Murphy (ed.), *The British Cinema Book* (3rd edn) (London, BFI/Palgrave, 2009).
2. Anson Dyer, 'Better and Better Every Day', *The Journal of the Association of Cine-Technicians*, 1–2 (Dec 1936–Jan 1937), pp. 81–2.
3. Particularly notable are Malcolm Cook (2018), Early British Animation: From Page and Stage to Cinema Screens, London, Palgrave; and Clare Kitson (2008), *British Animation: The Channel 4 Factor* (London, Parliament Hill Publishing).
4. See Vivian Halas and Paul Wells (2007), *Halas and Batchelor Cartoons: An Animated History*, London, Southbank Publishing; and Peter Lord and David Sproxton (2018), *Aardman: An Epic Journey: Taken One Frame at a Time* (New York, Simon & Schuster).
5. Honourable mention should be given here to Ken Clark, a keen amateur animator and constant member of the Grasshopper Group who spent many years researching and writing for a history of British animation, meeting and corresponding with many of the key players. Sadly, Clark never found a publisher, but his work deserves wider recognition.
6. Rachel Moseley (2015), *Hand-Made Television: Stop Frame Animation for Children in Britain, 1961–1974* (London, Palgrave Macmillan). A title that marks a valuable step in this direction.
7. *Artistic Creation* (1901) also makes use of double exposure: rewinding the film after a first scene is recorded, and then filming again to overlay a second image on the first.
8. This describes most, but by no means all animation; a single definition that encompasses direct animation, pixilation, computer animation and VFX is more elusive.
9. The Imperial War Museum collected film from its foundation in 1917, but its remit was focused on conflict and the armed forces; the British Film Institute's National

Film Library (later the National Film Archive; now the BFI National Archive) followed in 1935.

10. For background on early film and its survival see Paolo Cherchi Usai (2010), *Silent Cinema: An Introduction* (London, BFI Publishing).
11. Emile Reynaud's *Théâtre Optique*, patented in 1888, arguably gave us the first animated films, but the images were hand-drawn directly onto film strips, bypassing any photographic process.
12. The dating of this film is just one controversy surrounding Arthur Melbourne-Cooper and his place in British film history. His family and some historians have claimed he was the man behind a number of pioneering British films such as *Grandma's Reading Glass* (1900), which have been otherwise credited to George Albert Smith. For a convincing summary and dismissal of the claim see Stephen Bottomore, 'Smith Versus Melbourne-Cooper: An End to the Dispute', *Film History*, No. 14, 2002, pp. 57–73 .
13. Dennis Gifford [ed.], *British Film Catalogue: Volume 1: Fiction Film, 1895–1994*
14. 'Paul Film Catalogue 1906', in Dennis Gifford (1988), *British Animated Films, 1895–1985: A Filmography* (London, McFarland), p. 8.
15. The Charles Urban Trading Co. advertisement, *The Era*, 14 December 1907, 37
16. Marie Seton (1937), 'The British Cinema 1907–1914', *Sight and Sound*, Vol. 6, No. 22, Summer, p. 67.
17. *The Bioscope*, 18 December 1913.
18. A profile of the largely forgotten Rogers gives further details about the film, describing three-inch high dolls living in a city 'built of playing cards, chessmen, dice and dominoes' and a forest improvised from sticks of rhubarb. Alberto Cavalcanti, 'A Pioneer', *Sight and Sound*, Vol. 7, No. 26, Summer 1938: p. 56.
19. Advertisement in Pathé's *Cinema Journal*, 22 November 1913.
20. 'The Neptune Film Company's First Trade Show', *The Bioscope*, 8 October 1914, pp. 150–51.
21. *The Bioscope*, 28 January 1915.
22. *The Bioscope*, 18 March 1915.
23. *The Times*, 18 October 1924, p. 4.
24. Supplement to *The Kinematograph and Lantern Weekly*, 6 March 1919, p. xv.
25. Buxton's relative obscurity is indicated by the fact that they get his name wrong in the advert, billing him as Dudley Hardy.
26. *The Kinematograph and Lantern Weekly*, 13 March 1919, p. 79.

27. *Moving Picture World*, 24 May 1919, p. 1225.
28. Cinemagazines were weekly, light-hearted newsreels that were a staple of the cinema programme.
29. 'The Film World', *The Times*, 25 August 1919, p. 8.
30. Dyer's lost 1927 production *The Story of The Flag* is sometimes misleadingly cited as Britain's first animated feature film, but it was in fact a series of six short films that proved more suitable for educational than theatrical use.
31. Ken Clark, unpublished manuscript.
32. Victor Hicks, 'How a Christmas screen cartoon is made', *Picture Plays*, 20 December 1919, p. 8. Hicks continued to produce innovative poster designs into the 1940s, including a series for the Ministry of Labour that are well worth seeking out online.
33. 'Daily Mirror Pets' Record Film', *Daily Mirror*, 24 November 1920, 2.
34. Joe Noble, 'Early Animation: Part One: The Years of Sammy and Sausage', *Film and Television Technician*, March 1968, 14.
35. Tom Titt was the pseudonym of Polish-born Jan Junosza de Rosciszewski, who became well-known for his theatrical cartoons for *The Tatler* magazine.
36. *The Sphere*, 5 January 1929, p. 11.
37. Even Disney couldn't claim to be the first, with a number of animators experimenting with adding tunes to cartoons even before Mickey's debut.
38. Eisenstein himself was present for the programme, at the Strand's Tivoli Palace on 10 November 1929, which was completed by Jean Epstein's *The Fall of the House of Usher* (France, 1928).
39. Patent No. 321436, 9 July 1928.
40. https://worldwide.espacenet.com/publicationDetails/biblio?II=0&ND=3&adjacent=true&locale=en_EP&FT=D&date=19291111&CC=GB&NR=321436A&KC=A# (accessed: 28 November 2019)
41. 'Short Stuff', *Kinematograph Weekly*, 22 January 1931, p. 59 .
42. A copy of *Bingo the Battling Bruiser* (1930) also exists with German intertitles, indicating that it had some export success.
43. Distributors were able to subvert the quota with cheap, rapidly made British films – the notorious 'quota quickies' – intended only to pad out the cinema programme.
44. Denis Gifford, *British Animated Films, 1895–1985: A Filmography* (London: McFarland, 1988).
45. Rachael Low, *The History of the British Film 1918–1929* (London: Allen & Unwin, 1948), p. 102.

46. Harry Bruce Woolfe, *Sight and Sound*, 4, No.16, (Winter 1935–36): pp. 166–69.
47. John Russell Taylor (ed.) (1980), *The Pleasure Dome: Graham Greene: The Collected Film Criticism 1935–40* (Oxford: Oxford University Press,), p. 115
48. '*Fox Hunt*: A New Kind of Cartoon at the Curzon Cinema', *The Bystander*, October 28 1936, p. 163
49. Joy Batchelor BECTU History Project – Interview No. 294, transcript at https://historyproject.org.uk/sites/default/files/Joy%20Batchelor.pdf, accessed 20 March 2020
50. For example 'Disney Rival', *The Era*, 11 September 1935, p. 3; Michael Orme, 'The World of the Kinema: British Colour Cartoons', *Illustrated London News*, 21 September 1935, p. 480.
51. Myller had worked with Griffiths at Super-Ads in the early 1930s and after a spell back in Copenhagen had returned to London with his young protégé, Mikkelson, working on *Giro Fast and Loose* (1935) and other films at British Utility Films before joining Anglia Films.
52. It was adapted to a three-colour system in 1937
53. *World Film News*, No. 1, April 1936, p. 5
54. *Ibid*.
55. Robert Del Tredici, 'Len Lye Interview', *The Cinema News* (San Francisco), No. 2–4, 1979, p. 36.
56. Len Lye, 'The Tusalava Model or How I Learnt the Genetic Language of Art', March 1972, unpublished manuscript.
57. Roger Horrocks puts the artist in 'a part-time job in a London studio, Hopkins and Weir, that produced cartoon commercials for beer and toothpaste'. This would be Albert Hopkins and Reginald Wyer, joint managing directors of Publicity Pictures. It's unclear whether 'filler in' should be read as animating 'in-betweens' or painting cels. Roger Horrocks, *Len Lye: A Biography* (Auckland: Auckland University Press, 2002), p. 91.
58. A group of fine artists formed in 1919. As its membership evolved during the 1920s, the Society pulled away from more traditional arts and increasingly came to represent the cutting edge of abstract art in Britain, counting Ben Nicholson, Henry Moore and Barbara Hepworth among its leading figures. Lye was a member during the mid-point of this transition.
59. *Film and Television Technician*, March 1968, p. 16.
60. CG/3/1/1/51, Carl Giles Trust Collection, British Cartoon Archive. 'Early' general

correspondence: sundries (P)' including "Laurie Price, a former work colleague at Super Ads" Other names referenced in the correspondence are Charles Stobbart, Jorgen Myller and Chris Millet.

61. *World Film News*, Vol. 1 No. 3 August 1936, p. 47.
62. Instead of using articulated puppets, Pal's studio constructed series of figures with changeable heads and limbs in different cycles of motion so that they could be swapped frame by frame. The technique brought some of the plasticity of cel animation to stop motion, and has seen a resurgence in the 21st century, often in conjunction with 3D printing.
63. There are no credits on the film, but many of the characters are similar to contemporary drawings by Brian White.
64. *Daily Express*, 7 May 1925, p. 1.
65. *World Film News*, No. 1, April 1936, p. 5.
66. Reiniger was no stranger to advertising work, having made shorts for Julius Pinschewer's Berlin ad studio, including *Das Geheimnis der Marquise* (c. 1921) for Nivea
67. Prints of Reiniger's films had frequently been embellished with tints and tones in processing, but *Heavenly Post Office* (1938) was filmed directly through the distinctive réseau of Dufaycolor
68. Roger Horrocks suggests a total production cost of £400. Horrocks (2002), *Len Lye: A Biography*, p. 407 n.18
69. Norman McLaren, quoted in Maureen Furniss, *Art in Motion: Animation Aesthetics, Revised Edition* (Eastleigh: John Libbey Publishing, 2007), p. 8.
70. The film was reportedly frowned upon by the Postmaster General as overly symbolic and withheld from wide distribution. But it was reviewed in the Documentary Newsletter in February 1940, and shown at film societies – the changed circumstances of the war had likely rendered its sales message a little out of date.
71. At least four more episodes followed in a similar vein, the last released on 9 November 1939.
72. Lawrence Wright was an architectural draftsman who taught himself to animate in the 1930s by making films about his other hobby of gliding, as well as *The Life and Career of Archie Teck* (1935) on the amateur 9.5mm film gauge. He occasionally adopted the pseudonym Lance White for his film work and made one further professional film, *The Mail Goes Through* (1947), before leaving animation behind.
73. The prodigiously talented Mackendrick began his career at JWT, producing

scripts and storyboards for a range of advertisements. You can find echoes of his cartoon sensibility in his Ealing comedies, especially *The Man in the White Suit* (1951) and *The Ladykillers* (1955), and his personal working scripts are littered with storyboard sketches.

74. When the company was newly incorporated in 1944 it switched to the friendlier and descriptive name of Halas & Batchelor Cartoon Films.
75. Or re-established, since the Ministry of Information had a brief life in the First World War.
76. Len Lye made *Musical Poster No. 1* (1940) to spread the 'careless talk costs lives' message, but it was made before the Five-Minute Film scheme. In a response to Information Minister Duff Cooper in their September 1940 issue, the editors of *Documentary Newsletter* claimed that it was commissioned by the British Council. In any case it was something of a one-off.
77. The 'International System of Typographic Picture Education' was developed by Austrian Otto Neurath.
78. *Documentary Newsletter*, November 1941, p. 207.
79. https://historyproject.org.uk/interview/joy-batchelor (accessed: 28 November 2019). A likely complication was John's status as an 'enemy alien'. On marrying him in 1940, Joy surrendered her own British citizenship, regaining it only after the war.
80. Sadly, after this handful of wartime shorts Peter Strausfeld appeared to lose interest in animation. But after George Hoellering took over London's Academy Cinema Strausfeld's iconic film posters would decorate the capital's street from 1947 until his death in 1980.
81. Initially a private home, the building had been used as a school since the 1870s.
82. Given their importance for official messaging, Halas & Batchelor Films were also evacuated from London, but only as far as Bushey, about 20 minutes north of the city. As the Blitz died down they returned to London, now in leafy Soho Square at the heart of the film industry.
83. Murphy – later Kathleen Houston, but usually known as Spud – can be seen in the animation room in *You're Telling Me*.
84. The Central Office of Information replaced the wartime Ministry of Information in 1946.
85. Many branded goods were replaced with consolidated goods in generic packaging during the Second World War..
86. The projection appears in an undated confidential report, 'Setting Up Report for C.O.I', HAB-4–2-7, Halas and Batchelor Collection, BFI National Archive.

87. Halas is credited with direction, colour and design, though he brought in fellow Hungarian Peter Foldes to work on backgrounds. Vera Linnecar remembered that the camera department had problems with Foldes' unconventional work: some had textured reliefs, so the cels wouldn't lie flat on them. Though inexperienced at this stage, Foldes would go on to be a key, if peripatetic figure of world animation in his own right (Vera Linnecar interviewed by author, 25 January 2012).
88. *The Cine-Technician*, March-April 1953, p. 38.
89. The company was variously credited as WM Larkins & Co, the WM Larkins Studio, and the Larkins Studio. In the industry it was usually just 'Larkins'.
90. *Imagery*, 4, No.1 (Summer 1952), p. 16.
91. 'If any single company can be said to have dominated production of sponsored film in the post-war era, then it is the many-headed hydra that was the Film Producers Guild ...': Patrick Russell and James Piers Taylor [eds.] (2010), *Shadows of Progress: Documentary Film in Post-war Britain* (London: British Film Institute/Palgrave Macmillan), p. 42.
92. J. Arthur Rank, quoted in Terry Staples, *All Pals Together: The Story of Children's Cinema* (Edinburgh: Edinburgh University Press, 1997), p. 91.
93. The expanding Rank company swallowed its rival Gaumont-British in 1941.
94. The buildings had housed Odeon office staff during the worse of the Blitz
95. Recruitment particularly prioritised returning servicemen and women..
96. David Hand's lectures were transcribed, and copies circulated around the wider British animation industry as an unofficial handbook. Harold Whitaker was particularly pleased to get his hands on a copy in the 1950s, and I was equally delighted when he passed a copy of it to me over half a century later.
97. Gaumont-British Animation had previously produced some cinema commercials, and an entry in the Rank cinema clubs' Let's Sing Together series (1947–48).
98. 'More Cartoons to Come: UK Series', *Sunderland Daily Echo and Shipping Gazette*, 31 October 1949, p. 8.
99. Geoffrey McNab, *J. Arthur Rank and the British Film Industry*, (New York: Routledge, Chapman & Hall. 1993), p. 185.
100. Figure taken from Rank's 1949 AGM statement (McNab, 1993, p. 187).
101. 'The Big City', *Fifeshire Advertiser*, 15 November 1947, p. 8.
102. Originally Animated Productions Ltd; the 'British' was added in 1947.
103. Letter from Capital and Provincial News Theatre Ltd to Pathé Pictures Ltd, 12 May 1949, British Animated Pictures Collection, Vestry House Museum.

104. Daniel Leab, *Orwell Subverted: The CIA and the Filming of Animal Farm* (Pennsylvania State University Press, 2007), is the source of this and other details of *Animal Farm*'s genesis included here.
105. The Larkins Studio had made *Without Fear* (1953) for the Economic Cooperation Administration, but the extended character animation and consistency of style required for an animated feature had never been the studio's forte, and it seems unlikely its Film Producers' Guild overseers would have been interested.
106. *West London Observer*, 24 April 1953, p. 4.
107. Also known as *Make Believe*, directed by Eric Owen, who had worked on aircraft recognition films with Sid Griffiths at Analysis Films.
108. Anson Dyer, private correspondence with author, 22 October 2010.
109. London was home to Europe's only Technicolor laboratory, and getting exposed film through customs meant impossible delays. So in May 1948, two Italian technicians arrived in Stroud with a camera and 39 cases of artwork to shoot *La Rosa Di Baghdad* (Italy, 1949). Parts of the troubled French feature *La Bergère et le Ramoneur* (first released in unfinished form as *The Shepherdess and the Chimney Sweep*, 1952), were also filmed at Stroud.
110. John Halas saw off a rival approach from French producer André Sarrut, who was looking to expand into the UK.
111. *The Times*, 31 December 1954, p. 8.
112. The last was suggested by Louis De Rochement, who nixed the other ideas.
113. 'Britain is now one of the largest centres of animation', *Audio-Visual Selling*, 3 June 1960, p. 2.
114. Larkins returned to sponsored filmmaking, surviving into the 1980s under the direction of Beryl Stevens, who increasingly took on live-action work.
115. 'Biograph cartoons are commercial success', *Commercial Television News*, 26 October 1956, p. 3.
116. Vera Linnecar, interview with author, 25 January 2012.
117. The equivalent of over £4 million in 2018.
118. David Davis, 'Cartoon Move For Tyne Tees', *The Times*, 25 October 1968, p. 25.
119. In 1960 John and Joy started a second company, Educational Film Centre, to produce films for the classroom, including hundreds of silent animated loops, distributed on 8mm film cassette. Leslie Oliver, consultant's report, 1966–67, HAB-4-2-9, Halas and Batchelor Collection, BFI National Archive.
120. L'Association Internationale du Film d'Animation, founded in 1960.

121. Adam Abraham, *When Magoo Flew: the Rise and Fall of Animation Studio* UPA (Middletown, CT: Wesleyan University Press, 2012), p. 206.
122. Or so the popular version of the story goes. Feel free to delve into the conflicting oral histories included in Robert R. Hieronimus's *Inside the Yellow Submarine* (2002) to try and get to the bottom of this one.
123. John and Paul were shorn of their Liverpudlian accents to make them more intelligible to American audiences.
124. Bob Godfrey Interview, 10 September 1990, BECTU History Project, BFI National Archive.
125. Gordon Murray's Trumptonshire trilogy had been cannily filmed in colour from the start, so remained in regular rotation into the mid-1980s. Gerry and Sylvia Anderson's 'Supermarionation' series had been filmed in colour since *Stingray* (1964) with US syndication in mind.
126. The 625-line PAL standard began to replace the old 405-line standard (once called 'high definition') with the launch of BBC2 in 1964. BBC1 and ITV switched to 625 lines in 1969.
127. Both *Noggin the Nog* and *Ivor the Engine* later returned in colour versions.
128. The exception was a political short, *The Revolution* (1967), which combined Taylor's progressive politics and aesthetics.
129. *Willo the Wisp* developed from a character created by Spargo for *Super Natural Gas* (1975), a sponsored film about the offshore gas industry.
130. Trident was formed as a holding company following the merger of Yorkshire Television and Tyne Tees, Halas & Batchelor's majority stakeholder since 1968. In 1972 John and Joy felt forced to relinquish their remaining shares in the company.
131. The course originated at the Guildford School of Art, which merged with the Farnham College of Art to become the West Surrey College of Art and Design. The animation course moved to Farnham, now part of the University for the Creative Arts.
132. Dick Horn had started his career at Halas & Batchelor as a trainee and had been through most British studios, including the amateur Grasshopper Group, and a couple of Canadian ones before settling with Melendez Films. The sudden death of Jacques Vausseur thrust him into the role of animation director on *Dick Dickeye*.
133. 'Turning a fine, fast buck', *Sunday Times*, 9 November 1978.
134. Martin Rosen's most significant credit at that time was as co-producer on Ken Russell's *Women in Love* (1969).
135. John Hubley had graduated through Disney and United Productions of America

(better known as UPA) to found his own company, Storyboard Productions, making distinctive 'cartoon modern' commercials and increasingly experimental animated shorts with his wife Faith.
136. https://bbfc.co.uk/sites/default/files/attachments/Watership-Down-report.pdf (accessed: 28 November 2019)
137. Terry Gilliam wasn't the first to bring animation to more adult formats: Biographic made sequences for the post-Goons ITV series *Son of Fred* (1956) and *It's a Square World* (1960–65).
138. https://genome.ch.bbc.co.uk/55bf7160f65d46ba8f878035fa2c292e (accessed: 22 November 2019).
139. John and Faith Hubley's *Moonbird* (1959) and *A Windy Day* (1967), which respectively featured the voices of their sons and their daughters, were important precedents. Bill Mather saw *A Windy Day* at the Cambridge Animation Festival in 1967.
140. 'Thames Sale to US cable', *The Stage and Television Today*, 1 March 1984, p. 21; Jo Thomas, 'Dangermouse, the Hero Rodent of Baker Street', *New York Times*, 11 September 1984, p. 22.
141. Sue Summers, *Evening Standard*, 16 December 1983, p. 19.
142. Kenneth Grahame's work had just fallen out of copyright, and the film acted as a pilot for five series of shorter episodes (1984–90).
143. 'Danger Duck', *The Stage and Television Today*, 8 October 1987, p. 19; 'The Quack of Doom', *Daily Mail* (*You Magazine*), 8 November 1987, pp. 124–6.
144. Broadcasting Act (1981) Available online: http://www.legislation.gov.uk/ukpga/1981/68/part/I/crossheading/special-provisions-relating-to-the-fourth-channel (Accessed 18 May 2020).
145. Richard Brooks, 'Cartoons come of age', *The Observer*, 16 December 1990, p. 55.
146. A possibly apocryphal label attributed to Jeremy Isaacs. True or not, it sums up how the appointment of Paul Madden, formerly a television archivist at the BFI, was initially seen by animators.
147. It didn't screen on the channel until 1990.
148. Barry Purves was no beginner, having worked at Cosgrove Hall, most notably animating Mr Toad for *Wind in the Willows*.
149. As Clare Kitson points out in her excellent and insightful book on Channel 4 animation, she was actually appointed assistant commissioner of animation – even though there was no-one else to assist and the job was more than a full-time commitment.

150. The name has evolved over the years: the dynamic animate! became Animate, before being reborn as Animate Projects in 2007.
151. Richard Brooks, 'Cartoons come of age', *The Observer*, 16 December 1990, p. 55.
152. Kitson would have loved to have worked with S4C more, but adaptations of popular classics didn't fit Channel 4's remit. Clare Kitson, *British Animation: The Channel 4 Factor* (London: Parliament Hill, 2008).
153. The series returned in 1981, in a much-reduced late-night slot.
154. http://www.telepathy.co.uk/aardman/showcase/info/i_close02.html (accessed: 23 October 2019).
155. http://www.telepathy.co.uk/aardman/news/recent/recent10.html (accessed: 6 July 2019)
156. American deals set HIT shares soaring. Raymond Snoddy, *The Times*, 22 December 1999, p. 23.
157. Animation's importance to Channel 4's early history is in danger of being forgotten, too. Maggie Brown's *A Licence to be Different: The Story of Channel 4* (London: BFI, 2007), doesn't mention animation at all – not even *The Snowman*, Clare Kitson or Aardman.
158. A pioneering video-on-demand platform in the pre-YouTube era.
159. 'Angry Kid Gets Animated', *Lancashire Telegraph*, https://www.lancashiretelegraph.co.uk/news/6086496.angry-kid-gets-quite-animated/ (accessed: 24 October 2019).
160. Oliver Poole, '*Angry Kid*, son of *Wallace & Gromit*, slips the net for TV', *Daily Telegraph*, 24 September 2000, www.telegraph.co.uk/news/uknews/1356565/Angry-Kid-son-of-Wallace-and-Gromit-slips-the-net-for-TV.html (accessed 24 October 2019). Much of the reporting of the internet launch of *Angry Kid* states that it was turned down by Channel 4, but it appears in TV listings throughout 1999 in early morning slots.
161. *Automania 2000*, *The Question* and *Players* all fit this theme.
162. Ian Pearson and Gavin Blair later took their experience and ideas to Vancouver, developing the landmark computer-animated TV series *ReBoot* (1994–2001).
163. Erik Ipsen, 'Quicker Cartoons Draw in Profits', *International Herald Tribune*, 7 August 1995, https://www.nytimes.com/1995/08/07/business/worldbusiness/IHT-quicker-cartoons-draw-in-profits.html (accessed: 19 Oct 2019)
164. Originally developed by FutureWave, Flash was snapped up by Macromedia in 1995, which was in turn acquired by Adobe in 2005..

165. Now UCA Farnham.
166. UKIE website https://ukie.org.uk/research (accessed: 19 October 2019)
167. https://hansard.parliament.uk/Commons/2012-03-21/debates/12032154000001/FinancialStatement (accessed: 1 March 2021)
168. Oli Hyatt of Blue Zoo quoted in Maija Palmer, 'Animators quit UK for tax breaks abroad', *Financial Times*, 18 November 2011, https://www.ft.com/content/373739dc-0a16-11e1-85ca-00144feabdc0 (accessed: 12 August 2019).
169. https://www.boxofficemojo.com/movies/?page=main&id=chickenrun.html (accessed: 12 August 2019).
170. Then known as Richard Goleszowski.
171. Mike Goodridge, 'Aardman to make Wallace And Gromit movie', *Screen Daily*, 20 June 2000, https://www.screendaily.com/aardman-to-make-wallace-and-gromit-movie/402734.article (accessed: 21 Ocotber 2019).
172. Willow Green, 'Script Rethink Forces Aardman Halt', *Empire Online*, 4 July 2001, https://www.empireonline.com/movies/news/script-rethink-forces-aardman-halt/ (accessed: 14 July 2019).
173. For example, Dalya Alberge, 'Creators of Wallace and Gromit roll up the Plasticine', *The Times*, 16 February 2006, p. 29.
174. Geoffrey McNab, 'On a wing and a prayer', *The Guardian G2*, 24 March 2003, p. 10.
175. Fiachra Gibbons, 'North Berwick is like the Caribbean', *The Guardian Film and Music*, 11 June 2010, p. 5.
176. Chomet evidently saw something of himself in the character.
177. Released overseas as *The Pirates! Band of Misfits*.
178. Shaun debuted in the Wallace and Gromit story *A Close Shave*, before winning his own successful television series (BBC, 2007–16).
179. Maija Palmer, 'Animators quit UK for tax breaks abroad', *Financial* Times, 18 November 2011, https://www.ft.com/content/373739dc-0a16-11e1-85ca-00144feabdc0 (accessed: 19 October 2019).
180. James Graham, 'Cosgrove Hall quietly shut down', 10 June 2010, http://www.thebusinessdesk.com/northwest/news/24736-cosgrove-hall-quietly-shut-down (accessed: 15 June 2019).
181. Robert Kenny and Tom Broughton, October 2011, http://citeseerx.ist.psu.edu/viewdoc/download?doi=10.1.1.469.371&rep=rep1&type=pdf (accessed: 15 August 2019).

182. The video games industry had won a similar prize in the Labour government's pre-election 2010 budget, only to have it snatched away three months later by incoming Conservative chancellor George Osborne.
183. Figures from two BFI reports: 'Economic Contribution of the UK's Film, High-End TV, Video Game, and Animation Programming Sectors', February 2015, and 'Screen Business: How screen sector tax reliefs power economic growth across the UK', October 2018.
184. https://www.animationallianceuk.org/film-policy-review-submission/ (accessed: 18 July 2019).
185. Ibid.
186. https://www.silentsignal.org/Collaborations/loop/ (accessed: 25 November 2019).
187. https://www.ukscreenalliance.co.uk/subpages/inclusion-and-diversity-in-the-uks-vfx-animation-and-post-production-sectors (accessed: 29 November 2019).
188. https://www.theguardian.com/media/2010/jan/16/aleksander-orlov-price-comparison-ads (accessed: 29 July 2019).

INDEX

Index entries in **bold** indicate illustrations; entries in *italic* refer to endnote references within the main text.

2001: A Space Odyssey (1968) 106, 148
2DTV (2001–04) 150–1, 152
Aaagh! It's the Mr. Hell Show (2001–02) 150
Aardman Animations 9, 107, 114, 128, 129, 134, 135, 139, 140, 142, 143, 144–5, 150, 157–9, 160, 161, 167, 171, *174n*, *184n*, *185n*
Abenteuer des Prinzen Achmed, Die / The Adventures of Prince Achmed (1926) 56, 92
Abu and the Poisoned Well (c. 1943) 68, **68**
Academy Awards / Oscars 44, 63, 79, 80, 101, 106, 107, 116, 121, 130, 138, 142, 147, 158, 164
Addison, Abigail 164
Adolf's Busy Day (1940) 63, **65**
Adventures of Parsley, The (1970) 112
Akbah's Cheetah (2000) 137
Albion (1979) 128
Aldridge, Sidney 18
Alexander the Mouse (1958) 93
Alexeieff, Alexandre 57
Alf, Bill & Fred (1964) 78
Alien (1979) 148
Amateur Night (1975) 118
Analysis Films 69, 74, *181n*
Anderson, Gerry and Sylvia 92, *182n*
Anderson, Jesse 32, 35
Anderson, Wes 159
Anderson, Will 164
Anglia Films 46, 47, *177n*
Angry Kid (character) 144–5, **144**, 166, *184n*
Animal Farm (1954) 84–6, **85**, **86**, 87–8, 90, 94, 99, 116, 172, *181n*
Animaland (1948–50) 81–82, **83**
Animated Conversations (1979) 128, 130, 134
Animated Cotton (1909) 16
Animated Putty (1911) 16
Animation Alliance 163, 165
Animation City 117
Animation for Live Action (1976) 118, 173
Annecy International Animation Film Festival 101, 163
Armstrong, Charles 16

Arnall, Dick 137, 164
Arthur Christmas (2010) 160, 161
Artistic Creation (1901) 11, **11**, *174n*
Arts Council 119, 136, 137, 163, 164
Astley Baker Davies 153, 161–2
Astley, Neville 152
Audition (1976) 128
Austin, Phil 117, 134
Autobahn (1979) 147–8, **148**, 173
Automania 2000 (1963) 101, **104**, 173, *184n*
Ayres, Ralph 86
B3ta 154–5
Babbitt, Art 106
Babylon (1984) 135
BAFTA 9, 106, 107, 142, 158, 164
Bagpuss (1974) 110
Bairnsfather, Bruce 19
Baker, Mark 9, 117, 152, 162, 173
Barker, David 51
Barron, Steve 140, 152
Bartosch, Berthold 56, 57, 101
Batchelor, Joy 42, 45, 64, 69, 72, 74, 87, 99, 170, 172, *174n*, *177n*, *179n*
Bateman, H M 51
Battle of Wangapore, The (1955) 94, **94**
BBC 78, 79, 87, 89, 91, 92, 93, 96, 99, 110, 112, 114, 116, 123, 125, 127, 128, 131, 133, 134, 138–9, 140, 142–3, 144, 149, 150, 151, 159, 162, 163, 171, *182n*, *185n*
BBFC 123, 125, *183n*
Beatles, The 42, 78, 105, 108
Becher, Will 137
Beddington, Jack 66
Bell, Steve 79
Belleville Rendevous (2003) 160
Bernstein, Sidney 57
BFG, The (1989) 131, **132**
Big City, The (1946) 83, *180n*
Big Knights, The (1999) 152
Biggar, Helen 59, 124
Bingo (character) **29**, 40, *176n*
Biographic Cartoon Films 78, 90, 91, 94, 100, 173, *183n*
Birth of the Robot, The (1935) 59, **60**, 66
Black Dog, The (1987) 126, 127, 134, 138, 173

Blue Zoo 162, 163, *185n*
Bob the Builder 144, 162
Bob's Birthday (1993) 150, **151**, 173
Bond, Michael 96
Bonzo the Dog (character) 25–6, **25**, **29**, 31, 33–4, 35, 40, 172
Booth, Walter 11, 13, 14, 15, 16
Borowczyk, Walerian 100
Borthwick, Dave 142, 173
Bride and Groom (1955) 78, 94
Briggs, Raymond 133, 134, 135, 160
Britannia (1993) 138, **139**
BFI 7, 12, 17, 40, 94, 118, 119, 137, 146, 147, 161, 163, 165, 170, 172, *174n*, *175n*, *179n*, *181n*, *182n*, *183n*, *184n*, *186n*
British Utility Films 56, *177n*
Brodax, Al 105
Bruce, Cat 164
Brunel, Adrian 33
Bully Boy (1914–15) 20, **21**, 23
Buxton, Dudley 19, 20, 22, 24, 26, 29, 33, 35, 50, 51, 112, 152, 172, *175n*
Café Bar (1975) 126, **127**
Calder, Emma 103, 173
Camberwick Green (1966) 96, **97**
Cambridge Animation Festival 137, 138, *183n*
Canterbury Tales, The (1998) 138
Captain Pugwash (1957–66; 1974–75) 93, **93**, 96
Cartoon (2002) **166**, 167
Cartoonland (1948) 87
Cat with Hands, The (2001) 137
Cat-man-do (2008) 167
Cavalcanti, Alberto 57, *175n*
Cavalli, Mario 138
CBeebies 152, 162, 163
cel animation 28, 33, 46, 47, 64, 68, 86, 94, 96, 112, 113, 114, 131, 143, 147, 153, *178n*
CelAction 152
Central Office of Information (COI) 72, 116, 167
CGI 7, 152, 156, 158–9, 160, 161, 162, 166, 167, 169
Channel 4 127, 129, 133–7, 138, 139, 144, 145, 148, 150, 151, 160, 164, 166, 167, 170, *174n*, *183n*, *184n*

INDEX

Chaplin, Charlie 19, 31
Chapman, Keith 144
Charge of the Light Brigade, The (1968) 106
Charley Says (1972) 115, **115**
Charley series (1948–50) 72–3, **73**, 84, 88
Charlie and Lola (2005–08) 152
Cheerio Chums (1919) 26
Chicken Run (2000) 143, 157, **158**
Chigley (1969) 96
Chomet, Sylvain 160
Chorlton and the Wheelies (1976–79) 113, **113**
Christmas Carol, A (1971) 106
Cinematograph Films Act 40, 41
Clangers, The (1969–72; 2015–) 110, **111**, 163
Claymation 16, 140, 142, 167
Close Shave, A (1995) 142, *185n*
Clown and his Donkey, A (1910) 16
Coates, John 104, 108, 133, 160
Cobb, Norman 29, 40
Colour Box, A (1935) 8, 42, **53**, 59, **102**, 172
Community Song series 40, 42, **43**
Confessions of a Foyer Girl (1989) 128
Connelly, Dennis 45, 46
Conversation Pieces (1983) 134
Corpse Bride, The (2005) 159
Cosgrove Hall 113, 130, 144, 159, 162, *183n*, *185n*
Cosgrove, Brian 112
Count Duckula (1988–93) 130
Cowboys (1991) 137, 173
Cows & Cows & Cows (2010) 155, 173
Crapston Villas (1995–97) 150, **151**
Creature Comforts (1990; 2003–06) 129–30, **129**, 135, 142, 150, 157
Cribbins, Bernard 116
Crick, Allan 74
Crook, Rosalie 'Wally' 69, **70**, 72
Crown Film Unit 61
Crystal Tipps and Alistair (1971–74) 112, 115
Cunliffe, John 133
Curse of the Were-Rabbit, The (2005) 158, 159
Custard (1974) 117
Cut-out animation 19, 20, 24, 26, 28, 31, 32, 53, 56, 92, 93, 96, 112, 115, 125, 143, 148, 152
Cyriak 117, 154–5, 168, 169, 173
Daborn, John 78, 94, 95
Dad's Dead (2002) 164, 173
Danger Mouse (1981–92) 130, **131**
Danot, Serge 96
Davies, Roland 47, 48
De Vere, Alison 116, 126–7, 133, 134, 138, 139, 173

Deakin, Camilla 160
Dear Margery Boobs (1977) 125, **128**
Death and the Mother (1997) 137
Decision, The (1981) 118
Dick Deadeye, Or Duty Done (1975) 121, 123
Dickinson, Thorold 57
Dilemma (1981) 148
Direct animation 58, *174n*
Disney 9, 37, 41, 45, 46, 63, 71, 81, 82, 87, 88, 90, 107, 116, 117, 131, 148, 159, 162, *176n*, *177n*, *182n*
Dog (2001) 164
Do-it-Yourself Cartoon Kit (1961) 78, 100, **101**, 173
Do-It-Yourself Film Animation Show, The (1974) 79, 171
Dot (2010) 167
Double Negative 161
Down and Out (1979) 128
Dragon Productions 53, 116
Dream of Arthur Sleap, The (1972) 146
Dreamland Adventures (1907) 15
Dreamless Sleep (1986) **124**, 135
Dreams of Toyland (1908) 13, 14, **14**, 96, 172
Dreamworks 143, 152, 157, 158, 159, 161
Dudok De Wit, Michael 117, 173
Dufaycolor 59, *178n*
Dunbar, Geoff 116, 119, 139, 173
Dunning Color 47
Dunning, George 101, 104, 105, 108, 121, 133, 147, 173
Dustbin Parade (1942) 67, 172
Dyer, Anson 8, 9, 19, 22, 26, **27**, 28, 30, 33, 46–7, 56, 61–2, 63, 64, 69, 76, 81, 87, 112, 152, 169, 172, *174n*, *176n*, *181n*
Early Man (2018) 161
Edelmann, Heinz 108, 126
Edwards, Dave 138
Eggeling, Viking 42
Ellitt, Jack 58
Elstree 'Erbs, The (1930) 39, **39**
Emes, Ian 42
Empire Marketing Board 57
Ethel & Ernest (2016) 160
Ever Been Had? (1917) **23**, 24, 172
Eye and the Ear, The (1945) 42, **43**
Fable of the Fabrics (1942) 64, **66**
Fact and Fantasies (1937) 57
False Friends (1967) 126
Famous Fred (1996) 138
Fantastic Mr Fox (2009) 160
Fearon, Percy aka 'Poy' 26
Felix the Cat (character) 26, 28, 29, 91
Fell, Sam 137
Felstead, Bert 90
Few Ounces a Day, A (1941) 66
Fielding, Ruth 160
Figurehead, The (1953) 74, **74**

Filling the Gap (1942) 67
Film Producers Guild 76, 77, 90, *180n*, *181n*
FilmFair 112
Fine, David 150, 173
Fireman Sam (1987–94) 137
Firmin, Peter 93, 96, 110
Fischinger, Oskar 52
Flash animation software 152, 154, 167, *184n*
Flatworld (1997) 142
Fleischer Brothers 34
Flexipede, The (1967) 146, **147**
Flushed Away (2006) 137, 152, 158–9
Foo-Foo (1960) 98, **99**
Football Freaks (1971) 117
Fox Hunt (1936) 44, **44**, 45, **45**, 47, 69, 172, *177n*
Framestore 155
Frankenweenie (2012) 159
French Windows (1972) 42, **43**
Friel, Dick 32, 33, 35
Fun Fair (1947) 84
Furniss, Harry 18
Gasparcolor 52, 59
Gaumont-British Animation 78, 81–2, 85, 86, 87, 90, 94, 116, *180n*
Geesink, Joop 81
Geni and A Genius, A (1919) **30**, 31, 152, 172
Gilbert & Sullivan 99, 121, 163
Giles, Carl 44, 47, 51, *177n*
Gilliam, Terry 28, 123, 125, *183n*
Gilpin, Denis 90
Girls Night Out (1987) 138, 173
Giro the Germ (1929–34) 55, 56, **56**, *177n*
Go Jetters (2015) 163
Godfrey, Bob 9, 76, 77, 78–9, 90, 91, 94, 100, 109, 113–14, 117, 118, 121, 125, 128, 131, 147, 171, 173, *182n*
Going Equipped (1990) 129–30, 135
Goldberg, Eric 117
Goldman, Thalma 118, 119, 173
Gorillaz 140, **141**, 167
Gouldstone, Ian 164
Go West Young Man (1996) 154, **155**, 173
GPO Film Unit 57, 59–61
Grace, Christopher 137
Grand Day Out, A (1989) 139, 142
Grand Slamm 116, 118
Grant, David 125
Grasshopper Group 94–5, 154, *174n*, *182n*
Gravity (2013) 155
Great (1975) 79, 121, 147
Great Rock 'n' Roll Swindle, The (1980) 117
Greaves, Daniel 30, 142, 167

Green Men, Yellow Woman (1973) 118, **119**, 173
Greene, Graham 45, *177n*
Grierson, John 37, 57, 59, 61
Griffin Animation 90
Griffiths, Sid 29, 34, **34**, 35, 36, 40, 47, 51, 54, 56, 61, 69, 172, *177n*, *181n*
Grillo, Oscar 116
Gross, Anthony 44, 45, 47, 172
Guard, Candy 138, 150
Guild Television Services 90
Gulp (2011) 167
Guy 101 (2006) 164
Guy, Tony 123
HaBa Tales (1959) 98
Halas & Batchelor 9, 67, 68, 69–70, 72, 73, 74, 77, 84–7, 90, 91, 94, 95, 98, 99, 100, 101, 103, 104, 105, 116, 117, 118, 119, 121, 126, 147, 148, 170, *174n*, *179n*, *181n*, *182n*
Halas, John 42, 64, 72, 77, 87, **99**, 106, 109, 148, 172, 173, *180n*, *181n*
Hale, Jeff 90, 91
Hall, Mark 112
Hand of the Artist (1906) 13
Hand, David 81, 87, 90, *180n*
Handling Ships (1944–45) 68, 69, 74
Hangovers (1978) 128
Hanna, Nancy 76, 77, 90, 91, **91**
Hard Day's Night, A (1964) 78
Hardcastle, Lee 168
Harris, Ken 106
Hart, Tony 114
Hattytown Tales (1969–74) 112
Hayes, Derek 117, 128, 134, 138
Hayton, Hilary 112
Hayward, Stan 78, 131, 146, 147, 148, 149
Heavenly Post Office aka H.P.O (1938) 57, **58**, *178n*
Hell Unltd (1936) 59, **124**
Help! (1965) 78
Henderson, Ainslie 164
Henry 9 til 5 (1970) 78, 125
Henry's Cat (1983–93) 78, 131–2
Hepworth, Cecil 28, 30, 46, *177n*
Herbs, The (1968) 96, 112
Hewlett, Jamie 140, 167
Hey Duggee (2014–) 9, 152, 163
Hicks, Victor 30, 31, 32, 152, 172, *176n*
High Fidelity (1976) 118
Hilberman, David 90
Hill Farm, The (1989) 162
HiT Entertainment / Hot Animation 144, 162
Hitchhikers Guide to the Galaxy, The (1981) 149
Hodgson, Jonathan 173
Hoellering, George 67, *179n*
Hogg, Ross 164

Hokusai – An Animated Sketchbook (1978) 119
Holdsworth, Gerald 77
Holloway, Stanley 46, 47
Hoppin, Hector 44–5, 47, 172
Horn, Richard (Dick) 94, **95**, 121, *182n*
Hubley, John 122, *182n*, *183n*
Humberstone, Arthur 86
Jennings, Humphrey 66
Hurd, Earl 28, 33
Hyatt, Oli 162, *185n*
Illusionist, The (2010) 160, **161**
Isaacs, Jeremy 134, *183n*
Isle of Dogs (2018) 160
ITV 78, 89, 90, 93, 98, 100, 106, 112, 117, 127, 130, 131, 132, 133, 136, 150, 159, 162, *182n*, *183n*
Ivor the Engine (1959) 96, 112, *182n*
J Walter Thompson (JWT) 52, 64, 69, 72, 77, 80, *178n*
Jamie and the Magic Torch (1976–79) 113
Jason, David 130, **131**
Jazz Stringer, The (1929) 37
Jenkins, Charlie 42, 106, 116
Jerry the Troublesome Tyke (1925–27) **29**, 34, **34**, 35
Joe and Petunia (1968–73) 116
John Bull's Animated Sketchbook (1915–17) 19, 22
John the Bull (1930) 54–5, **55**
Joie De Vivre (1934) 44
Jones, Chuck 30, 106
Kaleidoscope (1935) 59
Kama Sutra Rides Again (1971) 78, 125, 173
Karrot Animation 163
Kass, Janos 148
Kine Komedy Kartoons 32, 35
Kinemacolor 16, 17, 18
Kineto War Map (1914–16) 22
Kinsella, Edward 32
Kitching, Alan 146
Kitson, Clare 133, 135, 136, 144, 150, 170, *174n*, *183n*, *184n*
Knight and the Fool, The (1967) 95
Koch, Carl 57, 61
Korda, Alexandra 44
Kraftwerk 147
Kurtzman, Harvey 125
Lacey, Gillian 119
Lambie-Nairn, Martin 148
Larkins Studio 9, 74, 75, 76–7, 78, 90, 100, 106, 115, *180n*, *181n*
Larkins, William 52, 69, 74, 76, 77, *181n*
Latest News, The (1904) 15, **16**
Latham, William 103, 153
Lautrec (1974) 119
Le Grice, Malcolm 146, 153
Le Petit Prince (unrealised) 80

Learner, Keith 90, 91, 94
Leave it to John (1936) 52
Leeds Animation Workshop 121, 122, 124
Lewis, Len 118
Lingford, Ruth 137, 154, 173
Linnecar, Vera 70, **70**, 72, 76, 77, 90, **91**, 94, *180n*, *181n*
Lip Synch (1989) 135, 150
Little Island, The (1958) 106, 173
London Film Society 33, 37, 49, 56
Loop (2017) 165
Lord, Peter 114, 128, 129, 134, 139, 142, 143, 158, 171, *174n*
Lord, Rob 149
Love and War in Toyland (1913) 18
Love Me, Love Me, Love Me (1963) 106
Love on the Range (1939) 52, **54**
Love on the Wing (1939) 60, **61**, 172
Low, Douglas 72
Lupus Films 160
Luscombe All-British Productions 42
Lye, Len 42, 49–50, 53, 57–9, 60, 61, 66, 73, 102, 108, 155, 171, 172, *177n*, *178n*, *179n*
Mackendrick, Alexander 9, 52, 64, *178n*
Mackinnon & Saunders 159
Madden, Paul 134, *183n*
Magic Ball, The (1971–72) 112–13
Magic Canvas, The (1948) 42, **43**, 73, 77, 106, 172
Magic Roundabout, The (1965–77) 96, 112
Mainwood, Roger 147, 160
Manipulation (1991) 30
Martin, Max J 18
Mathematician, The (1976) 147, 148, **149**
Mather, Bill 53, 114, 128, *183nn*
Matter of Loaf and Death, A (2008) 159
Max Beeza and the City in the Sky (1977) 117
Max Headroom (1985) 149
McCay, Winsor 22
McKee, David 112
McLaren, Norman 60, 61, 73, 94, 101, 102, 108, 124, 172, *178n*
Meet Mr York – A Speaking Likeness (1929) 39
Meitner, Lazlo 44
Melbourne-Cooper, Arthur 13–15, 96, *175n*
Melendez Films / Bill Melendez 94, 121, 122, *182n*
Méliès, George 15
Memoirs of Miffy (1920–21) 33
Men of Merit (1948) **75**, 91
Merchant of Venice, The (1919) 28

Messmer, Otto 28
Mickey Mouse 37, 39, 51
Mikkelsen, Henning Dahl 47
Millennium the Musical (1999) 78
Milligan, Spike 78
Mills, Ernest H 19
Ministry of Information 59, 65–7, 69, 71, 77, *179n*
Miracle Maker (1999) 138
Money for Nothing (1985) 140, **141**, 152
Monkey Dust (2003–05) 150, **151**
Monty Python's Flying Circus (1969–74) 123, **125**
Moore, Sam 165
Moo-Young, Ian 118
Moreno Jr, George 83
Morgan, Horace 32
Morgan, Rob 137, 173
Morph 114, 134, 139
Moth Animation 164
Mouse and Mole (1997–98) 127
Moving Picture Company 152
Moysey, Frank 86, 90
Mr Benn (1971–72) 112, 113, 152
Mr Pascal (1979) 126, 133
Mr Trimble (1971–77) 117
MTV 140, 152
Mulloy, Phil 137, 138, 173
Murphy, Kathleen 'Spud' / Spud Houston 44, 69, *179n*
Murray, Gordon 93, 96, *182n*
Music Man (1938) 64
Musical Paintbox (1948–50) 82
Myller, Jorgen 47, *177n*, *178n*
N or NW (1938) 59
Nash, Percy 20
National Coal Board 104
National Film Board of Canada 101
National Film School / NFTS 117, 135, 139, 164
Natwick, Grim 106
Neighbours (1952) 94
Nettlefold, Archibald 46
Neubauer, Vera 114, 117, 118, 119, 138, 173
newsreels 7, 23, 35, 36, 40, 41, 57, 61, 63, 67, 68, 85, *176n*
Next (1989) 135, **136**
Nicholson, Ben 90, *177n*
Nickelodeon 130, 162
Noah and Nelly in… SkylArk (1976) 78
Noble, Joe 29, 33, 35, **35**, 36, 37–9, 50, 63, *176n*
Nocturna Artificialia (1979) 118–19, **120**
Noggin the Nog (1959–65) 96, 112, *182n*
Octonauts (2011–) 162
Oh'Phelia (1919) 28, 172
Old Toymaker's Dream, The (1904) 15

Oppidan Film Productions 125
'Orace the 'Armonious 'Ound (character) 37–8, **38**
Orchard, Grant 9, 152
Paddington (2014), *Paddington 2* (2017) 155
Pal, George 9, 52, **52**, 54, 64, 69, 71, 76, 77, 80, 167, *178n*
Parabella Animation Studio 164
ParaNorman (2012) 137
Park, Nick 129, 139, 142, 143, 157, 158, 159, 161, 173
Parker, Osbert 118
Passion Pictures 166
Patterson, Ray 81
Paul, R W 15
Peace and War Pencillings (1914) 18
Peanut Vendor / Experimental Animation 1933 (1933) 42, **43**, 58
Pearl & Dean 90, 95
Pearson, Colin 78, 100
Peppa Pig (2004–) 8, 9, 152, **153**, 161
Peter and the Wolf (2006) 164
Peters, Maybelle 118
Phillips Philm Phables 26
Pingwings, The (1961–65) 96, 110
Pink Floyd 42
Pink Guards on Parade (c. 1934) 52
Pinky & Perky 92
Piper, Keith 154, 155, 173
Pirates! In an Adventure with Scientists!, The (2012) 161
Pixar 9, 107, 152, 159, 160
Plague Dogs, The (1982) 123
Plain Man's Guide to Advertising (1962) 78, **79**, 91
Please, Mikey 164
Plume (2010) 163
Pogles, The (1965) 96, 110
Polychrome Fantasy (1935) 59
Polygamous Polonius (1960) 79, 100
Polygamous Polonius Revisited (1985) 79
Pond Life (1996; 2000) 150
Pongo the Pup (character) 25–6, **29**, 33, 34
Postgate, Oliver 93, 96, 110, 171
Postman Pat (character) 8, 133
Potterton, Gerald 78, 94
Pritchett, Tony 146, 147, 148
Prosser, Dave 164
Psyche & Eros (1994) 126
Publicity Pictures 49, 51, *177n*
Purdham, Richard 106
Purves, Barry 135, 136, 138, 163, 171, 173, *183n*
Putting on the Ritz (1974) 118
Quay Brothers / Brothers Quay 103, 119, 121, 134, 170, 173
Quinn, Joanna 138, 139, 171, 173

Rabbit (2005) 164, 173
Radage, Edric 85, 86, 90
Raemaekers, Louis 19
Rainbow Dance (1936) 59, **102**
Ralph, Graham 138
Rank, J Arthur (and Rank Organisation) 81, 82, 87, 104, *180n*
Realist Film Unit 59, 67
Red Tape Farm (1927) 54
Reed, John 81, 87
Reiniger, Lotte 16, 56–7, 58, 61, 92, 172, *178n*
Rex the Runt (1998–2000) 150
Richter, Hans 42
Right Spirit, The (1931) 54
Rise and Fall of Emily Sprod, The (1964) 78, 100
Ritchie, Alick 18, 19
River of Steel (1951) **75**, 77, 172
Road Hogs in Toyland (1911) 16
Robbie Finds a Gun (1945) 81
Robey, George 32
Robin Hood (1935) 45
Robinson, William Heath 51
Robotic Mutation (1998) 154
Rogers, Edgar 18, *175n*
Roobarb (1974) 9, 78, 79, 113–14, **114**, 131
Rosen, Martin 122, 123, 173, *182n*
Rotha, Paul 67
rotoscope 42, 55, 116
Royal College of Art (RCA) 115, 117, 118, 138, 153, 164
Ruddigore (1967) **43**, 99, 121
Ruhemann, Andrew 166
Run Adolf Run (1940) 63
Rushes Post-production 149, 152
Ruttman, Walter 56
S4C (Sianel Pedwar Cymru) 131, 137–8, 163, *184n*
Sachs, Peter 9, 75, 76, 77, 78, 90, 98, 115, 172
Sallis, Peter 142
Sally and Jake (1973–74) 113
Sam and His Musket (1935) 46, 47
Sammy and Sausage (1928–29) **29**, 35, **36**, *176n*
Sarah & Duck (2013–17) 163
Saturnz Barz (Spirit House) (2017) 167
Scarfe, Gerald 42
Scott, Terry 130, **131**
Sea Dreams (1914) 20, **21**
Second World War 10, 63, 75, 83, 159, *179n*
Secret Adventures of Tom Thumb, The (1993) 142, **143**, 173
Secrets of Life 41
See How They Won (1935) 52
Sellers, Peter 78, 94
Sewell, Bill 42, 116

INDEX

Shadows! (1928) 35, **36**
Shakespeare 28, 58, 121, 135, 138
Shaun the Sheep (character) 161
Shaun the Sheep Movie: Farmageddon, A (2019) 137, 161
Shepherd, Chris 117, 164, 165, 173
Shepherd, J. A. 26
Shoemaker and the Hatter, The (1950) 85
Shootsey Animation 118
Signal Film Unit 77
Silas Marner (1983) 127, 134
Silver Lining, The (1947) 80
Simon's Cat (character) 167, **168**
Simonetti, Sergio 116
Simple Simon (c. 1917) 32
Simpsons, The (1989–) 150–1, 167
Sinderella (1972) 125
Sketches for The Tempest (1979) 121
Skywhales (1983) 134
Sledgehammer (1986) 140, **141**
Small Miracle, A (2002) 127
Smallfilms 93, 96, 110, 112
Smith, F Percy 16, 22, 51
Smith, Mike 118
Smoke from Grand-pa's Pipe, The (1920) 32, **32**, 33
Snow White and Rose Red (1953) 92
Snow White and the Seven Dwarfs (1937) 81, 90
Snow White and the Seven Perverts (1973) 125
Snowdon, Alison 150, 151
Snowman, The (1982) 8, 71, 133–4, **135**, 160, 173, 184n
Socialist Car of State, The (1930) 54
Son of Fred (1956) 78, 183n
Sorcerer's Scissors, The (1907) 13, **13**
Soyuzmultfilm 138
Spargo, Nicholas 90, 116, 182n
Spark, The (1963) 95
Speed, Lancelot 20–1, 22, 31, 67, 96, 172
Spitting Image 150
Sproxton, David 114, 128, 134, 139, 142, 171, 174n
Squirrel War (1947) 81, 87
Starkiewicz, Antoinette 118
Starzak, Richard 150, 157, 161
Steamboat Willie (1928) 37
Steve Cinderella (1937) 47
Stevens, Beryl 90, 181n
Stokes, Jack 90
stop-motion animation 14, 15, 17, 52, 58, 59, 68, 74, 81, 94, 96, 98, 112, 113, 116, 128, 130, 133, 143, 150, 157, 159, 160, 161, 163, 167, 171
Story of the Flag, The (1927) 46, 176n
Story of Time, The (1951) 80, **80**

Stowaway, The (1960) 98
Strausfeld, Peter 67, 179n
Street of Crocodiles (1986) **103**, 134, 173
Stressed Eric (1998–2000) 150
Studdy, George 22, 23, 25, 26, 33, 34
Sullivan, Pat 28, 99
Summer Travelling (1945) **75**, 77
SuperTed (1983–86) 131, 137, 138
Sweet Disaster (1986) 135
T For Teacher (1947) **75**, 77
T.I.M. Marches Back (1944) 67
Taking a Line for a Walk (1983) **103**, 134
Tale of the Ark, The (1909) 15
Tales from Hoffnung (1965) 99
Taylor, Richard 90, 94, 115, 118
Tchaikovsky – an Elegy (2011) 163
Technicolor 41, 44, 47, 59, 61, 62, 64, 69, 72, 81, 155, 181n
Tempest, Douglas 19
Templeton, Suzie 117, 164
Thames Television 113
Thatcher, Margaret 79, 129, 130
Themerson, Stefan and Franciszka 42
Thief and the Cobbler, The (unfinished) 106, 107, 121
Thomas, Gary 164
Thompson, Eric 96, 112
Titt, Tom (Jan Junosza de Rosciszewski) 35, 176n
To Demonstrate How Spiders Fly (1909) 16
Toby's Travelling Circus (2013) 164
Tocher, The (1938) 57
Tofield, Simon 167, 168
Toy Story (1995) 152
Trade Tattoo (1937) 59, 155
Trickfilm 116
Tropical Breezes (1930) 40, 172
Trumpton (1967) 96
Tufty (character) 116
Tupy, Peter 149
Tusalava (1929) 49–50, **50**, 172, 177n
TV Cartoons / TVC London 104–5, 108, 133
Two Faces (1968) 126
Two's Company (1953) 94
Ubu (1978) 119, 173
UK Film Council 159, 163
UK Screen Alliance 165
Unemployment and Money (1938) 67
UPA 90, 101, 104, 121, 182n, 183n
U-Tube, The (1917) 20, 172
Valiant (2005) 152, 159
Vester, Paul 117
VFX 156, 161, 169, 174n
Victor, The (1985) 134

Victoria's Rocking Horse (1962) 95
Video Animation Ltd 147
Village, The (1993) 162, 173
Vision On (1964–76) 114, 118
Visual Education 50, 51
Wallace and Gromit (characters) 139, 142, 143, 157, 158, 159, 163, 184n, 185n
Walsh, Darren 144, 166
Warburton, Alan 156
Ward, William 33
Warner Bros 82, 106, 161
Watch the Birdie (1954) 94, 100
Water for Firefighting (1949) 74
Watership Down (1978) 122–3, **123**, 173, 183n
We're Going on a Bear Hunt (2016) 160
We've Come a Long Way (1951) 91
Webster, Tom 19, 35
Weschke, Karl 126, 127
What She Wants (1994) 154, **154**, 173
Whatrotolis (1929) 35
When the Pie was Opened (1940) 59
When the Wind Blows (1986) 108, 124, 134, 160
Whitaker, Harold 87, 123, 180n
White, Brian 35, 40, 51, 54, 56, 86, 172, 178n
White, Tony 102, 119
Who Framed Roger Rabbit? (1988) 107, 166
Who Needs Nurseries? We Do! (1976) 121
Who Robbed the Robins? (1947) 81
Widdicombe Fair (1947) 77
Williams, Elizabeth (Liz Horn) 70
Williams, Richard 53, 95, 104, 106–7, **107**, 117, 121, 147, 166, 171, 173
Willo the Wisp (1981) 116, 182n
Wind in the Willows, The (1983) 130, 159, 183n
Wombles, The (1973–75) 112, 133
Wonderful Adventures of Pip, Squeak and Wilfred, The (1921) 21, 31
Wood, Ivor 96, 112, 133
Woodland Animations 133
Woolfe, Harry Bruce 41, 177n
Wragg, Terry 121
Wrake, Run 164, 173
Wright, Lawrence 63, 178n
Wright, Ralph 81
Wrong Trousers, The (1993) 142, 173
Wyatt & Cattaneo 106, 117, 126
Yellow Submarine (1968) 8, 42, 101, 105, **105**, 108, 116, 119, 126, 173, 182n
You're Telling Me (1939) 61, 62, **62**, 179n
Young, Mike 131
Z (2012) 156, **156**

ILLUSTRATION CREDITS

While considerable effort has been made to correctly identify the copyright holders, this has not been possible in all cases. Where no rights holder is listed, the image is understood to be out of copyright. Any omissions or corrections brought to our attention will be remedied in any future editions. The majority of images are sourced from digitised films from the BFI National Archive. Images marked with an asterisk are from BFI National Archive Special Collections

Ruddigore and *The Magic Canvas* p. 43; *Fable of the Fabrics* p.66; *Abu and the Poisoned Well* p. 68; H&B staff photo p.70; Charley storyboard p.73; *The Figurehead* p.74; *Animal Farm* poster p.86; *Snip and Snap* series p.98; John Halas and Foo-Foo p.99 *; *Xeroscopy* p. 103; *Automania 2000* p. 104; *Autobahn* p. 148 * © Halas & Batchelor Collection

Bob Godfrey cartoon p. 76; *The Plain Man's Guide To Advertising* p. 79 & p.91; *Dear Margery Boobs* p. 128 © Bob Godfrey Collection

A Colour Box (1935) p. 53 & 102; *H.P.O.* p.58; *Love on the Wing* p.61; *Rainbow Dance* p. 102 © Royal Mail, British Postal Museum and Archive

p.27 *; p.29 *Felix Wins and Loses* *; p.43 *Experimental Animation* 1933 © Len Lye Foundation; *French Windows* © Ian Emes; *Pink Floyd The Wall* © Sony Music Entertainment; *The Eye and the Ear* © Themerson Estate *; p.44-5 © Anthony Gross Estate/Hector Hoppin Estate *; p.50 © Len Lye Foundation; p.51 *; p.53 Health Education Council: *Superman III* © National Institute for Health and Care Excellence; *Kelloggs' Frosties: Soccer* © Kellogg's ; *John Lewis: The Bear & the Hare* © John Lewis & Partners; *3M Scotch Videotape: Not Fade Away* © 3M; BT: *Buzby - Snowman* © BT Group plc; p.54 © Aimia Foods Ltd; p.75 *Full Circle* © BP plc; *River of Steel* © Tata Steel; p.80 © Rolex; p.83 © David Hand Estate/ITV plc; p. 84 *; p.85 *; p.92 © Primrose Productions *; p. 93 © The John Ryan Estate *; p.94-5 © John Daborn Estate; p.97 © Gordon Murray Estate/BBC *; p.101 © Biographic; p.102 *Calypso* © Margaret Tait Estate; *Dresden Dynamo* © Lis Rhodes; *Mutations* © William Latham; *Feet of Song* © Erica Russell/Channel 4; p. 103 *Stressed* © Karen Kelly *; *Now* © Denys Irving; *The Queen's Monastery* © Pearly Oyster Productions; *Who I Am And What I Want* © Chris Shepherd and David Shrigley; *Animated Genesis* (1952) © BFI *; p. 105 © Apple Corps*; p.107 *; p.111 © Jetpack Distribution Ltd *; p. 113 *Chorlton and the Wheelies* SPD-932824 © Freemantle Media *; p.114 © BBC/Bob Godfrey Collection/Grange Calveley *; p.115 © Crown Copright; p.119 © Thalma Goldman; p.120 © BFI/Brothers Quay *; p. 122 © Leeds Animation Workshop; p.123 © Watership Down Enterprises; p. 124 *Hell Unltd* © Norman McLaren Estate/Helen Biggar Estate; *Animated Genesis* © BFI; *The Jellyfish* © Amber Films; *Dreamless Sleep* © David Anderson Estate/Channel 4; *A Short Vision* © BFI; *Pretend You'll Survive* © Leeds Animation Workshop; *When the Wind Blows* © Meltdown Productions; British Screen; Film Four; Penguin Books *; p. 125 © BBC *; p. 126 © Ben Weschke; p. 129 © Aardman Animation; p.131 © Freemantle Media *; p. 132 © ITV *; p. 135 © Snowman Enterprises; p. 136 © Bare Boards Productions; p. 139 © Beryl Productions; p. 140 Peter Gabriel - 'Sledgehammer' © Virgin Records; Dire Straits – 'Money for Nothing' © EMI Records; A-Ha – 'Take on Me' © Warner Brothers; Radiohead – 'Burn the Witch' © XL Recordings; Art of Noise – 'Close (to the Edit)' © ZTT; Gorillaz – 'Clint Eastwood' © Parlophone; p. 143 © Bolex Brothers *; p. 144 © Aardman Animations; p. 147 © Tony Pritchett Estate; p. 149 © BFI/Stan Hayward; p. 151 *Crapston Villas* © Channel 4; *Bob's Birthday* © NFBC/Channel 4; *Monkey Dust* © Talkback Thames/BBC; p. 153 © Astley Baker Davies Ltd/Entertainment One UK Limited; p. 154 © Ruth Lingford; p. 155 © Keith Piper; p. 156 © Alan Warburton; p. 158 © Aardman Animations/Dreamworks Animation; p. 161 © Pathé/Django Films/Allied Filmmakers; p. 165 © Chris Shepherd; p. 166 © NSPCC; p. 168 © Simon's Cat Ltd; p. 169 © Cyriak Harris.